For my mother and father

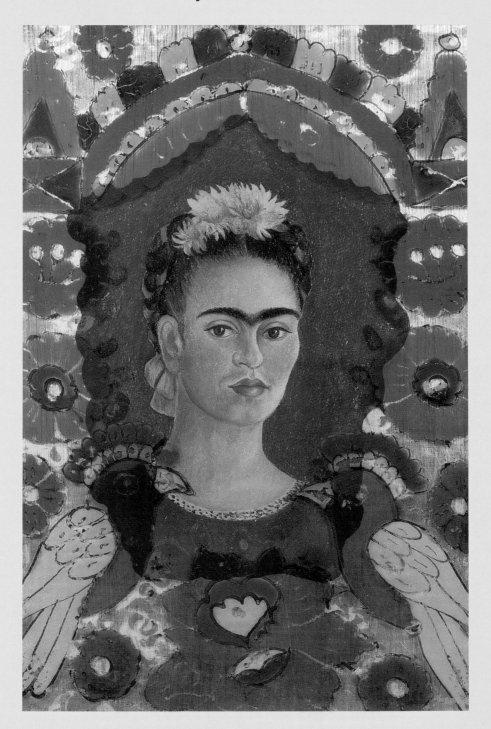

*They are your people sister; those who today speak
your name.
We who from everywhere, from the water and the land
with your name leave unspoken and speak no other
names.
Because fire does not die.*

Pablo Neruda

FRIDA KAHLO IN MEXICO

Robin Richmond

Pomegranate Artbooks

San Francisco

First published 1994 by Pomegranate Artbooks
Box 6099, Rohnert Park, California 94927-6099

Conceived, designed, and produced by
New England Editions Limited
25 Oakford Road
London NW5 1AJ, England

ISBN 1-56640-802-4
Library of Congress Catalog Card Number 93-87358

Editor/Art Director: TRELD PELKEY BICKNELL
Typographer: GLYNN PICKERILL
Photographer: ALEX SAUNDERSON
Endpaper Map by ROBIN RICHMOND
Typeset in Souvenir Light by THE R & B PARTNERSHIP
Printed in Singapore by IMAGO PUBLISHING

Contents

INTRODUCTION
THE EAGLE AND THE SERPENT 9

CHAPTER 1
THE HEART OF THE ONE WORLD
 CRACKED OPEN: 23
Pre-Hispanic Mexico

CHAPTER 2
CONQUEST AND REVOLUTION 38

CHAPTER 3
THE FAULTY MIRROR: 57
Frida Kahlo's Early Years

CHAPTER 4
THE FROG AND THE SWALLOW: 73
Frida and Diego

CHAPTER 5
FOLLY AND FAME: 95
A Career in Art

CHAPTER 6
DEATH AND LAUGHTER: 117
The Last Years

GLOSSARY & NOTES 147

ACKNOWLEDGEMENTS 152

ILLUSTRATIONS 153

SELECT BIBLIOGRAPHY 154

INDEX 156

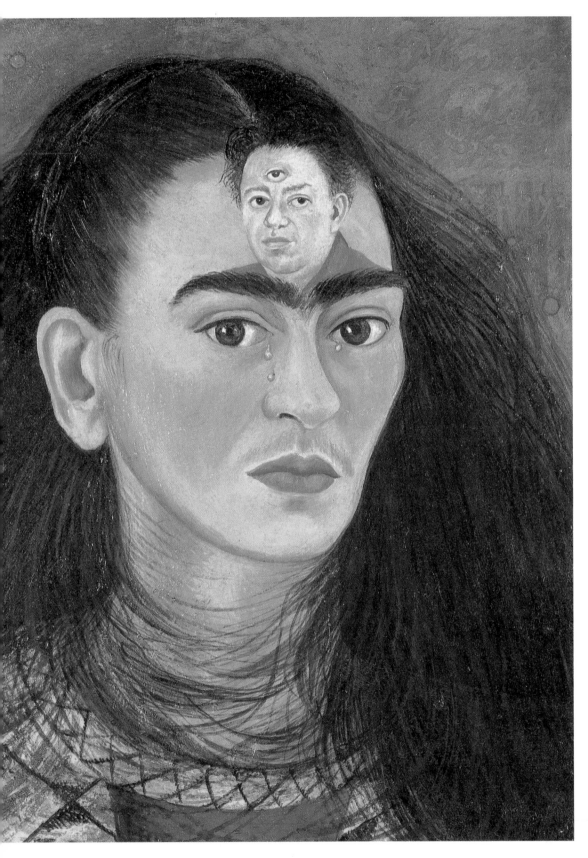

Diego and I, 1949.
Frida Kahlo's love for her husband, Diego Rivera, was sometimes as constraining and impossible as being wrapped in barbed wire. Her hair, normally bound in elaborate braids, seems metallic, gripping her neck like the necklace of thorns from **Self-Portrait with Thorn Necklace and Hummingbird** *(page 116). Even with his all-seeing Third Eye, Diego will never comprehend her grief. Oil on canvas mounted on Masonite, $11^{5}/_{8}$" x $8^{13}/_{16}$". Private Collection, courtesy Mary Anne Martin Fine Art, New York.*

INTRODUCTION

THE EAGLE AND THE SERPENT

Good art is made in a state of challenge, and should be viewed in the same spirit. *Frida Kahlo in Mexico* is about an artist who lived and worked in a constant state of challenge. After years of neglect, the last two decades have seen the work of Frida Kahlo become the subject of a manic form of hagiography. The attention focused upon her painting has been positively reverential. She has become the stuff of cinema and mythology. Her work is the subject of legal battles between collectors and the Mexican state. To many people, she has become St. Frida of the Many Wounds. All this does her an extraordinary injustice, and although I think that it would have amused her, she ultimately would have hated it. Frida Kahlo abhorred pretension, and ridiculed it with her inimitable raucous guffaw—often to the intense embarrassment of her companions. Frida has now been banished by her well-meaning admirers to the land of inaccessibility, to an Olympus of Art, where she sits queen-like on a gilded throne. I don't think it's any coincidence that a screenplay based upon the details of her turbulent life has been circulating in Hollywood over the last few years. But it seems wrong that Frida Kahlo, an earthy woman who identified so strongly with her race and her nation, has been both deified and sequestered. Through an excess of devotion she has been made an exile in her own land.

In her short, eventful lifetime she sold relatively few paintings, preferring to give her work away to admiring friends and benevolent patrons. But recently, an intimate painting of Frida's, *Diego and I*, fetched over a million dollars at auction, making her—posthumously—the most successful Latin American artist in history. In a very short time in the context of the long history of art, her life and work have achieved an iconic status that actually competes with an artist like Michelangelo in its partisan intensity. How

"If you tie a snake in knots, and leave it to its own devices, it will free itself."

BUDDHIST SAYING

amused, delighted, and shocked Frida would be to be in such exalted company, and male company at that!

Different interest groups have gradually appropriated her for themselves. She is esteemed by artists—they admire her style of painting, which confidently side-steps what is considered "high" art and looks positively towards folk art. Her personal vision of the world and the place of women within it, leavened with an openness about her sexuality, has promoted her to almost goddess-like status within the feminist and gay communities. Her unflinching gaze in endless dramatic photographs and self-portraits stares down at us from posters in every feminist bookshop from Tokyo to San Francisco. She is adored by an entire generation of women and men who see in her work a vindication of their pride in their Latin American cultural, political, and artistic roots. She is seen as an asker of awkward questions: about self-love, the love between people, the importance of gender, and the role of *machismo* in society. Her influence on Chicano-Latino art in the United States—particularly in California—is enormous. In Mexico itself she is considered a national monument, like the Lincoln Memorial or the Arc de Triomphe!

There is even a new word in the language—Fridomanía. There are films, operas, ballads, and even puppet shows about her life. On Cinco de Mayo in Mexico City, Haight-Ashbury in San Francisco, or Bleecker St. in New York, you can buy anything from wristwatches and earrings emblazoned with her face to a coffee mug or a miniature Frida shrine for your pocket. The *Creation of Adam* from the Sistine Chapel and the statue of *David* by Michelangelo were once the world's most popular ashtray images. Now, Frida's self-portraits glare balefully from behind their own plastic coating and have recently joined these male images in a dubious form of distinction. As an artist who wantonly played with images of sadism in her work—and was an unrepentant smoker herself—she would have appreciated the bizarre spectacle of a cigarette being stubbed out upon her face! Her work has generated cults and has given birth to myth. Her chroniclers and biographers have, on the whole, been generous and respectful towards her. There are biographies and analyses of her life and work from every point of view. Vituperative rivalry rages between scholars and collectors, who argue fiercely between themselves about everything from the accuracy of dates to questions of attribution. ("New" paintings by Frida have appeared regularly on the New York auction house scene.)

The Circle, 1951.
Frida's life-long questioning of the nature of self-love and the relationship between her physical and spiritual worlds became—towards the end of her life—an obsession. In this late painting, she presents a disturbing image in which the very essence of her physical life seems to be leeching away into the external world. A prophetic image, perhaps, of the "feeding frenzy" that now surrounds her.
Oil on sheet metal, 5' 9" in diameter (tondo).
Dolores Olmedo Collection, Mexico City.

Art historians, philosophers, political thinkers, psychoanalysts, poets, folk-singers, fiction writers, and worshipful admirers have all made their multi-textured contributions to "Frida Kahlo Studies."

History is the sum total of many lives, both famous and unknown, but it only seems to progress in a straight line when we are looking at it from the point of view of the Now. In fact, history takes some wild curves and inexplicable turns—as do the individual stories of our lives. We can unlock any artist's personal dynamic force if only we use the right sort of key. What *really* makes each artist unique is his or her sense of place, and how he or she fits into it. A knowledge of an artist's cultural and biographical history helps us climb inside the work. This seems so difficult at first. In Frida Kahlo's case, how can we understand a Mexican artist, if we have never even been to Mexico? But if we look at context, this becomes easier. This is why this book begins with a short exegesis of Mexican history, which precedes Frida's own personal history.

Artists in most societies today have no clear role. Their work is seen not in the place it was created, but in a gallery or museum. This is especially sad in the case of Frida Kahlo's work, which draws so much of its color-soaked energy from a pure joy in being Mexican, with its ancient history and ancient problems. Without understanding some-

thing of her complicated racial and cultural history, her art can appear mysterious and arcane. Frida Kahlo's painting was neither. She was a woman who related extremely vividly to her environment. She had a complex but deeply satisfying rapport with her fellow Mexicans of all classes and races. She might have looked like an Aztec goddess to the fashionable matrons of San Francisco, New York, and Paris in the 1930s and 1940s, but her long, embroidered skirts and elaborate head decorations did not look odd when she was shopping for chilies in the street markets of Mexico City, where many other women looked very much like her. She relished the country of her birth, and its tragic history, with an enthusiasm that sometimes bordered on the fetishistic.

Her husband, Diego Rivera, shared her passion for place. He had his own complicated relationship with Mexico, and adorned Frida's damaged body like a mixture of a religious shrine and a pagan goddess—intrinsically a very Mexican duality. In the many photographs that exist of Frida, his gifts of pre-Hispanic necklaces rest like ancient stones on her fine, slender neck. Her treasured ropes of heavy jadeite and silver made her look barbaric and delicate at the same time—a knowing, sophisticated combination that only Frida could have managed. She made her devotion to her country into almost an anthropological joke and, for all her apparent tragedy-queen role-playing, she was an

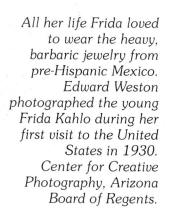

All her life Frida loved to wear the heavy, barbaric jewelry from pre-Hispanic Mexico. Edward Weston photographed the young Frida Kahlo during her first visit to the United States in 1930. Center for Creative Photography, Arizona Board of Regents.

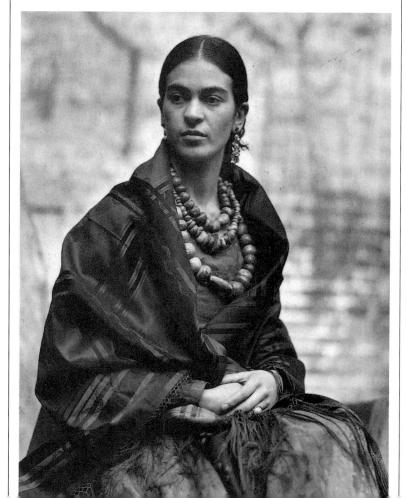

Victor Fosado, the famous Mexican silversmith, knew Frida well, and Diego Rivera bought many of Fosado's pieces as gifts for his wife. His jewelry was inspired by the native designs of Michoacán. A bejeweled Frida stands in the garden of the Blue House in Coyoacán. Photograph by Guillermo Zamora, 1953. Courtesy Arturo García Bustos.

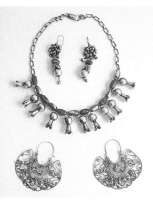

Earrings and necklace in the style of Michoacán and Mexico state, made by the Fosado family— silver and red seeds. Private Collection.

Silver and turquoise necklace in the form of Quetzalcóatl, the Plumed Serpent. Private Collection.

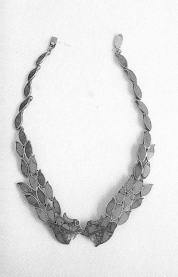

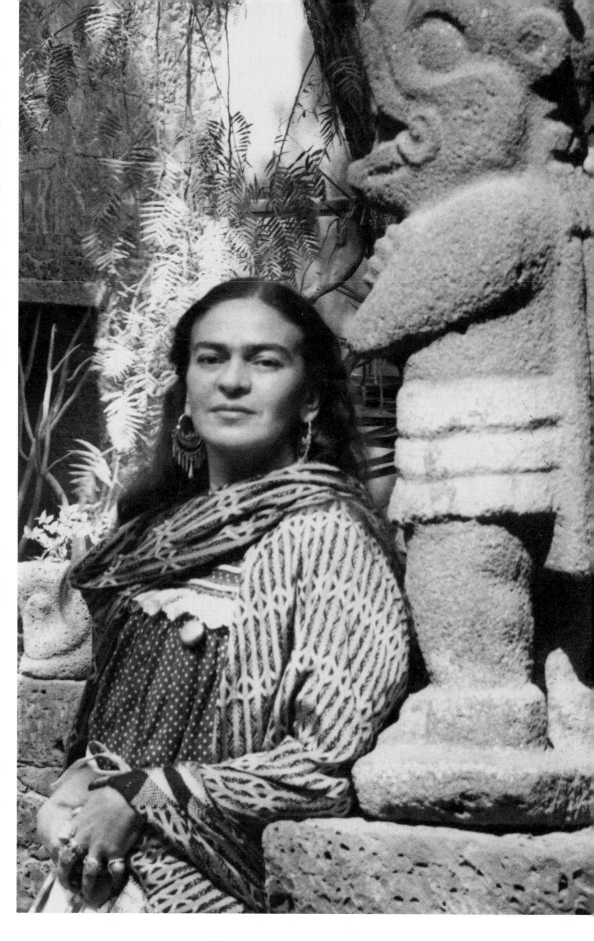

13

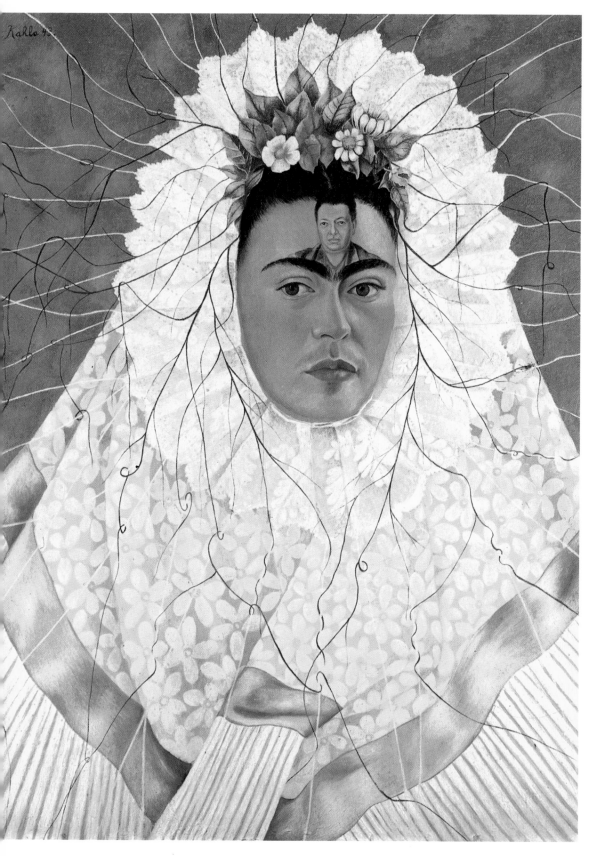

Diego in My Thoughts (Frida as a Tehuana), 1943. *It is said that when the Spanish came to Mexico in the sixteenth century, the Indian women became enamored of the lacy skirts of the Spanish women and, misinterpreting their function, placed them on their heads as headdresses. The women from the Tehuantepec Peninsula, where a matriarchal system prevails to this day, still wear this elaborate costume on special occasions. Frida's mother, Matilde, came from this region and Frida owned such a costume. Oil on Masonite, 29⅞" x 24". Collection of Jacques and Natasha Gelman, Mexico City.*

extremely funny lady who laughed at life and its tragedies with great gusto. Everyone that I have met who knew her well savors the memory of her wild, vulgar, scatological sense of humor. Their faces invariably light up with fond remembered pleasure and affection when they speak her name.

Frida Kahlo is not a suitable candidate for the canonization she is enduring at the hands of her admirers. An artist who cannibalized Catholic iconography in her painting, she would be astonished and even offended by the way she has, in turn, been made a saint by many scholars—especially those with a political agenda. She was an intellectual but never an intellectual snob, and would have hated the thought of her work being used to serve a didactic purpose. She disdained elitism of any sort. She read the great philosophers and writers and was very well-educated in the classics, but she had another, more plebeian, side to her. She loved the popular *charro* (cowboy) movies. She loved cartoons even more, and the sillier the better. If a friend or student wouldn't go to the movies with her, she would happily take her chauffeur. She shopped in the street markets of Mexico City with the excited acquisitiveness of a ten-year-old—greedy for anything from jewelry bargains to little straw frogs that hop when you press their backs. She wore gold and tin with equal relish. Her sensuality was evident in her gloriously decorated kitchen and in her cooking, both of which delighted her gargantuan *gourmande* of a husband. Like many cooks, she liked to drink as she chopped garlic and chilies. Her relation to her home and to her culture was both easy and complex.

So was her art. Ambivalence is a very useful tool to artists. W. B. Yeats said that out of our quarrel with others, we make rhetoric, but out of our quarrel with ourselves, we make poetry. Frida's art is pure poetry. It drew its creative fire from inner tension. It thrived on a feeling of divided self. It drew its coherence from a conviction of duality. Frida was both a woman of the people and a member of the elite. She was a very feminine woman who liked to dress as a man. She played wickedly recondite games with gender stereotypes. She relished her own Indian heritage, and never ceased to celebrate it in her dress and cultural ideology, but intellectually rejected its very source—her own Indian mother. She despised narcissism in others and yet concentrated on self-portraiture as her subject matter. She was in thrall to her marriage and yet appears to have connived in

Patzcuaro, Mexico— women selling garlic and guayabas.

its (temporary) destruction. She was deeply humanist but affected a wholesale rejection of any form of spirituality which she found to be sentimental. She was of the earth in her love of all growing things, whether they be plants or children, and yet her real domain was not earth-bound at all, but transcendental and of the sky.

The emblem of the modern Mexican state since independence in 1821 is the eagle perched upon the branches of a cactus, a snake writhing in its mouth. The story of the founding of the capital is based on this compelling image prophesied in ancient times by sorcerers who foresaw a great city of the future built out of swampland. This holy spot, known then as Tenochtitlán—"Place of the Fruit of the Nopali Cactus"—is now known as Mexico City. Something of Frida's very essence is contained in this image of the foundation of her birthplace. The eagle has always represented the domain of the sky to the Mexicans, and it is the symbol of transcendental, spiritual freedom. The cactus and the serpent represent the fertile earth, and the sexual energy of the grounded self upon the earth's sacred soil. Frida Kahlo, in her life and art, was both the eagle and the serpent. She had

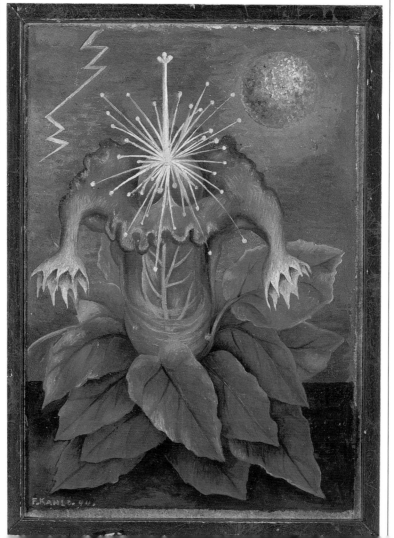

Flower of Life, 1944.
*The red womb-like flower bursts with vivid sexual energy. Oil on Masonite, 11" x 9".
Dolores Olmedo Collection, Mexico City.*

the conviction that she was grounded in the earth of her country, in her Indian genes, but that her European origins cast her somewhat adrift, condemning her to float free. Her work as an artist is galvanized by this dualism and, just as her people once worshiped the opposing forces of good and evil embodied in the respective forms of Quetzalcóatl and Tezcatlipoca, the old gods, Frida is pulled in two directions in the quarrel within herself.

Making sense of one's roots is a compelling reason for making art, and many artists are what anthropologists call de-racinated. Frida's genetic background was a potent mix, and provided her with strong fertilizer for the making of imagery. Her dearly beloved father was a displaced Hungarian intellectual, from a bourgeois Jewish family. Her mother was part Indian, born into a Catholic family from Oaxaca. Frida herself was brought up on a potentially confusing mixture of Kant on the one hand and *The Lives of the Saints* on the other. She distrusted the tenets of Catholicism and its strictures, but adored all its baroque trappings. In later life, a favorite outing on a dull Saturday afternoon, when her husband Diego was off working on a mural somewhere or entertaining an admirer, was a visit to what she called "the sadistic Christ" in her local church. This was not to express any form of piety, but rather to delight in the gory extremity of his wounds as represented by the anonymous sculptor.

Frida's multihued and varied ethnic background is typical of the average Mexican, who is racially a combination of European and Indian—and known as *mestizo*, or mixed. It gave her rich, fertile soil to tap into for her work and was her inspiration. She lived for much of her life in the same place: in the Blue House where she was born. She traveled throughout her country, and delighted in its infinite contradictions.

Frida presented herself and her contradictions to the world in the form of an elaborate *masque*. In an almost Elizabethan manner, she arrayed herself in splendor. Her clothes, jewelry, and hair were exuberant quotations from the costume of the Tehuantepec peninsula, birthplace of her mother's people. They were a potent testimony to her vaunted racial allegiances. Her husband, Diego, conspired with her in this adaptation of ethnicity, and delighted in her *Mexicanidad*. He taught her to look far back in time for inspiration, as he did so voraciously in his murals. He devoted much of his own tireless energy to collecting, painting, and rejoicing in all things pre-Hispanic. He impoverished them both with his purchases of pre-Hispanic art, and

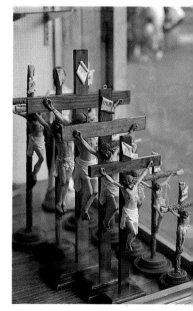

A strangely casual display of crucifixes found in a Mexico City shop window. Photograph by Robin Richmond.

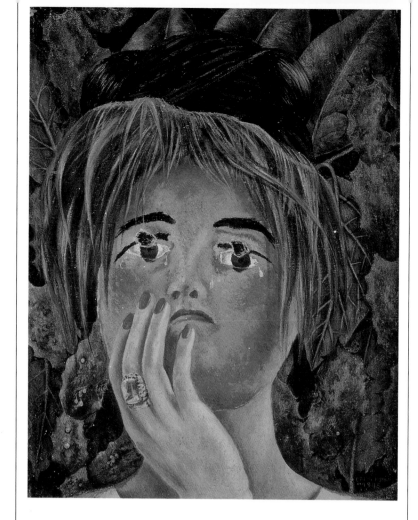

The Mask, 1945.
An image of over-powering feelings of alienation, the vanity of the manicured hand contrasts violently with the "bullet-holes" of the mask's eyes, through which Frida looks at the world. 11" x 14". Dolores Olmedo Collection, Mexico City.

Wooden masks from Veracruz and Oaxaca, nineteenth century. Private Collection.

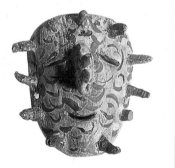

even created a personal museum that rivals the best public collections for its depth and rigor. But Frida's *masque* is more of a *mask* than she was prepared to acknowledge. Her European blood was at least as important to the development of person and artist as her Indian origins, and she derived inspiration from being two things at the same time. She delighted in all the rich ontological confusion that that entailed. She exploited and explored her identity as a deracinated person, simultaneously celebrating and mourning the Colonial process in her own genes. Frida identified with so much of her country's cultural mythology. She was both *La Llorona*—the legendary mother who stalks Mexican folk history in song and poetry weeping for her dead children—and the proverbial daughter of *La Malinche*, the young Nahua slave who was the mistress of the sixteenth-century conquistador Cortés. Malinche is also known as *La Chingada*, the violated one. Frida's loss of her babies in pregnancy, and the barely suppressed sexual aggression in her work, is embedded in these dual notions of grief and cultural violation. Frida's mask is her painting.

In the early 1980s, my own work as an artist became

very influenced by Frida's. I admired her detachment and confrontational style. I was after bravery and boldness in my portraits of other people and of myself, and Frida was a good role model in both these areas. From my reading I'd gleaned much more about the dramatic circumstances of her life than anything really substantial about her actual work. I only saw my first Frida "in the flesh" in 1982, at the Whitechapel Gallery in London, and found it to be as exciting as I'd hoped. Conceptual art reigned supreme at the time, and gallery walls seemed to be more often papered with printed text than with painted imagery. It was a joy to find an artist using color in the way that Frida did—with a thrilling, abandoned energy that seemed almost vulgar, in the cool English light.

I find now that, although many artists greatly admire her use of color, their very real admiration of the formal qualities of her work is all too often eclipsed by the anecdotal and biographical. Frida's life and art—so intensely intertwined— have become virtually indistinguishable from one another. It is perhaps inevitable, considering the dramas that befell her, yet it is a great pity. Artists *do* operate in a particular way and upon certain principles in their lives that are sometimes different from other people's, and they *are* probably moodier and more temperamental than most of the population. But artists live with the same problems that most people (at least those who have the luxury to dwell on their problems) face every day. The difference is that the problems of

Robin Richmond,
Portrait of Marjorie Eaton, 1985.
A very good friend of both Diego Rivera and Frida Kahlo from their days in New York, the late actress Marjorie Eaton modeled for this portrait. The pose is one of great theatricality. Watercolor on paper, 18" x 24". Collection of the artist.

artists—whether they be health-related, financial, or emotional—can be explored and focused upon in their work. But this focus is not always as explicit as some critics would believe. Flaubert's famous dictum that "*Madame Bovary, c'est moi,*" doesn't hold true for every artist. Artists can separate off an identity from their art. They can play psychological games in their work within the relative safety of a piece of paper or a canvas. Picasso once said that art is a lie that makes us realize the truth. The use of psychonalysis in understanding art has addressed this ability to "lie" by separating two conflicting energies—or dualism—in great depth. Frida Kahlo herself spent five years, from 1945 to 1950, reading the entire works of Sigmund Freud. However, I am chastened in my own interpretative speculations by a story that I was recently told about Frida.

In one of her most confrontational and tragic self-portraits, painted after one of many painful operations on her spine, called *The Broken Column*, Frida depicts herself, as she so often does, as a victim, pierced by the slings and arrows of her outrageous fortune, tears pouring from her eyes. Arturo García Bustos, Frida's friend for thirty years, who was with her every day in her studio while she painted this picture, told me how Frida roared with laughter at his terrible distress upon seeing the finished work.

"You must laugh at life, you innocent little boy," she scolded him. (He was all of eighteen years old.) "Look very, very, closely at my eyes. What do you see in them? My eyes are twinkling. The pupils are doves of peace. That is my little joke on pain and suffering, and your pity."

The avid devotion to the maimed and destroyed Frida is a product of who we are today. Our own media-induced voyeurism conditions the way we look at her art. The real "Fridolaters" have seen all the movies and the plays; the 1976 *Life and Death of Frida Kahlo* by Karen and David Crommie, the impressionist *Naturaleza Viva* by Paul Leduc, the play *Trece Señoritas* by Carmen Boullosa, and *Artist's Journeys* by Helen Chadwick for the B.B.C. Our hunger for information is insatiable because we feel powerless, and our psychological fragility lends greater morbidity to our view of Frida's work than is warranted. We are heedless victims of cultural obsessions with gender and sexuality. We have apparently very open minds about what is appropriate behavior in our own society, but are relentlessly literal-minded when it comes to understanding other cultures. This leads to our lamentable lack of imagination when we refuse

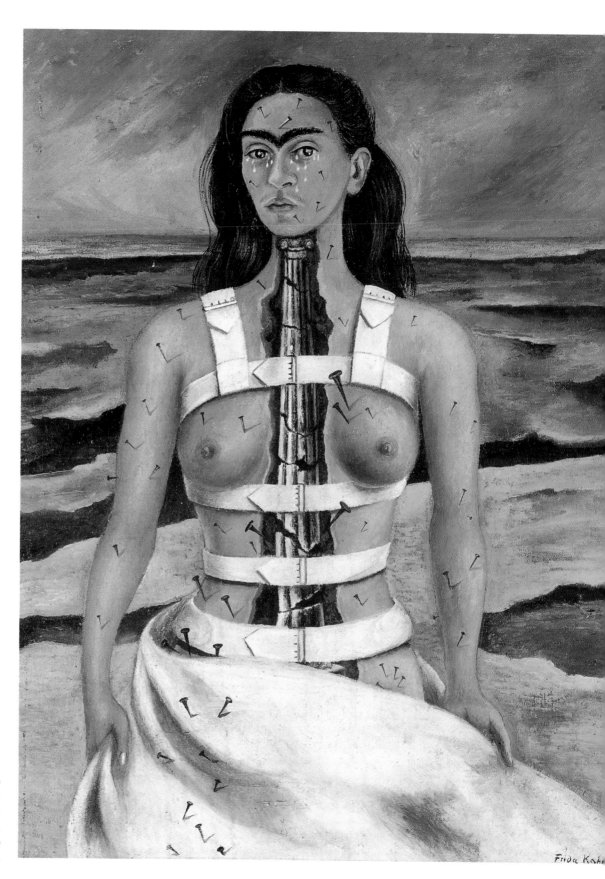

**The Broken Column,
1944.**
*Oil on Masonite,
15³/₄" x 12¹/₄".
Dolores Olmedo
Collection, Mexico City.*

to read much of anything besides the "as-told-to" biographies, which so dominate the best-seller lists. While there is no doubt at all that the circumstances of an artist's life bear greatly upon his or her work—and in Frida's case this is certainly so—I believe that it does the artist a disservice to dwell too lovingly on the life, and dismiss the work as incidental.

Frida and Diego Rivera were the world's most inventive and consummate confabulators. Actually, I think liars may not be too strong a word. They told different people what they wanted them to know. It was a power game, and they played it with arrogance but also with humor. One finds that for this reason no two biographies of Frida tell precisely the same stories. We know that she told her friends different versions of her reality. Perhaps she was not very clear about what her reality actually *was*. The unregenerate junkie, nymphomaniac, suicidal alcoholic witch that she appears to be in some books is at odds with the sweet, loving companion of other versions. But *everyone* sees Frida as a victim. She is always depicted as a sort of martyr—all too often by herself. Perhaps she *was* a victim of her own self in the end, and we are the victims of her own perceptions. It has been a very moving experience for me to witness the way Frida Kahlo inspired great protectiveness in her friends. In my experience, totally narcissistic and self-involved "victims" do not do this. They are not loved the way Frida is still loved by those fortunate enough to have known her.

I think Frida herself would have been amused but perhaps unsurprised by what has been called by the critic Teresa del Conde the "furtive passion" contained in almost everything written about her. She certainly had the conviction that she had something unique and important to contribute to her country and to the world. It might sometimes manifest itself as a stated conviction about her incomplete, de-racinated self. It might appear in the work as an exploration of undiluted narcissism. But looking at her painting in the context of her environment—that brilliant, mad, confused, kindly, barbaric, sad, wondrous, ancient, ephemeral, exuberant place that is Mexico—is as good a way as any to think about Frida Kahlo, and I think she would have liked it. She loved Mexico so intensely that her own intensity becomes infinitely more understandable when set against its vibrant Mexican backdrop.

Robin Richmond, 1994

CHAPTER I

THE HEART OF THE ONE WORLD CRACKED OPEN

Pre-Hispanic Mexico

Corn, or maize, has been the very essence of Mexico ever since about 5000 B.C., the time of the first "Mexican" farmers' harvests. The settlers of what we now call Mexico were nomadic tribes. They swept down through the North American continent during thousands of years of migrations, from northern or eastern Asia. Fossil remains tell us of a man who is somewhat like a Mongol in bone structure, with little body hair and high ckeekbones, but with an uncharacteristic copper-toned skin. Interestingly, there are Mexican babies born today that have the distinguishing purple-blue mark on the buttocks that is found, and celebrated, on certain Asian babies. But the genetic story of the migration is probably very complex. As the zoologist Jonathan Kingdon has said: "We are not, in the old-fashioned sense, races. We are all of us mosaics. We are all hybrids: packages of genes which have very definite prehistorical roots, which affect appearance, and some of those genes in those complexes tend to cluster."

Until 12,000 years ago, at the end of the fourth Ice Age, the ice that lay across the Bering Strait was a sturdy bridge for migrants chasing reindeer and moose, mastodon and bison. Anthropologists differ in their dating of the first migrations (and over their geographical origin) but it seems highly likely that the first migrations began over 50,000 years ago. There is clear evidence, based on radiocarbon

"In the middle of the water, in the middle of the lacy net, in the cane field where we live, where we the Tenochca people were born."

FROM THE
*CHRONICLE OF
THE PEOPLE OF
TENOCHTITLAN*

23

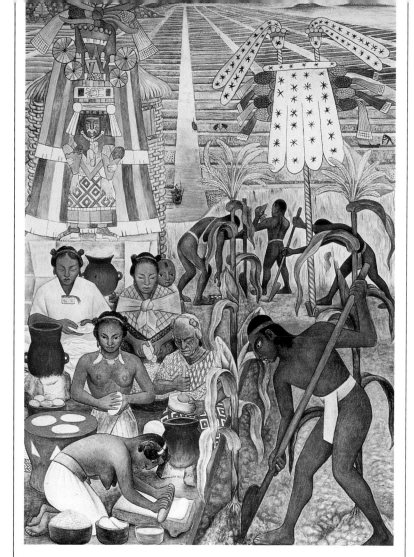

Diego Rivera, **The Huastec Civilization, 1950.** *Rivera celebrates the cultural and agricultural accomplishments of this pre-Hispanic tribe in a fresco. The corn goddess presides over the life-cycle of the maize plant—from its planting and harvesting to its final manufacture into tortillas. Patio Corridor, National Palace, Mexico City.*

dating, of human settlements in the region of Mexico City as far back as 21,000 B.C.

When these wandering tribes replaced their unsatisfactory diet of wild fruit and hunted animals with cultivated corn, the Mexican linked his destiny to the earth and sky forever. Since those ancient times, gods have been worshiped that are the very incarnations of the soil, the seed, and the water. Frida Kahlo's obsession with her *Mexicanidad*, her Mexican-ness, and what came to be known as *La Raza* (the race), must be seen in the context of this ancient link. Her Indian mother's forebears, who came to worship one God, were once worshipers of many. It is essential to understand this history of corn, *pantheism,* and Christianity to understand Frida's own history. Her dualisms, paradoxes, and personal labyrinths are uncannily reflected in the past of her country.

It is the soil of Mexico that is the spiritual provider of nourishment for her as an artist, and her work actually reflects concerns that reach far beyond the boundaries of the personal. In her engagement with her country and race,

Frida is a very Mexican artist. In its habitual state of self-reflection—through a glass often very darkly—her painting mirrors many of the existential concerns and desires of her birthplace. Worked with light strokes of the brush, her pictures demonstrate in miniature many of the heavy, time-worn confusions of her ancient country. Her artistic energies are directed towards understanding *personal* identity. Since the Spanish Conquest, the Mexican people have been engaged in a long, weary conversation about their *racial* identity. Frida Kahlo's painting is, in part, an investigation of the interface between personal identity and its public context. Both artist and country are planted deep in the soil of their past, and like Mexico's, Frida's past was dramatic, bloody, and sad. In its relentless exploration of personal joy and sorrow, Frida's painting addresses her ambivalent relationship with the world outside herself. This world is partly formed by a fault that runs through her sense of identity like the volcanic stress that makes the country itself so seismically unstable. Her complicated heritage is what makes Frida so very representative of her nation, for like ninety percent of her compatriots, Frida Kahlo was born *mestiza*—a highly confusing, combustible, and creative mixture of the Old and the New World. In her work, the European meets the Indian.

Forty years after her death, and almost 450 years after the *conquistadores* set foot on the ancient land of Anáhuac, the country is as addicted to self-analysis as Frida Kahlo ever was in her short lifetime. In her passion for understanding the past, Frida is the consummate Mexican artist. Like her, the Mexican people are locked—even blocked—in a constant state of psychic crisis, forever picking at psychological and historical sores. With its tragic history of territorial and cultural violation behind it, and the mixed heritage that has been the result, the country is understandably introspective. An awkward, crooked elbow of land linking two oceans horizontally and two continents vertically, it is also understandably less than confident of its innate stability, coherence, and identity—"so close to the United States, so far from God."

Mexico has many presents, but she has three pasts. There is the past that existed before the Conquest, the pre-Hispanic era, which stretches from about 2000 B.C. to the sixteenth century, when the Spanish arrived. This is followed by the traumatic period of the Conquest, and its aftermath, the long period of Colonial rule. The Mexican Revolution and its consequences make up the third past. Frida Kahlo's painting relates to all three—in attempting to resolve ethnic,

religious, and political tensions in personal terms. From our very first glimpse of her work we can see, with varying degrees of shock, that her extreme, self-revelatory painting plays many games with meaning. It utterly delights in juggling with opposing forces and dualisms. Good wrestles with evil. Light fights against the dark. The victim jousts with the murderer. The masochist is locked in combat with the sadist. The child outwits the adult. Personal power outwits impotent anger. The reflection in the mirror of a self-portrait by Frida Kahlo shows us far more than the physical revelation of the silvered surface of the glass. Frida's versions of, and solutions to, existential problems are displayed in a uniquely Mexican manner. These are typically Mexican concerns.

The pre-Hispanic peoples had a name for the domain of duality—it was known as *Omeyocan*. The origins of the central ambivalence or dualism explored in Frida's work lie in this domain, in the very ancient belief system of the earliest documented inhabitants of the country. Their versions of reality, represented in a complicated system of religious beliefs and gods, provide valuable insight into her mind as an artist. They provide clues to her iconography and subject matter. Frida herself treated her pre-Hispanic predecessors almost as household gods. Her studio and home were crowded with a superb collection of Indian art, craft, and ethnography from prehistory to her lifetime. She was an acquisitive buyer and enthusiastic consumer of her country's cultural artifacts. She felt—or at least wanted to feel—that the pre-Hispanic Indians were her "prime-movers," her progenitors, both as an artist and as a woman. She saw herself as the proud product of the old, primitive, non-European world, in all its barbaric, consummate beauty, cruelty, and tragedy.

In 1519, the elite trinity of the masters of Italian painting—Leonardo, Raphael, and Michelangelo—was shattered by the loss of its elder statesman, Leonardo da Vinci, who died aged sixty-seven, at Cloux near Amboise in France, while in the service to the king of France. A year later, another untimely death occurred. Raphael died in Rome in the employ of Pope Leo X, at only thirty-seven and at the pin-

nacle of his artistic powers. Michelangelo, however, at work on the *Risen Christ* in Santa Maria Sopra Minerva, had decades of life and work left in him. Yet there is a distinctive feeling of a conclusion with the passing of Leonardo and Raphael. The period of artistic brilliance that we now designate as the Italian Renaissance gradually began to lose its coherence at around this time.

As the pulse of Italy, the very heart of the Old World, gradually and imperceptibly began to weaken, on the opposite side of the globe, a young, opportunistic government employee penetrated, and then quite literally broke the heart of, the New World. He had arrived in Haiti, a Spanish protectorate island, at the age of nineteen, from the town of Salamanca in Spain, and had worked his way up through the hierarchy of colonial government in the islands of Santo Domingo and Cuba, conquered by the Spanish thirty years before. In the year of Leonardo's death, on February 10, 1519, he set out from Haiti with a large convoy of ships bound for the elbow of land that juts out into the Caribbean Sea known as the Yucatán Peninsula. He was accompanied

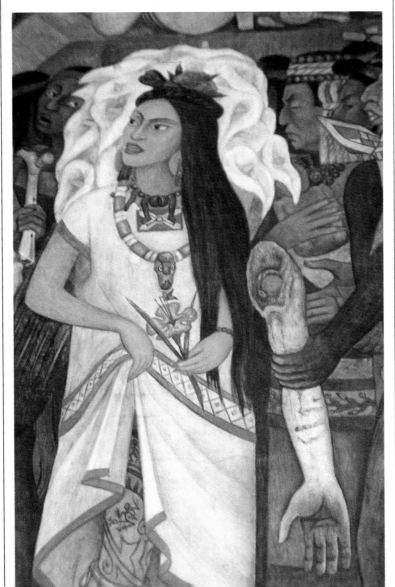

Frida Kahlo appears as a tattooed Aztec woman. Another figure holds out a severed human arm for sale. Painted by Diego Rivera in the mural **Great City of Tenochtitlán, 1945.** *National Palace, Mexico City.*

by eleven ships carrying 500 men, sixteen horses, thirty-two crossbows, ten bronze cannons and four young falcons. His was the third Spanish expedition to the Yucatán, and in Spanish terms by far the most successful. His name was Hernán Cortés.

With his dramatic arrival upon the shores of *Anáhuac*—"the land between the waters" in what we now know as Mexico—this ancient world shattered into pieces. Evil portents could be seen everywhere. A comet with three heads hung over the land. The temple of the Aztec war god Huitzilipochtli caught fire and burned to the ground in Cem Anáhuac Yoyotli, the Heart of the One World—a holy name given by the Anáhuac people to their capital Tenochtitlán—set on a high plateau hundreds of miles from Cortés's landing point. As the heart of the Old World began to weaken across the Atlantic, the Heart of the One World cracked wide open, and the heart of the New World began to beat in its place.

Cortés was acting upon a strong personal instinct, but also upon good information. His restless, youthful imagination was fired by the stories that had filtered back to Spain since Christopher Columbus's discovery in 1492 of what he famously misconstrued to be the continent of India—now known as the West Indies, the chain of tropical islands in the Caribbean Sea. Like many would-be explorers, Cortés had listened avidly to the tales which circulated around the governer's palace in Cuba, where he was stationed. His imagination had preyed endlessly upon elaborate stories of vast caches of gold lying in wait for the intrepid adventurer. He had his own personal vision of what lay beyond the sandy shores of the peninsula and had heard the legend of a magnificent, gilded empire in the interior of this strange tropical country. It was obvious that Yucatán was not an island like Cuba, but a major landmass. Back in Haiti he had been regaled with stories of contact with the native "Indians" in the two earlier, unsuccessful invasions, and became excited by accounts of his Spanish predecessors. The Spaniards had been barbarically repelled, attacked by apparently crazed, blood-smeared warriors armed only with simple bows and arrows and obsidian javelins. The well-armed Spanish soldiers were beaten back by these monstrous fighters. They had been hurt, but they were damnably, irrevocably fascinated.

Cortés was a very arrogant, minor employee of Diego Velásquez, the Governor of Cuba. Like his own employer and

Mist over Michoacán Valley (above). The mountains of Mexico—Chihuahua (below). Photographs by Jenny Cook.

28

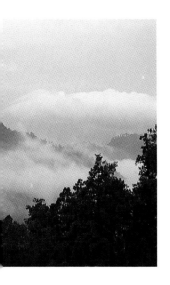

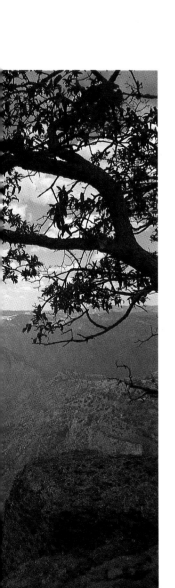

many other explorers during this period, Cortés's role in the plan to invade the peninsula was very ambiguous, extraordinarily ambitious, and totally self-appointed. King Ferdinand and Queen Isabella, patrons of Christopher Columbus in 1492, and, later, their successor King Charles I (subsequently known as Emperor Charles V), encouraged entrepreneurial exploration of the globe. Gold was necessary to subsidize the overweening Spanish nobility while the ever-present state of war in Europe needed vast injections of wealth.

Spain, a country that penetrates both the Atlantic Ocean and the Mediterranean Sea, had been plagued for centuries by problems of national identity. So many different ethnic groups had passed through her boundaries. A virulent form of religious supremacism was behind Spanish cultural ideology in the sixteenth century. At the time of the conquest of the New World, Spain had long been obsessed with the bitter, notorious, blood-soaked conflict between Mohammedanism and Christianity known all too euphemistically as the Crusades. Spanish Catholicism, as well as being deeply felt and legitimately concerned with a devotion to Christian doctrine and observance, also contained an element that was a coherent response to internal racial enmities. It embodied a vital desire for unity in a land riven by the divergent interests of Moorish, Jewish, Celtic, Teutonic, Roman, Carthaginian, Iberian, and many other racial groups. The Spanish court devoutly desired a means of sealing its Catholic identity through the conquest of lands outside its immediate vicinity, where it had no roots, no history, and no past to haunt it. When King Ferdinand of Castille married Queen Isabella of Aragon, the seal was set upon the future of the New World. Their famously reluctant acceptance of the somewhat fanatical plan of the humble, middle-aged Genoese navigator Christopher Columbus to find India, conquer foreign lands, convert the heathen to Christianity, and even redeem the Holy Sepulcher from the Turks set a program of colonization in progress that was carried on by Cortés.

In the Heart of the One World, news of Cortés's arrival on their shores confirmed an ancient prophecy to the Aztec people and their ninth *Huey Tlahtoani* (He-Who-Speaks-with-Authority), or emperor. Moctecozoma Xocoyotzin, the Angry Lord the Younger, was compelled to take serious notice of events. After conquering the Yucatán, wantonly smashing the beloved idols of the Indians—who mistook the Christian cross he erected for a symbol of their own rain god

Tlaloc—Cortés stopped next in the region of Tabasco, nearer to the One World, where he quickly overcame the Indian people with his "tubes-of-fire" (firearms) and his "magical beasts with six legs" (soldiers on horseback). The Indians had never seen a horse. They naturally assumed man and beast to be conjoined by some magically potent and lethal force, and they submitted to a shower of ammunition of two kinds: physical and spiritual. Cortés and his priest, Father Olmedo, preached a mass to the proud but bowed heads of the Indians and were presented with the gift of twenty nubile girls for their pleasure.

The great significance of this gift lies in the choice Cortés made for his own mistress. A young Nahua slave called *Malintzin* became his companion. She was baptized with the Spanish name of Marina and was taught the Spanish language. She thus became a translator and intermediary of sorts. She was also the mother of his son, and therefore the mother of the modern Mexican nation, ninety percent of which consists of her "children"—people of mixed Indian and Spanish blood. With the help of Malintzin, Cortés was able to communicate with the "savages." For the Mexicans, *La Malinche,* as she is notoriously known, is a traitor.

On April 22, 1519, Cortés landed at the port of Veracruz, only 200 miles from the Aztec capital of *Tenochtitlán,* which is now known as Mexico, or Mexico City. By this time, the Aztec world was a divided one, descending rapidly and inexorably into decadence. With no real term for "fine art" and no interest in creating objects destined only for contemplation, they appeased their own angels and devils, focusing on their mission to bring their prisoners towards a "flowery death" on the ritual altars of their temples, tearing still-beating hearts out of youthful bodies.

It is interesting that the Aztecs, though the most famous—and infamous—of pre-Hispanic cultures, were actually the last culture to flourish before the Conquest. Their period is perhaps the most notorious in Mexico's long history, but their troubled reign lasted barely 150 years. The actual "parents" of Mexico are the Olmecs, "the people of rubber." Their highly organized civilization flourished from before 1200 B.C. and at its height, their heartland on the coast of the Caribbean spread over 10,000 square miles. The Olmec presence in Mexico lasted well over 1,000 years, longer than any other. Although not as famous as the highly evolved Mayan civilization that followed it, and without the infamy of the Aztecs, the Olmec culture was nonetheless very great. At the height of

their importance, their territory stretched from Tres Zapotes in the north down to La Venta, and their population reached 350,000. Olmec craftsmen were among the greatest artists in Mexico's history; their monumental basalt heads and statuary based on worship of the supernatural jaguar rival Aztec art for realism and presence.

The Aztecs were the very last descendants of the ancient, barbaric *Mexica* tribe, sometimes known as the Chichimeca, the "dog people," for whom the country of Mexico is named. They were nomads from the north from the legendary place known as Aztlan, "the place of cranes." The derivation of *Mexica* is uncertain, possibly coming from the ancient Nahuatl word *metzli* (moon), *metl* (Maguey cactus), or *citli* (hare). Possibly their name is derived from their food. We know that the barrenness of the land forced them to live on a poor diet of *mexixin*, a bitter-tasting pepper grass. Whatever the derivation, the country of Mexico owes its name to this tribe who entered the Valley of Anáhuac in about 1325, inexorably drawn to the site of their capital. It was to be the birthplace of Aztec culture and the burial ground of the last true Indian culture.

Why choose this valley, with its poor soil, for a capital city? Some historians say that the Chichimeca-Mexica nomads imagined the swampy waters of Lake Texcoco to be

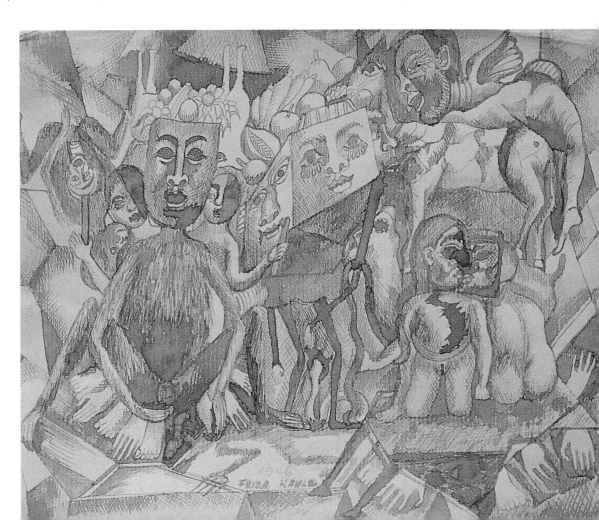

Sepia ink drawing by Frida Kahlo, 1946. A nightmarish vision of Frida's own angels and devils. 8^{1}/2" x 10^{3}/4". Private Collection, Mexico City.

suitable agricultural land. This seems unlikely since the waters were brackish and the soil water-logged, necessitating the construction of floating rafts weighted to the bottom of the lake with stones called *chinampas* as foundations for the city, and for growing fields. The city was fraught with structural problems from its beginnings, and still is. The Valley of Mexico is seismically unstable and notoriously prone to earthquakes. The city is ringed by volcanoes; Popocatépetl and Iztaccíhuatl are very close indeed. Some scholars believe that Tenochtitlán, the Aztec capital, "place of the fruit of the nopali cactus," was chosen for another reason. It was the larger of two islands in the old Lake Texcoco.

This reason is mysterious. The city was probably established due to a sense of predestination. It perhaps confirmed the fulfillment of the famous numinous prophecy that determined that the tribe should settle definitively when a Mexica tribesman espied an eagle perched upon the nopali cactus with a serpent in its mouth. Although irrational, it seems a likely reason for settling on the poorly situated islands in the lake. The Mexica, like Frida Kahlo and the Mexican people today, were very keen and even dependent on the value of portents in matters of decision making.

The Mexica peoples also knew the tales of the great Toltec culture that had risen from the ashes of Teotihuacán, the ancient city "where men became gods" (twenty miles north of Tenochtitlán) after its destruction between A.D. 650 and 850. The Mexica greatly admired the war-like Toltecs, whose capital was at Tollan, "place of the rushes," now called Tula, not far from Teotihuacán. This culture flourished from A.D. 950 to 1150. Its sister culture lay in Mayan lands, in the Yucatán Peninsula, and is called Chichén Itzá. The Toltecs worshiped special gods. Among the many, they especially revered *Tlaloc*, divinity of rain and patron of farmers, *Xipe*, the "flayed god" of Spring, and *Mictlantecuhtli*, Lord of the Dead. *Huitzilopochtli*, "Hummingbird on the Left," the god of the sun and of war, and his mother *Coatlícue*, "She of the skirt of snakes," were even more important to the Toltecs and their Aztec heirs. *Tezcatlipoca*, the creator god, was also a seminal figure in the pantheistic scheme. He was the embodiment of darkness, the *Smoking Mirror*, a god of evil. But, to create a balance, and to uphold the necessary dimension of duality, they also worshiped Tezcatlipoca's counterpart, his "precious twin," his benevolent reflection in the mirror, light of skin and fair of judgement. This is *Quetzalcóatl*, the great Plumed Serpent.

Napoli cactus—with its vitamin-rich fruit (tunas)—the ubiquitous symbol of Mexico. Photograph by Jenny Cook.

The Love Embrace of the Universe, The Earth (Mexica), Diego, Me, and Señor Xolotl, 1949. *Frida holds the all-seeing, yet infantile, Diego in her arms, as she herself is held in the powerful embrace of her Mexican past. Oil on Masonite, 28" x 24¹/₆". Collection Jacques and Natasha Gelman, Mexico City. Photograph by Jorge Contreras Chacel.*

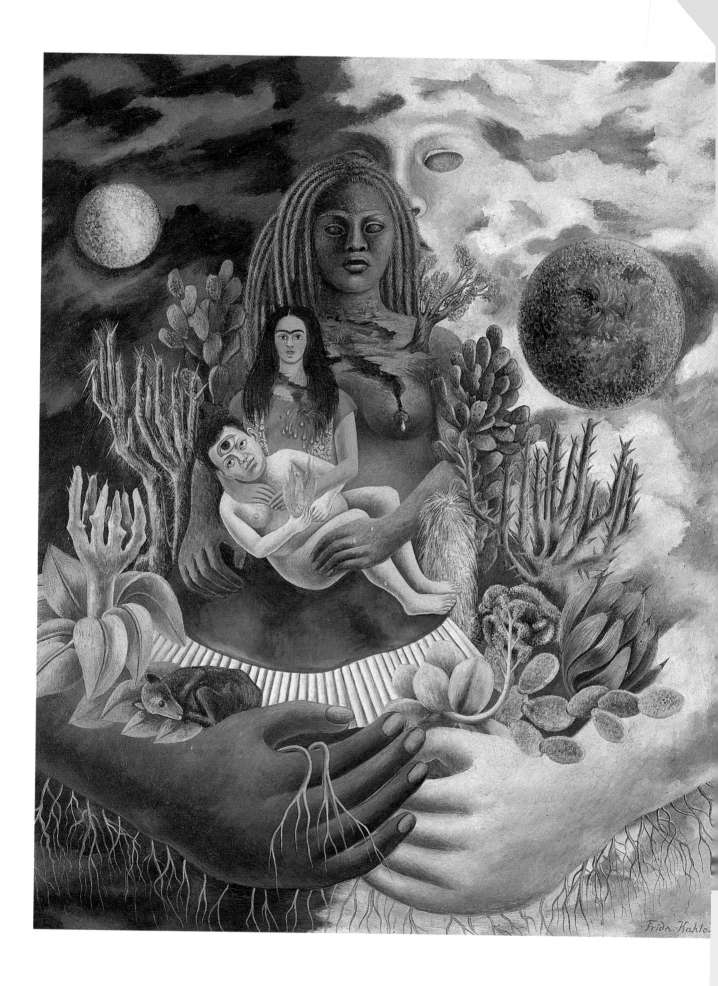

The brooding sense of two selves in a Frida Kahlo self-portrait is like the opposition of Smoking Mirror and his mirror-reflection of Quetzalcóatl, who represents everything that Tezcatlipoca is not. The sense of a divided self, so evident in a painting like *The Two Fridas* of 1939 (page 111), is a psychological dynamic that clearly reaches back into the pre-Hispanic past. The concept of a reflection, an alter ego, a persona or a sense of the "other" is glimpsed by Frida in the mirror when she paints a self-portrait. She watches the smoking mirror that is just like the one Tezcatlipoca gazes into in the realm of the gods. In Frida's case, there is a self that she sees that is whole and beautiful like Quetzalcóatl, who has inspired writers from the sixteenth-century religious missionary Fray Bernardino de Sayagún to the twentieth century literary missionary D. H. Lawrence. But there is sometimes a darker reflection in the mirror. The horrible irony, not lost on Frida, is that it was Quetzalcóatl who brought about the tragedy that was to destroy Mexico in its pre-Hispanic incarnation as Anáhuac.

The energy generated by these two opposing forces—good and evil—is the very source of the vitality of the tribe that eventually emerged from the Mexica—the Aztecs. And yet it is the most tragic, powerful paradox of Mexico that worship of Quetzalcóatl, the Plumed Serpent—transcendent master of the sky in his shining feathers, and master of the earth in his snake-form—would signal the end of their civilization. The most heroic figure in the savage pre-Hispanic cosmology is the cause of the spoiling of 10,500 years of a rich, indigenous culture. In the Christian religion, Adam ate the forbidden fruit and was punished for his disobedience. In the pre-Hispanic religions, the destruction of Edenic Anáhuac is locked into the Fall of Quetzalcóatl. The story of Quetzalcóatl is as tragic as any Judeo-Christian, Greek, Roman, or Eastern chronicle of human weakness. We must understand it in order to make sense of the very history of Mexico.

Quetzalcóatl has a polymorphous presence like many other pre-Hispanic deities, but his name can mean many things in Nahuatl. It can be variously read as "blessed one of the spirit of the bird," "spirit-god," "winged eternity of the wind," or even "precious twin." He is said to have "lived" in the legendary city of Teotihuacán, and later at Tula, but evidence of his worship is seen as far away as the Mayan-dominated Yucatán, and in Guatemala. He is an avatar, a deity who could assume human form.

Quetzalcóatl and Tezcatlipoca are mirror images of the unconscious mind. One represents the luminous intellect, the other, the black shadow, the formless chaos of the emotions. Quetzalcóatl's goodness is a foil not only to the deep, dark power of Tezcatlipoca, the evil god, but also to Huitzilopochtli, the god of war. He is the precious twin, an aspect of light, twinned by the dark. He embodies the divided, polarized nature of Mexican consciousness, so clearly explored in Frida Kahlo's painting. Quetzalcóatl represents the force of self-sacrifice and regeneration. He is the essence of what is true and vital. He is of the earth and thus grounded, but can be transcendental and heavenly. He even has a celestial incarnation as Venus, the morning star. He can also appear in the guise of a serpent, emblazoned with the shimmering feathers of the quetzal bird. He can be manifest as a bearded, pale, smooth-skinned man. His luminous incarnation as a god contrasts with the violence of his opposing force Huitzilopochtli, the god of war and of fire, sometimes known as "Warrior God of the South." Quetzalcóatl's abhorrence and rejection of human sacrifice defies his fellow gods, whose very existence is contingent in the Aztec mind upon the ritual spilling of human blood. The sorry tale of Quetzalcóatl's downfall is part of the tragedy of the end of Anáhuac, the end of pre-Hispanic Mexico, the crushing of The One World and the violence of the Conquest.

There are many rich legends about Quetzalcóatl. His identity is so arcane and mysterious that he has been variously associated with many great figures in history. There are stories which categorically identify him with Christ. He is also linked with St. Thomas. When the first Spanish friars came to perform their mission in Mexico after the Conquest, they found crosses on early painted images of Quetzalcóatl's tunic. They thus ascribed to him an early Christian identity. To some scholars, he is a Viking lord. To others his existence is inexplicable, and they interpret his presence as evidence of alien life from another planet! New Age archaeologists believe that the two-and-a-half mile road between the gigantic temples at Teotihuacán, known to the Aztecs as the "Way of the Dead," has, in the past, been used as a runway for extraterrestrial landing craft. The only consensus in all these wild and wonderful hypotheses is that for some reason, in the distant past, whether out of shame, devotion, or saintliness, the deity Quetzalcóatl, who could also assume human form and therefore human frailty, abandoned his people.

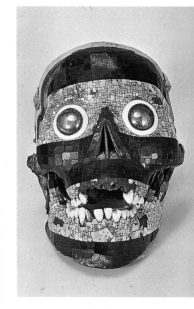

Mosaic mask of Tezcatlipoca. Courtesy of the Trustees of the British Museum, London.

The Story of Quetzalcóatl

The story of the fall and loss of innocence of the Plumed Serpent takes many forms. One story tells of a priest of the dark order—possibly Tezcatlipoca himself in disguise—coming one night, in the Aztec year One Reed, to a high-priest known as *Cé Ácatl Topiltzin Quetzalcóatl* (One Reed, Our Lord, the Plumed Serpent) in his bedchamber. Another offers a witch-goddess in the place of the priest. In both stories, Quetzalcóatl is offered refreshment of a particularly mind-enhancing kind. One version of the myth has the priest offering the god a potent drink from the maguey plant. Another version substitutes an hallucinogenic magic mushroom for the drink. In both stories it seems that the god has never before tasted such delight or drunk so deeply; he is intoxicated and his mind wanders away. He loses his memory. He loses his sense of identity. It is *this* crucial loss of identity that makes this myth so very resonant in the context of Mexican history. When the god's beautiful sister appears in his chamber, he succumbs to his baser, human instincts. The snake takes over from the eagle.

The next morning when Quetzalcóatl awakes out of his drunken stupor, he knows of his unpardonable sin. He is afflicted by a shame more devastating than even a god can bear. He builds himself a raft of snakes (again) and bids farewell to his people, whose love and devotion he feels that he no longer deserves. He dethrones himself in an act of self-sacrifice that finds many echoes in Christianity. It is the year One Reed, *Cé Ácatl.*

His followers grieve for him, but they cannot prevent his departure to Tlapallan, into the East. They are empty and bereaved—hopeless at the desertion of their god. The soothsayers predict his return one day, when the year *Cé Ácatl* returns in the Aztec cyclical calendar. Their solar calendar, called Xiuhpohualli, posits a year divided into 360 days, with five "empty" days called *nemontemi* (days in vain). There are also eighteen "months" of twenty days each. In 1519, another year of One Reed, *Cé Ácatl*, the ancient prophecy

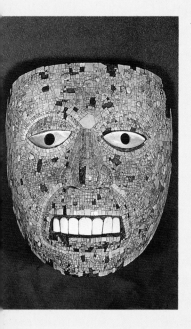

Mosaic mask of Quetzalcóatl. Courtesy of the Trustees of the British Museum, London.

36

decreed that Quetzalcóatl would return. The Toltecs had once waited for him, and the Mexica tribe (known as the Aztecs since 1325) waited patiently for him in their turn.

But it was not their beloved Quetzalcóatl who appeared to them in 1519. It was that opportunistic young adventurer from Salamanca via the Governor of Cuba's office—Señor Hernan Cortés.

This story can be interpreted in many different ways. It can be seen as an allegorical explanation of the inexplicable disappearance of the stars and Venus at sunrise. It possibly relates to the solar eclipse that we know occurred, with Venus still visible, in A.D. 750 Quetzalcóatl's desertion reflects a sense of purposelessness and decadence on the part of the Aztecs, who seemed to have no sense of time as an abstract concept, but believed that time could not move on without being actively fed, by all variety of rites and human sacrifice. The Aztecs were torn between the dualities of their existence and the exigencies of their religion that set the vicious, fiery war gods Tezcatlipoca and Huitzilopochtli against the gentler Quetzalcóatl, the redeemer. Perhaps they felt that he *had* to be sacrificed, like Christ in the Christian religion, in a cosmic scheme beyond their mortal comprehension. Certainly, the Aztecs identified with his glorious power. All their leaders, from the first, Acamapichtli, to the last, Cuauhtémoc "The Falling Eagle," claimed direct descent from Quetzalcóatl. In 1524, Fray Toribio de Paredes, known lovingly to the Indians as *Motolinia*, a Spanish missionary sympathetic to the conquered Aztecs' plight, had explained the succession of emperors thus: "An Indian named Chichimecatl tied a ribbon or leather strap to Quetzalcóatl's arm near the shoulder, and for this feat he was thenceforth called Acolhuatl. It is said that from this man descend the Colhua, Moteuczoma's (sic) predecessors, the lords of Mexico and Colhuacan."

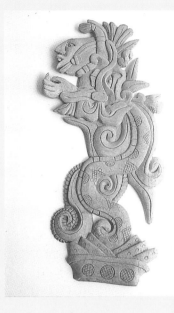

Wood effigy of Kulkulkán; Samahil, Yucatán. In Mayan mythology, the revered Toltec plumed serpent god Quetzalcóatl is known by this name. The slanting brow is a typically Mayan facial attribute.

Pre-Hispanic architecture, the pyramid of Teotihuacan. Photograph by Robin Richmond.

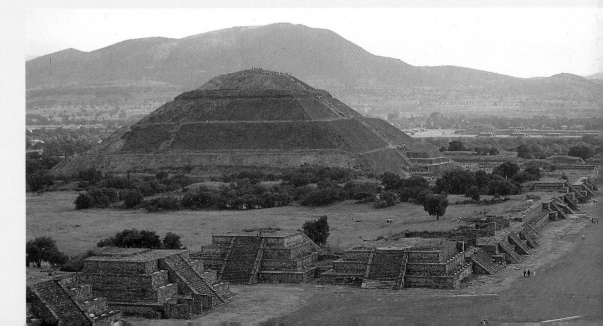

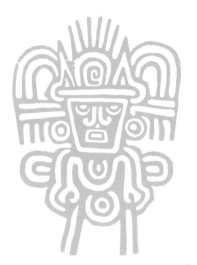

CHAPTER 2

CONQUEST AND REVOLUTION

In 1502, Moctecozoma (or Montezuma, as he was called by the Spanish) became Emperor *Huey Tlahtoani* of Tenochtitlán and high priest of Huitzilopochtli, the war god. He was the ninth Aztec emperor, and his reign was plagued by a series of ominous portents, but he was a good man and a sensitive leader. He ruled a huge, hard-won empire but he had not managed to conquer the savage Tarascans of Tzintzuntzan in what is now Michoacàn. Nor had he vanquished the Tlaxcala, 100 miles east of the One World, and it was this particular, rare failure that was to cost him his kingdom, and Mexico its past.

On November 9, 1519, the Tlaxcalans, in alliance with Hernán Cortés, who had butchered thousands of their people in his advance from the Yucatán, marched into Tenochtitlán with the young, minor diplomat from Havana and his 500 men. Bernal Diaz del Castillo, one of Cortés's captains, recalled in his *Conquest of New Spain:*

"The great Moctezuma descended from his litter and these other great *caciques* (chiefs) supported him beneath a marvelously rich canopy of green feathers, decorated with goldwork, silver, and pearls.... Many more lords walked before the great Moctezuma, sweeping the ground on which he was to tread and laying down cloaks so that his feet should not touch the earth. Not one of these chiefs dared look upon him in the face.... "

Cortés was welcomed as Lord Quetzalcóatl by Moctezuma in a series of long speeches in Nahuatl, the Aztec language—still spoken in some parts of Mexico. He was feted, given a necklace of the finest gold, and brought to the palace to rest. He was shown the myriad delights of Tenochtitlán, its blood-stained temples and sacrificial skull-racks. He was taken to the immense market on Tlatelolco

island, in which more than 70,000 people shopped every day. He was shown the zoos of rare animals and the aviaries filled with exotic birds. Cortés bided his time. After several weeks, he made his move. A confused and humiliated Moctezuma was arrested, and reluctantly made to pledge his allegiance to the King of Spain.

Cortés's absence from his job in Cuba, as well as his unauthorized sortie into imperialist conquest, was ultimately noticed by the Spanish governor of the island, who sent an expedition to Mexico in order to arrest him. Cortés headed away from Tenochtitlán towards the Gulf of Mexico to meet, and fight, his own countrymen. By this time, he was deranged by power. While he was away from Tenochtitlán, his men were attacked by the angered Aztecs, who had lost over 4,000 people in a massacre ordered by Cortés's crazed general Pedro de Alvarado in his absence.

The conquered Aztecs were sickened by Moctezuma's capitulation, and it is very likely that it was they, and not the Spanish, who killed him at this time, with a stone to the head. They crowned a new Emperor, Cuitláhuac, but he soon died. The people were disconsolate. Cuitláhuac had perished from a disease brought by the invaders that was to prove to be of greater danger to his people than the barbaric tubes-of-fire. He had died of smallpox, which was to sweep through Mexico and ravage the Indian people several times over many centuries. Syphilis was to follow.

On the night of June 30, 1520, Cortés, who had returned triumphant from the coast to the capital with reinforcements, became worried by a renewal of vigor of Aztec savagery against his men. He ordered them to retreat over the causeways of Lake Texcoco to Tlaxcala, the home

Diego Rivera,
Disembarkation of the Spanish at Veracruz, 1951. *In this detail from Rivera's harsh vision of the Spanish Conquest, the native people of Veracuz suffer at the hands of their new masters. Patio Corridor, National Palace, Mexico City.*

"Perhaps the only thing not stolen from the Indians has been their soul, their inaccessible world of strange languages and dialects, of hidden pride and strong heirarchy, of deep, religious sensitivity and powerful ritual, of mystery and magic."

ALAN RIDING:
DISTANT NEIGHBORS

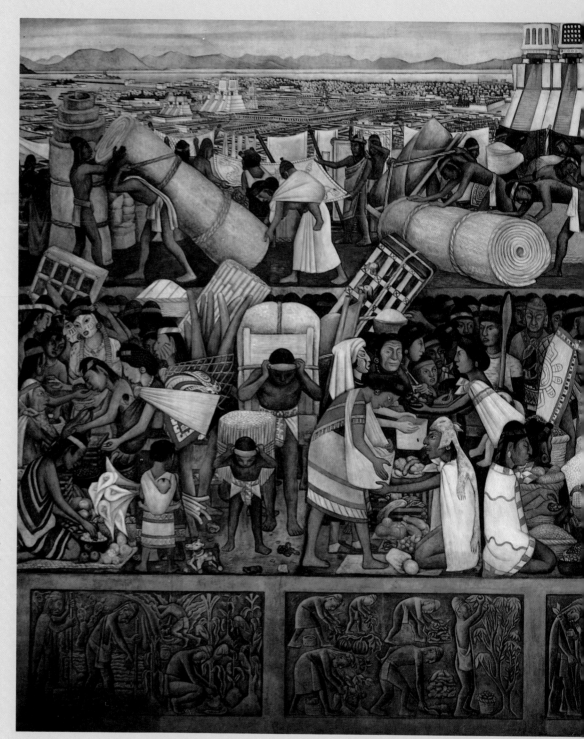

Diego Rivera,
The Great City of Tenochtitlán, 1945.
Rivera makes the Aztec Emperor, the Huey Tlahtoani, the focus of this powerful scene of Aztec everyday life. The bloodied stairways of the great pyramids of Tenochtitlán can be seen in the background. One of a series of murals depicting the pre-Conquest civilizations of Mexico in the National Palace, Mexico City.

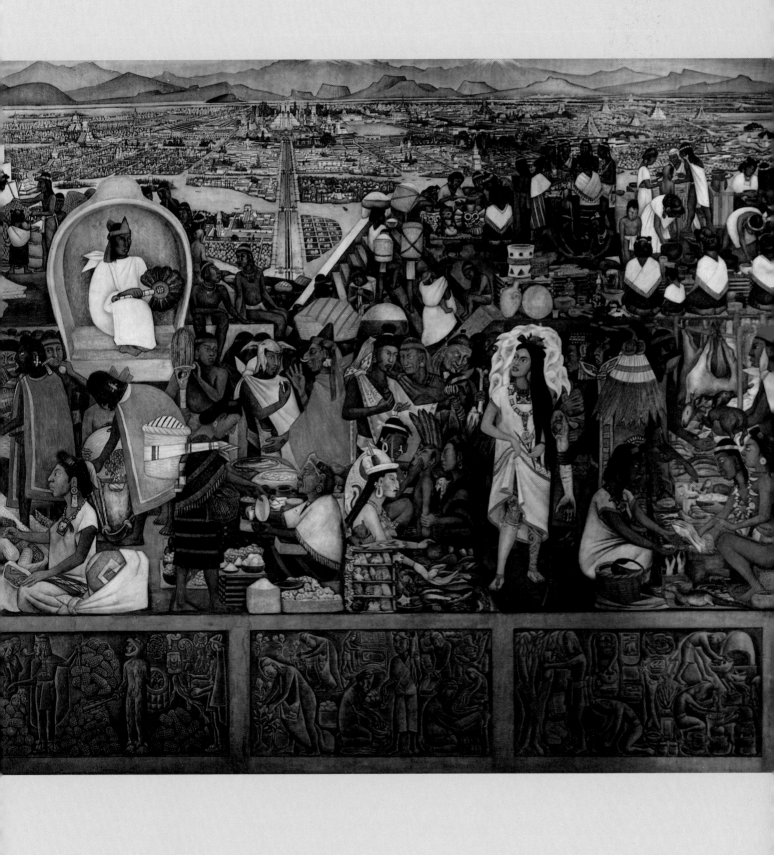

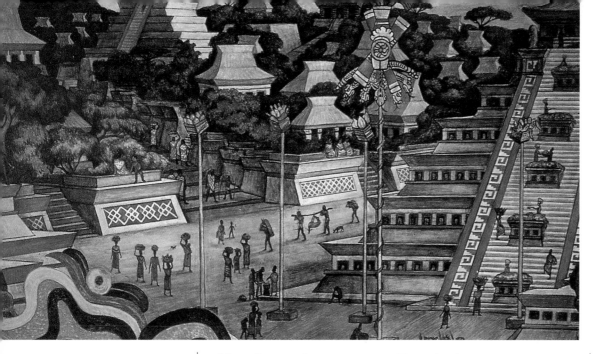

Diego Rivera, **Totonac Civilization, 1950**—*the elaborately painted temples of Tenochtitlán. Patio Corridor, National Palace, Mexico City.*

of his allies in the war against Tenochtitlán. The legend has it that the great golden riches of the Aztec empire were lost in this retreat. The bottom of Lake Texcoco is said to be home to the treasure that he and his army had stolen from the Aztecs. The stories tell of frightened Spanish troops dropping their booty into the waters of the lake in panicked haste. Evidently, the Spanish army had so overloaded their horses with gold and treasure that hundreds of Spaniards and Tlaxcalans were drowned on that fateful night, which became known as *"La Noche Triste,"* the sad night.

The brave and youthful Cuauhtémoc was the eleventh and last emperor of the Indian people, and the Mexicans still revere him today. He is the symbol of the indomitable spirit of the country before it was vitiated by the imperialism of the Old World. The last dictator of Mexico, Porfirio Diaz, in a fever of nationalism erected a statue in honor of Cuauhté-moc in 1887, on the Paseo della Reforma in Mexico City. The last Aztec *tlahtoani* is the "kitsch" hero of a thousand terrible tributes to this day, often depicted in a rictus of agony, his feet being burned by his Spanish torturers. On August 13, 1521, the will of the Indians finally collapsed in the face of smallpox—which killed as much as one-half of the native population—the superior firepower of the Spaniards, and the expansionist greed of Cortés and his men. After a siege of eighty days, when the Aztecs were reduced to drinking the brackish waters of Lake Texcoco and eating mud and straw, Tenochtitlán finally fell to the Spanish. An era was over. Twenty thousand Aztec warriors are said to have died in the siege of Tenochtitlán. It is also said that Cuauhtémoc took Cortés's dagger and begged the Spaniard to kill him. But Cuauhtémoc's desire to meet his "flowery death" was

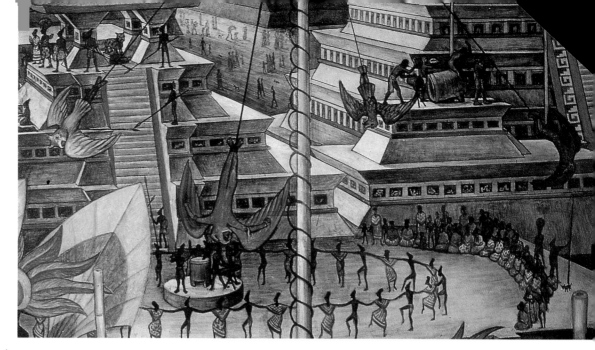

refused, and the young emperor was tortured and imprisoned. In 1525, he was executed in Chiapas, after two humiliating years as a puppet emperor for the real king—Cortés.

Today, inscribed on the site of the temple of Tlatelolco in Mexico City, are the following words: "On the 13th of August of 1521, heroically defended by Cuauhtémoc, Tlatelolco fell to Hernan Cortés. This was neither a victory nor a defeat. It was the anguished birth of the *mestizo* nation that is Mexico today."

This anguished birth also gave Frida Kahlo much of her material as an artist.

Cortés settled outside Tenochtitlán in the village of Coyoacán after the traumatic events of the Conquest. This was to be the site of Frida Kahlo's birth 386 years later. It must have brought a moment's pause to the idealistic young Frida, who treasured her claim to a piece of pre-Hispanic past through her mother. What shame to have had her family home, the Blue House on the corner of Calle Londres and Calle Allende, built on the very birthplace of the New Spain!

Cortés was quickly decreed Captain-General of New Spain, and just as the Colosseum in Rome was dismantled to build St. Peter's, the process of destroying the elaborate, bloodied temples of The Heart of the One World to create

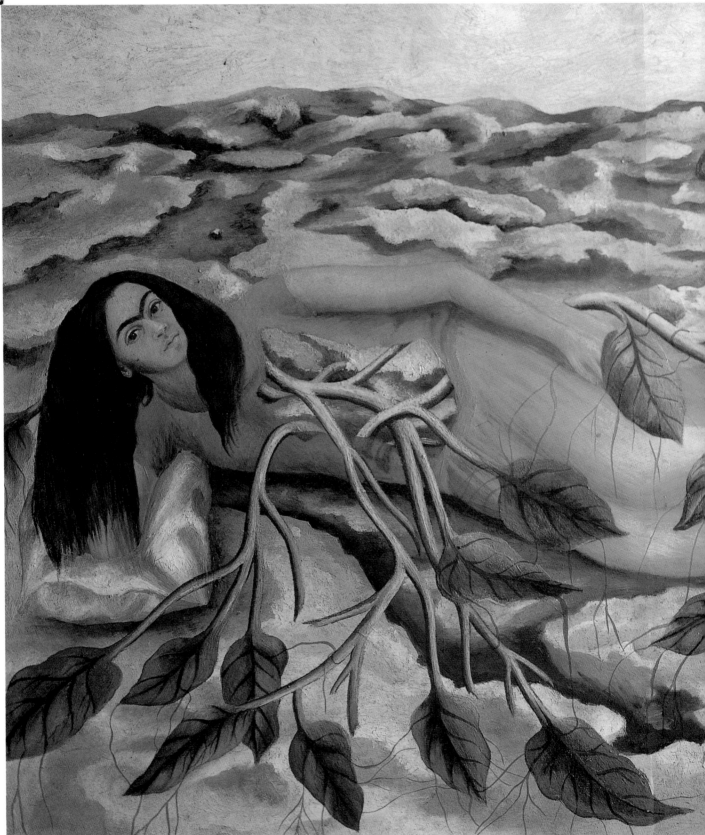

Roots, 1943.
This is an explicit depiction of Frida's connection to the Mexican soil. The roots that bind her to her country spill out of her eviscerated body. The serpent is an ancient symbol of the domain of earth. The Mexica people established their capital Tenochtitlán as the fulfillment of an ancient prophecy. In the painting, the veins of the leaves that curve over the barren terrain creep out of the vegetation as though the soil itself provides nourishment to a barren soul.
Oil on metal,
11¾" x 14½".
Private Collection, Houston, Texas.

churches in the new capital was enthusiastically begun. The magnificent pyramids, dedicated to the rain god Tlaloc and the tribal god Huitzilopochtli, which had once stood as high as the cathedral now standing in their place, were razed in 1522. But Cortés was not a happy man in the country of his dreams. His life never again reached such heights of excitement and success, and he lived the rest of his life making unsatisfactory exploratory expeditions. He died in Spain, where he had returned in 1540, neglected and despised. He is said to have remarked that "Spaniards have a disease that can only be cured by gold." If this is true, he died uncured.

The vanquished Aztecs and the conquering Spanish co-existed relatively peaceably for a century. Slavery, which had existed before the arrival of the Spanish (life was certainly not easy for the peasant class before the Conquest), was soon replaced by the system of the *encomienda*, which was a version of serfdom in which laborers were employed by a sort of feudal lord. The beloved land of Anáhuac came into the hands of private owners whose great, wealthy *haciendas* gradually took the place of small Aztec farms.

The Spanish Conquest of Mexico *did* bring certain advantages to the people. It is too simplistic and romantic to see the advent of the Spanish in purely negative terms. They did not only trail disease, ethnic cleansing, violation, and gratuitous cruelty in their wake. They also brought their religion to the New World, and for all its faults and haughty presumptions about the nature of reality and man's place in the grand Christian scheme, the missionaries were often very sympathetic to the spiritual plight of the Indians. Catholicism was in a period of stagnant decadence in Europe at this time, and the missionaries looked kindly upon this land of "virgin" souls with barely concealed enthusiasm, which was in turn rewarded by the devotion of their converts. As Catholicism decayed in Europe, it achieved increasing power in Spanish America.

The aim of the Spanish missionaries was to convert the "heathen" Indians in great numbers and claim lost souls for Christ, while subduing their inherent "violence." Though this aim could be seen as yet another example of heedless cultural supremacism in itself, and deeply insulting to the Indian cosmological view, the Catholic religion *did* bring certain positive elements to the lives of the people. The missionaries were also teachers. The Franciscans were the first to arrive in Mexico, followed by the Dominicans, the Augustinians, and, finally, the Jesuits (who were expelled in 1767). They

baptized all souls willing to join their faith, and in this dimension at least the people were considered equal, regardless of caste. The Holy Office of the Inquisition came to New Spain in 1571, addressing its court to abolish "heinous" moral practices such as astrology, homosexuality, and the smoking of the hallucinogenic drug peyote!

Ritual human sacrifice and cannibalism—staple parts of the pre-Hispanic religion—were, of course, forbidden by the Catholic Church. Although the abolition of these practices might be viewed as a positive development, they had been important forms of worship in the Aztec religion. These rituals were part of a complicated religious language. To die on the altar of a "flowery death" was an honor. The pain must have been terrible, but death was very quick. The victim, if he were not an enemy soldier, was given drugs before the act of sacrifice, and the afterlife beckoned to the sacrificial victims as surely as Heaven awaited those who died in Christ. Being "consumed" was a means of attaining immortality.

The Aztec Indians of Tenochtitlán were banished from the center of their old city. The economic system was altered irrevocably, with markets now being allowed only on one day of the week as in Europe, and coins introduced in 1535. New food was brought into New Spain from the Old World. Chile, beans, and maize were still the mainstay of Indian cuisine, but were now joined by a panoply of unusual foods such as apples, lemons, grapefruit, wheat, barley, and rice. Sugar and lard became important foodstuffs. Distilled alcoholic drinks such as *aguardiente*, *mezcal*, and *tequila* came to Mexico with the Spanish. New animals and plants were introduced—for the first time horses, donkeys, and sheep were seen in fields sown with geraniums, poppies and

Fruits and vegetables, Irapuato.

Herbs and spices in Irapuato market, including "new" and "old" foods. Photographs by Robin Richmond.

Women wearing traditional clothes made from modern fabrics in Durango, selling their baskets, which have hardly changed in style or decoration in centuries. Photograph by Jenny Cook.

An example of graceful Spanish colonial architecture in Chihuahua. Photograph by Jenny Cook.

violets. Pet dogs and cats were brought from Europe, the ancestors of the skeletal, ragged stray dogs and cats that roam the streets today.

Style of dress changed somewhat with the introduction of large mechanical looms, and wool and silk joined the ubiquitous cottons that were (and still are) woven into smocked *huipiles* (blouses) and *quechquemitls* (ponchos) for women and *maxtlatls* (knotted capes) for men. The Spanish Catholic insistence that women cover their heads with a mantle in church gave rise to the wonderful Mexican *rebozo*, the woven shawl that is still seen on women's shoulders all over Mexico, and was a great favorite with Frida. Iron, steel, and bronze replaced the neolithic technologies of the pre-Hispanic peoples. Farming changed beyond all recognition with the introduction of the horse and plow. The arts and crafts went through a form of revolution. The potter's wheel, metal glazes, expert silversmithing, and vast, noble buildings were Spanish imports. Where there once had been only mud and clay, there were now flying buttresses.

48

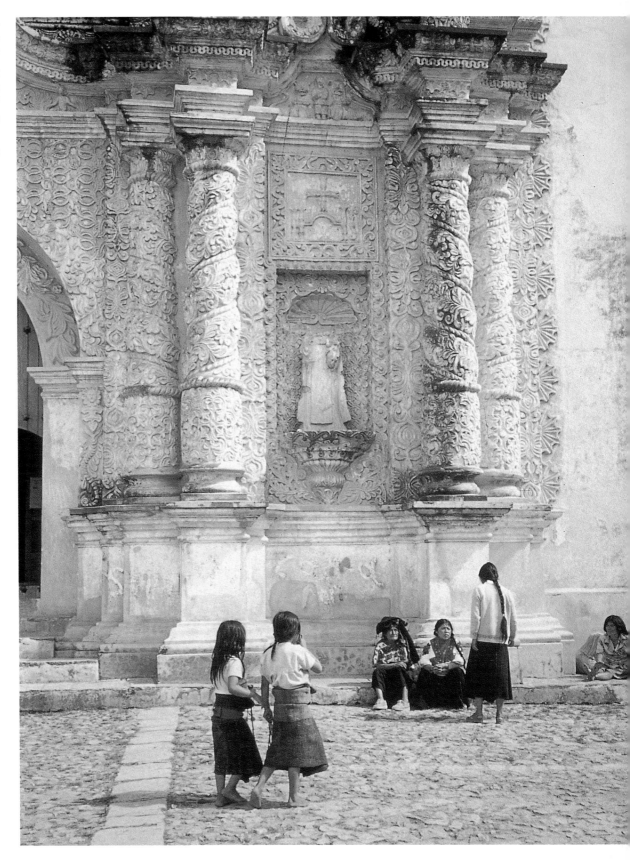

San Cristobal—mud and clay have been replaced by ornate stone tracery in this monumental European-style church. Photograph by Laura Kech.

The Virgin of Guadalupe

The story is told that, in 1531, a baptized Aztec Indian called Juan Diego Cuauhtlahtoatzin was walking up the hill of Tepeyac, north of old Tenochtitlán, when he witnessed a "miracle." A lady stood upon the hill, singing in the sweetest of voices. Her dress shone with beams of light and the rocks upon which she stood radiated flashes of brilliance. This vision happened on the very spot that had once cradled the holy shrine of Tonantzin in the great old days of the Aztec gods.

Tonantzin was an ancient fertility goddess and the mother of all gods to the pre-Hispanic peoples. Her worshipers had sat at her feet for centuries and had come from hundreds of miles to make sacrificial offerings to her. The sweet voice called to Juan from the old shrine, saying that she was the Mother of God, the Virgin Mary. He was transfixed. He raced with the good news to his bishop, who believed not a word of this Indian rubbish. Juan was told to bring proof. He went back to Tepeyac, and found to his amazement that gorgeous red roses had bloomed where there had once been only dry and dusty cactus. He swept up rose petals in his cape and brought them back to the sceptical bishop. When he opened his cape, instead of roses, a clear image of the brown Virgin's face was indelibly etched upon the plain maguey fiber.

So the Virgin of Guadalupe with her brown face was brought to the Indians by a miracle on the very spot where they had once worshiped Tonantzin. The Spanish had rejoiced in seeing crosses upon Indian paintings of Quetzalcóatl's tunic and identified him with Christ and the apostle St. Thomas. Now here were the Indians finding Christianity "for themselves" in the shrine of their own archaic gods. The brown Virgin of Guadalupe is still known to some people as the Guadalupe Tonantzin. They call her *Madre* as they once called the missionaries *tatas*, or daddies.

The shrine of the Virgin is the holiest place of homage for Mexican Catholics today. It is visited by millions of pilgrims, who seek solace in grief and miraculous cures from the Virgin. At various times in the religious calendar, hundreds of worshipers, muttering to themselves in deep prayer, approach the shrine from long distances on their dusty knees. The present Pope made his address to the Mexican people from this holy place, which is not unlike Lourdes or St. Peter's in its importance and relevance to Catholics from all over the world. When President John F. Kennedy visited Mexico in 1962, he paid a special visit and knelt reverently before the Virgin of Guadalupe, which earned him the everlasting affection of the Mexican people.

However, the Aztec idol still lurks behind the altar. Many Christian festivals exactly coincide with the dates of feast days in the Aztec cyclical version of the calendar, and churches are often decorated with pagan corn dollies.

In the post-Conquest Christianity of the newly baptized Indians, the hearts of the old gods still pulsed secretly. *Tezcatlipoca* was "re-interpreted" by the new theologists in two Christian incarnations. In one, he was linked with the dark, "smoking mirror" of the Devil. In another, he was amazingly associated with the Christian God. *Tlaloc*, the rain god, was also associated with the Holy Father. *Tonantzin*, mother of gods, and *Coatlícue*, mother of the war god and goddess of fertility, were both linked with the Holy Mother. Both *Quetzalcóatl* and *Huitzilopochtli* were identified with Jesus Christ, the Son.

Revolution

It was inevitable that Mexico would eventually rise up against its imperialist oppressor, Spain, and also reject the mandates of a church which made its edicts and deliberations from both a geographical and spiritual distance. The theoretical aspects of European Catholicism had very little to do with the practical exigencies of Mexican life. The war for inde-

pendence from Spain, which sowed the seeds of the civil war, and later the revolution, began in the small town of Dolores (Hidalgo) on September 16, 1810. It was a cry born of despair after centuries of traumatic political and religious domination by the Old World. The Mexicans had been subjected to a catalogue of assaults upon their culture, their history, and their faith. They had weathered the terrors of the Spanish Inquisition, almost total trade domination from Spain, and a punitive, colonial legal system. They were in despair, humiliated and worn down.

What the Mexicans fondly refer to as *el grito* or the shout was made by Father Miguel Hidalgo y Costilla in this small, northern town now as famous for its glorious ceramic industry as for its seminal role in Mexican history. Father Hidalgo's controlled passion and humble commitment to the cause of liberation gathered thousands of Indians to his cause, and the protest movement snowballed. In November, he led a protest demonstration of 60,000 people to Mexico City. His lament was that Spain, which had ruled so imperiously and so long over Mexico, was actually now in the voracious hands of Napoleon, and no longer a power in its own right. A proud, religious, patriotic man, Hidalgo carried a nationalist banner with the Virgin of Guadalupe emblazoned upon it.

This first dramatic foray into populist revolution by Father Hidalgo failed. After the priest and his followers were executed in 1811, one temporary government brutally and abruptly replaced another. Guerrilla wars blazed through Mexico like brushfire. On December 22, 1815, the great leader José Maria Morelos was sentenced to death by the Holy Office of the Inquisition for treason. Vicente Guerrero took up the torch of freedom and, with Captain Agustin de Iturbide, declared independence from Spain on February 24, 1821. Mexican political history is an endless succession of betrayals and disillusionment. For example, after promoting himself to General, Iturbide the republican appointed himself Emperor! He was soon deposed and punished for his arrogance. Then, the infamous General Santa Anna took over the government. He went on to lose the Mexican northern territories of Texas and California, a large area of New Mexico, Arizona, and Colorado in the war with the United States, which ended with the humiliating Treaty of Guadalupe Hidalgo in 1848.

It is an unfortunate and unhappy story.

Benito Juarez was only a tiny boy of four when Father Hidalgo made *el grito,* and fifteen when Mexico became independent. A Zapotec Indian from quite a modest background, he first trained as a scientist and then read law, working his way up through the ranks of local government until he was made governer of Oaxaca, which became a model of economic stability under his tenure. In 1857, he was the chief author of the reformist constitution which abolished the legal privileges of the clergy and established freedom of religion. The church was most unhappy with this development and threatened to excommunicate anyone who accepted the new reforms. Civil war broke out in 1858 between Juarez's liberal faction and the conservatives, who were wealthy landowners and devout followers of the Church. It was a time of terrible bloodshed, with deeply religious soldiers forced by political expedience to kill their own priests. This became known as the War of Reform, and it lasted for three horrific years. The victorious liberal Juarez, who had taken on the opposition to Santa Anna, was ultimately elected in 1861 to the presidency of Mexico.

As a result of the economic effects of the Civil War, Mexico was forced to renege on its world debts. The next year, a war broke out with three of its angriest debtors—England, Spain, and France. The United States, now reconciled with Mexico, and feeling some guilt for its earlier territorial gains, could only be moderately helpful to Mexico with munitions during this war, being preoccupied at home with its *own* Civil War. England and Spain were eventually to cease hostilities, leaving only France and the power-hungry Napoleon III at war with Juarez's government. Thus begins one of the strangest periods in Mexican history—the French presence in the country.

The Mexicans were understandably reluctant to accept the humiliation of renewed subjugation to the demands of yet another European master. With great fortitude they beat back Napoleon III's army on May 5, 1862, at Puebla. (This date is celebrated as one of the most important national holidays in Mexico today, known as *Cinco de Mayo.* There are streets all over Mexico with this name.) However, undaunted by Mexican bravery, and even more determined to take over the country for his empire, Napoleon brazenly sent another 28,000 troops to Mexico. Unfortunately for the Mexicans, this time he was more successful. Juarez was forced to withdraw his government from Mexico City. The underemployed Archduke Maximilian, Prince of Hapsburg, brother of Franz

Diego Rivera, **Farmers Embracing,** *March–July, 1923. This detail from a mural in the Court of Labor celebrates with a symbolic gesture the importance of the agrarian revolution. Ministry of Public Education.*

Josef, the Emperor of Austria, was invited—by the conservative party in Mexico and Napoleon in France—to assume the "crown" of Mexico.

Maximilian was thus installed in the capital, accompanied by his notoriously headstrong wife Carlotta, the beautiful daughter of King Leopold of the Belgians. Maximilian was a quiet man, most unsuited to the volatility of his new office. He was a well-meaning romantic, who had been attracted by Napoleon III's offer of a "throne on a pile of gold." But he was a good, rather liberal man, and he was prepared to love his newly adopted country. He valiantly took lessons in Nahuatl when he arrived in Mexico City. Moving from the effete, blowsy court of his native Vienna to the dusty barbarities of Mexico City was a fair shock to the prince, but he put a brave face upon it. He talked naively of setting up another "Aztec" court in his palace at Chapultepec, and of "occupying the throne of Moctezuma." Little did he know that Napoleon III would soon abandon him and Mexico as a lost cause, and that he would die with his generals, Miramón and Mejía, before a firing squad at Querétaro on June 19, 1867.

Word of his death reached Paris during the Universal Exhibition, and French liberals were appalled. In disgust, the Impressionist painter Edouard Manet commenced his series of angry, imaginary paintings of the execution. Napoleon III's Second Empire fell to the Prussians three years later. Juarez, reelected in 1867, but exhausted and unable to sustain his hold over the country, dropped dead at his desk of a stroke in 1872. The man who took over

Woman begging for alms in Mexico City.

from him, Porfirio Diaz, ruled Mexico with an iron grip for the next thirty-eight years. Frida Kahlo was four years old when he eventually resigned. This was the period known as the *Porfiriato.*

Diaz was a politician who was prepared to do practically anything to ensure economic and material progress for his country. Like a Mexican version of Mussolini, he achieved a dubious sort of triumph in making an anarchic country more organized, but at considerable expense. He was a ruthless pragmatist. Realizing that banditry was a grave problem, he organized a police force known as the *rurales* from the ranks of the guerrilla bandits. These men just went about their normal business of extortion, but with the imprimatur of legality. Diaz was corrupt, opportunistic, and snobbish. Although he was an Indian himself, a Mixtec, he favored the advancement of the upper classes at the expense of the more humble Indians.

In 1910, the profound problems underlying Diaz's system of government went out of control. Poverty was abject and endemic. A new, enlightened intellectual climate that centered on the outspoken thinkers José Vasconcelos and Antonio Caso began to grow around a group of social philosophers, artists, educators, and scholars. Frida Kahlo's husband, Diego Rivera, began to come to public notice at this time through his work and his association with the National Academy of San Carlos, where these two charismatic men lectured and taught. With the unconventional assistance of such famous bandits as Pancho Villa (real name, Doroteo Arango) and Emiliano Zapata, a new president, Francisco Madero, finally ousted the octogenarian Diaz in 1911. This was not the providential miracle that it might appear. Madero proved not to be the much-hoped-for savior of the liberal Mexicans, nor did he turn out to be a very good judge of character. His chief aide, General Huerta, was an unprincipled opportunist who ultimately betrayed his President, and was responsible for his murder in 1913. This act triggered the real beginning of the Mexican Revolution. The people were deeply enraged and inexorably driven to action. *El grito* was finally answered. Vasconcelos's celebratory aim, to make a new Mexico founded on "our blood, our language, our people," and to uphold the greatness of *la raza,* was fulfilled.

Frida Kahlo, the self-proclaimed *"daughter of la raza,"* was born at this time.

"The opinion that art should have nothing to do with politics is itself a political attitude."

GEORGE ORWELL

The daughter of "La Raza" against an industrialized, modern version of an Aztec goddess. Diego Rivera, portrait of Frida Kahlo from "Pan-American Unity" a mural now in City College, San Francisco.

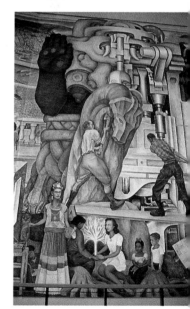

The facade of Frida's home in Calle Londres, Coyoacán. Always known as the Blue House, it is now the Frida Kahlo Museum. The exuberant colors of other buildings in Coyoacán are in keeping with the brilliant blue of Frida's home—as are the Volkswagens, locally manufactured at Puebla.

CHAPTER 3

THE FAULTY MIRROR

Frida Kahlo's Early Years

Magdalena Carmen Frida Kahlo y Calderón was born on July 6, 1907, at 8.30 A.M. This, however, is not the birth date she gives herself on the celebratory—and mendacious—plaque that confronts the visitor to her splendid birthplace, the Blue House, on the corner of Londres and Allende, in the leafy suburb of Mexico City called Coyoacán. This plaque also tells us that she lived here with Diego Rivera, her husband, from 1929 to 1954, the year of her death. This is another untruth. As the Nobel Prize-winning poet Octavio Paz has said about his fellow Mexicans, "Our lies are brilliant and fertile."

Frida Kahlo, who changed the German spelling of her name during the Second World War, was the fourth daughter of Wilhelm Kahlo, who was thirty-five years old at the time of her birth. He was the son of Jakob Heinrich Kahlo and Henriette Kaufmann Kahlo from Arad, in what was then Hungary and is now Romania. The Kahlos had emigrated to Germany before his birth and settled in Baden-Baden, where they owned a jewelry shop which had a sideline in photographic supplies. Wilhelm was sent to university in 1890, at the age of eighteen, but his student days at Nuremberg were interrupted by an accident which brought about the epileptic attacks that were to plague him all his life. He was summarily dispatched from home by his recently widowed and newly remarried father, with just enough money in his pocket to enable him to leave Germany well behind him. Just nineteen, with no money or family ties, Wilhelm boarded a ship bound for Mexico. He was never to return.

In Mexico, working for fellow German refugees in the modest position of salesman in a jewelry store, he met his first wife. Very little is known about this marriage, which produced two daughters, Maria Luisa and Margarita. It ended in tragedy with the death of his wife in childbirth

"We should be thankful that we cannot see the horrors and depradations lying around our childhood, in cupboards and bookshelves everywhere."

GRAHAM GREENE:
THE POWER AND THE GLORY

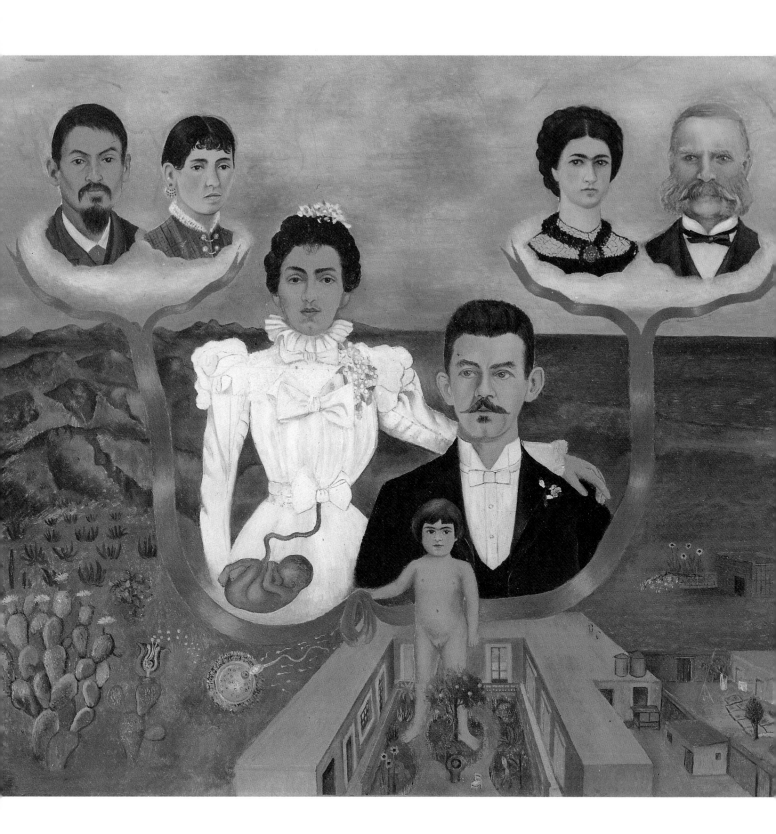

with their second child. This fact, shrouded in the romantic mystery of her father's life before her mother, was certainly not lost on the young, morbid Frida, who revered her father and remained closely involved with him until his death in 1952.

The two motherless girls of the first marriage were sent to a convent, and remained there when Wilhelm—now called Guillermo in the Spanish version of his name—married again. Why he did not reclaim them is a puzzle, but we must assume that his new ménage with Matilde Calderón y Gonzalez was too fragile to sustain a ready-made family. Matilde was a fellow employee, twenty-four years old, beautiful, and devoutly Catholic. She was *mestiza*—Indian on her father's side, Spanish on her mother's. She was intelligent but uneducated and very poorly read. Guillermo was German, Jewish, atheist, and extremely well read. He had a very strong accent in Spanish, which he never lost. He spent his spare time playing Beethoven on the piano and reading the great German poets and philosophers in his library, which boasted a huge portrait of his hero, Schopenhauer.

According to Frida, Guillermo was persuaded by Matilde's father, who was a photographer, to take up her father's profession in about 1904. The two men traveled through Mexico together and, over four years, produced a famous portfolio of meticulous architectural, archival photographs of the glories of Mexico—both pre-Hispanic and Colonial. The implications of this new job must have caused some ambivalence in Guillermo, whose politics were ostensibly liberal. His new employer was the Secretary of the Treasury, Limantour, whose boss was the infamous dictator Porfirio Diaz. Presumably the financial security that such a prestigious commission would bring to the young family was a major factor in this change of career, and the Blue House was built for the new family in the modern style in 1904.

Frida was the second child of Guillermo's second marriage, and was his favorite. Matilde was apparently ill when Frida was born, and did not breastfeed her new baby herself, but gave her to a *nana*, an Indian wet nurse—a common practice at the time. Later, Frida explained that her younger sister Cristina was born eleven months after her, and gives her mother's pregnancy as the excuse for Matilde's decision not to breastfeed her. Frida, who was an avid reader of psychonalytic literature in later life, including

My Parents, My Grandparents, and I, 1936. *In a picture about self-identity, Frida depicts herself as a small child in the courtyard of the Blue House in Coyoacán. She holds a blood-red ribbon, which connects her to her Mexican maternal grandparents on her right, who hover over her own mother Matilde's right shoulder, and her European grandparents on her left, hovering over Guillermo's left shoulder. On Matilde's starched, pristine white belly is Frida's depiction of herself as a fetus, and directly below this is an image of the moment of fertilization that created her. To the left of this miraculous moment— which clearly awes the adult Frida, who was able to conceive a child herself but unable to carry a pregnancy to term—is a nopali cactus flower opening to accept pollen into its cushioned, fleshy insides. This picture was exhibited in a group show at the National Autonomous University of Mexico's Department of Social Action in 1936. Oil and tempera on metal panel, 12⅛" x 13⅝". Museum of Modern Art, New York. Gift of Allan Roos, M. D. and B. Mathieu Roos.*

the entire works of Freud, is said by the biographer Martha Zamora to have been the first woman in Mexico to have undergone psychoanalysis (though I could find no evidence of this). She seems to have been assailed by powerful feelings of loss in her life, and it is possible that these were aggravated by the early circumstances of her babyhood. She certainly loved her baby sister as a child, but there was always competition between the two girls. (The adult Cristina hurt Frida beyond measure, breaking that most profound familial taboo—she betrayed her older sister in 1934 by sleeping with Diego.)

The fact that she was "replaced" so quickly with a rival sibling, combined with a conviction of being unloved by her mother, developed into themes in Frida's version of herself, transmuting into imagery of betrayal and martyrdom in her paintings. Even the *nana* employed to feed her would abandon her, dismissed for drinking while feeding Frida. "Anxiety in children is originally nothing other than an expression of the fact that they are feeling the loss of the person they love." Freud's characteristically categorical statement seems very apt with regard to Frida.

Matilde's purported illness in Frida's babyhood may be one of the first intimations of the hysterical hypochondria that Frida herself was to write about after her own accident:

"No one in my house believes that I am really sick since . . . I cannot say so because my mother . . . gets sick."

It seems likely that her mother was beginning to suffer from postnatal depression after Frida's birth as well as being pregnant again just two months later. Frida's moment in the sun with her mother was thus very short-lived. Matilde was known to fall down in fits of fainting, her "spells" uncanny imitations of her husband Guillermo's genuine epileptic seizures, which occurred at intervals of about six weeks. Frida was well aware at an early age of the attention-seeking nature of these pseudo-seizures, and she was scathing about her mother's maternal instincts and dismissive of her integrity, saying later, "My mother did not know how to read or write. She only knew how to count money."

Frida's earliest attitudes toward her mother are relevant to her convictions about herself as both woman and artist. In later life, her work became preoccupied with the metaphor of self-reflection in the mirror through self-portraiture. The often misused term *narcissism* is commonly applied to her life and work, and is certainly apt in this connection, but it has little to do with vanity. We know that she actually surrounded herself

Portrait (nude) of Eva Frederick, 1931. *Frida almost never painted herself in the nude, but in this portrait of a friend she rejoices in the soft curves of her model's body. This drawing also shows Diego's influence in its strong emphasis on outline and simplified forms. 24$\frac{1}{4}$" x 18$\frac{3}{4}$". Dolores Olmedo Collection, Mexico City.*

with mirrors as an adult, from which she could view herself from *every* angle, and that the canopy of her bed was glazed with an enormous full-size mirror. But for Frida, it seems that her own reflection in the mirror is not actually *herself* in the obvious sense, but a form of *object*. Her reflection, which is transmuted into self-portraiture in early adulthood, becomes a gesture of self-defense. Her mirrors tell her not that "she is the fairest of them all," but that she actually *exists*. They tell her that she is whole and well (which was not the case in later life.) Her reflection in the external object—the mirror—provides her with a palpable affirmation of an internal structure—herself.

D. W. Winnicott, the British pediatrician and psychoanalyst, has referred memorably to the "primordial mirror" of the mother's face in his eloquent theory of the "True and False Self" (Winnicott 1960). This seems very resonant in regard to Frida Kahlo's early life. Winnicott's theory—that the sensitive child of a not "good enough" mother is literally "faced," as the mother holds her infant, with palpable maternal ambivalence—is helpful here. He sees the child who creates a false self valiantly attempting to neutralize a danger perceived in the mother. The false self is the infant's

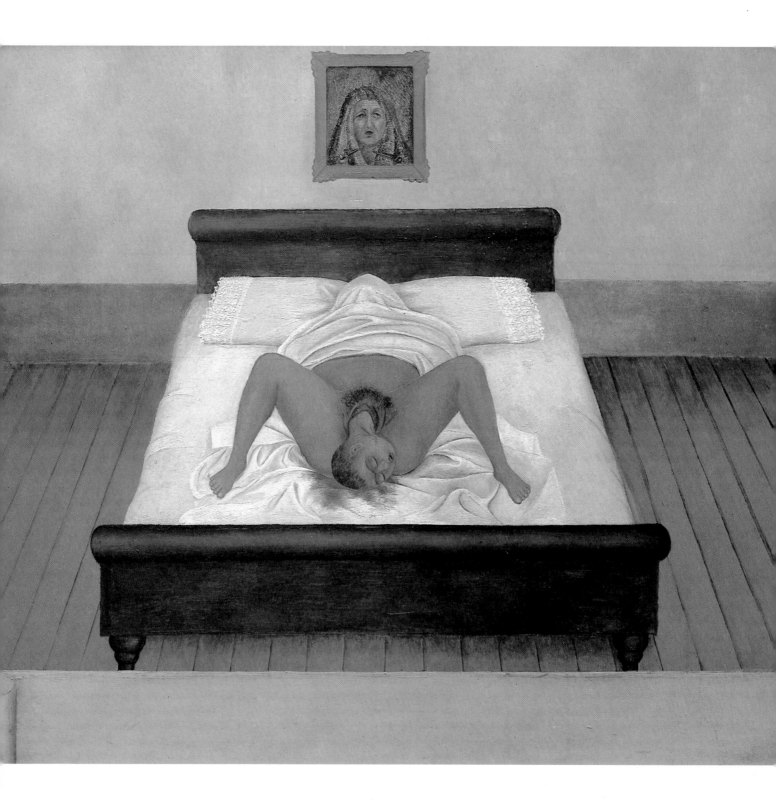

My Birth, 1932.
Oil on metal,
12½" x 14".
Private Collection,
Los Angeles, California.

way of dealing with the mother's "need to maintain a muddle in those who are in contact" with her. It is important to state that this contact is in the context of the baby being held—whether it is actually being fed by the mother or not. The "muddled" Frida was to create a false self out of her imagination at six years old. She conjured up an imaginary friend, "who was gay (and) laughed a lot." She later wrote in her diary about this friendship: "Every time I remember it, it revives and becomes larger and larger inside of my world."

This false self is a psychic structure that can distance pain and rejection, and in Winnicott's view, the mother who (unwittingly or not) creates this in an infant is either depressed or self-involved at the expense of the child. From everything Frida said about her mother in later life, this seems to hold true. Her mother was unresponsive and cruel, or so she said. It seems probable, from a reading of Frida's diaries, that Frida's mother appeared unclear to her, "opaque . . . like a mirror, show(ing) nothing but what is shown to (her)." This phrase actually comes from Freud's prescription for the successful relation of analyst to patient, "where every conflict has to be fought out." It would not seem a very good prescription for mother-child bonding, but Frida describes such opacity in her mother again and again.

The Mexican child psychoanalyst Salomón Grimberg is convinced that Frida's earliest life holds many of the keys to her work as an artist, too. He sees her as someone tragically "trapped in early experiences" and believes that "her early life is much more important than the later one." He sees no evidence of bonding or attachment with her mother in her work, and feels, as I do, that these very earliest childhood problems inform all of Frida's adult life, both as an artist and as a woman. In a painting like *My Birth* (1932), he sees Frida (for it is she, knitted brows and all) who is emerging from the dead mother's womb, showing "the ultimate expression of abandonment." The Virgin of Sorrows looks stoically out at the viewer, accepting the terrible loneliness of this infant who is forced to give birth to herself, out of emptiness. It is no coincidence that this picture was painted soon after the death of her mother and after the loss of a pregnancy of her own. Frida, to whom loneliness was no stranger, felt even more alone after these traumatic losses.

In the painting *My Nurse and I* (overleaf), Frida's ambivalence about her early years is in evidence again. Interpreted by most critics as a celebration of her Indian wet-nurse who nourishes the baby/adult Frida with droplets

of milk, I do not see this painting in these joyful terms at all. Although the pre-Hispanic head of the nurse must not have seemed as frightening to Mexican Frida as it does to a non-Mexican like myself, I feel that there is a high degree of alienation in the picture. Frida stares out of the embrace, dead-eyed and slack-jawed; she rarely shows emotion in any of her self-portraits. The milk that ostensibly "nourishes" her seems to be actually poisoning her. The veins, or skeleton, of the leaf to the right of her head, while botanically and diagrammatically echoing the florets within the lactating breast, are also basic representations of internal structure. We often talk of the "spine" of a leaf. Frida was to be plagued by the gradual disintegration of her own spine as she grew older, and spiny, membranous leaves feature too frequently in her work not to be potent symbols. The sky rains milk in the picture, but it is a dark, stormy gloom that envelops these two people, locked in their exclusive relationship. The paint has a viscous, oily quality, as is often the case in Frida's work. It seems to be as sticky as the milk that drops into the child's mouth.

Oddly, this small picture seems to function like an old-fashioned ink blot test. Different people respond to it in different ways, and it invites viewers to project upon it their own interpretations of the mother/child theme. The British artist Helen Chadwick, who has made a moving video portrait of Frida Kahlo, finds it unthreatening, and "compassionate and moving." The art-historian Hayden Herrera sees the picture in terms of "fear and abandonment," as I do, but ascribes to it Christian overtones in its iconographic similarity to a Madonna and Child. To me, the black head of the nurse/goddess is awesomely impassive, reflecting nothing back to the baby in the "primordial mirror." The head reminds me of the scary "black mummy" described so chillingly by one of Winnicott's most famous psychoanalytic patients, the two-year-old Piggle, and her mother in the analyst's fascinating 1965 case-study, *The Piggle*:

"Then she got into my dressing gown (which I was wearing) and told me something about dreaming that the black mummy had eaten her. Then she emerged and asked me about being born."
"She says she is frightened of the black mummy coming after her . . . "
"She is crying, she says (at night) because the dark will make her black."

My Nurse and I, 1937.
Oil on metal,
12" x 14".
Dolores Olmedo
Collection, Mexico City.

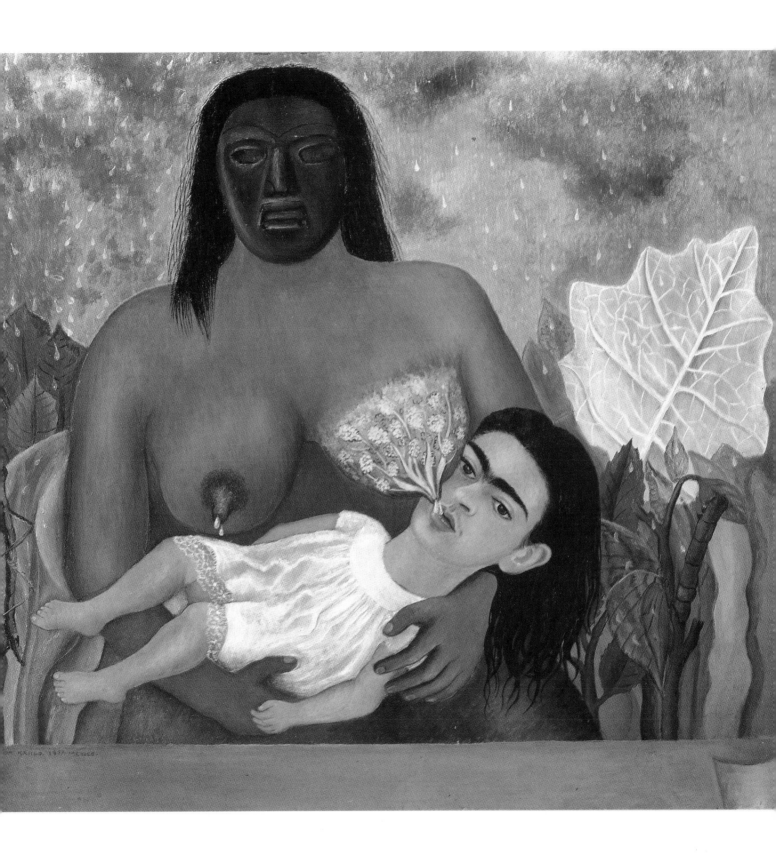

The Piggle's mother in a letter to Winnicott in 1964, after his third consultation with her daughter on April 10th.

"I broke the Black mummy into pieces. I am worried."
"I want to be the only baby."
The Piggle, in an analytic session with Dr. Winnicott (Winnicott 1991).

Interestingly, as regards Frida and Cristina Kahlo, the Piggle's problems were caused, in part, by the birth of a younger sister.

The analyst Melanie Klein, who wrote extensively about the infant-mother relationship, might be speaking of Frida Kahlo, who we know by her own admission was aggressive towards her mother, when she says: "In those children in whom the innate aggressive component is very strong, persecutory anxiety, frustration and greed are easily aroused, and this contributes to the infant's difficulty in tolerating privation and in dealing with its anxiety." Klein's idea that the anxious child feels guilt about its negative feelings towards the mother and in its baby-logic imagines that it has created a monster seems to be illustrated brilliantly by *My Nurse and I*. Here, Frida drinks from the "the hated breast (which) has acquired the oral destructive properties of the infant's own impulses when (he) is in a state of frustration and hatred" (Klein 1980).

Frida grieved terribly when her mother died in 1932, but her childhood remarks about her mother are the distraught reproaches of an alienated and unhappy child. Maybe they should not be taken too seriously. We know of Frida's penchant for confabulation and biographical sleight of hand. Yet there *is* clear evidence that Frida was a very angry person from a very early age. Matilde was devoutly Catholic and insisted that her daughters pray before meals, attend church regularly, and generally assume a suitable air of piety and seemly manners. Frida was incapable of this demeanor, and was to adopt her father's atheism and intellectual scepticism as an older child. What has been called the "derailment" of the dialogue between mother and child is very obvious from the earliest days of Frida's childhood. She would call her mother *"mi jefe,"* my chief, with an ironic humor masking an element of scorn, and she was a highly mischievous and teasing child who ferociously rejected the bourgeois domesticity of Matilde's dreams. She saw herself as the son that Guillermo never had, and later dressed up in men's clothes for a family portrait as if to establish this role in the family.

Portrait of Doña Rosita Morillo, 1944.
Compared to **My Nurse and I** (page 65), *this portrait of a friend's elderly mother is placid, contemplative, and idealized. However, the kindly figure, looking up from her knitting, seems to be on the point of being engulfed by the undergrowth—an anarchic tangle of cactus, its thrusting flowers bursting behind her gentle frame like fireworks.*
Oil on canvas, mounted on Masonite,
30½" x 28½".
Dolores Olmedo Collection, Mexico City.

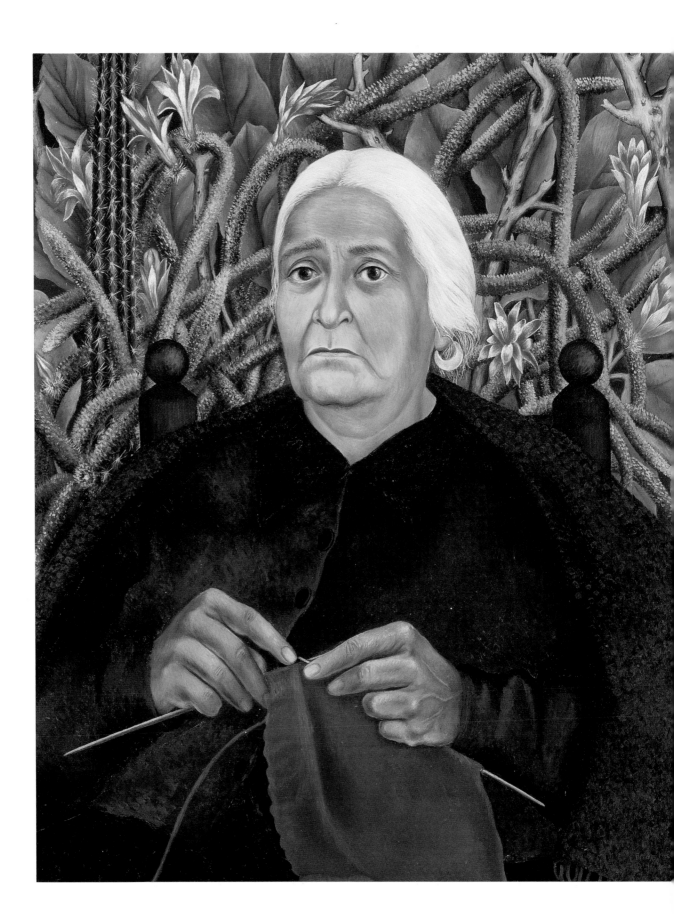

She was livelier than little well-brought-up Mexican girls are supposed to be, alert, quixotic, and very bright. She was a tomboy who sped around the family home with manic, unstoppable energy. Guillermo would say: "Frida is the most intelligent of my daughters. She is the most like me." This fact seems to have been completely accepted in the family, and the identification was certainly mutual. As Camille Paglia says: "Love is a crowded theater."

Frida's love for her father was extremely complex. In 1935, when she was twenty-eight, and in the aftermath of Diego's affair with her younger sister Cristina, she painted a picture called *A Few Small Nips*. This painting ostensibly refers to her own pain at Diego's rejection of her, "murdered by life" in her words, and seems to be a graphic expression of the anger she wishes to vent upon his Judas body. The roles are reversed of course. The painting took as its starting point a story that Frida had read about in the newspaper of a pimp who had murdered his girlfriend, and had explained to the judge, in apologetic terms: "But I only gave her a few small nips!" When one looks at the preparatory sketch for the painting, one is forced to think again about this picture. In the drawing, a child witnesses the horrific murder of the woman, and the woman has two shoes—one has fallen from her foot. The banner reads, "My Sweetie doesn't love me anymore," and the full text continues this with, "because she gave herself to another bastard, but today I snatched her away, her hour has come."

This painting, and the drawing, seem to be very clever expositions of twin childhood fantasies. In my view, the painting refers to two major themes in Frida's childhood—it expresses Frida's unconscious fantasy of killing her mother, and getting Matilde out of the way to have her beloved daddy, Guillermo, to herself. This is a common fantasy of little girls. But it has a deeper meaning that is very revealing about Frida. The child Frida, disguised as a boy, is witnessing a scene of sexual intimacy between her parents. She is mistaking it, as children often do, to be a scene of terrible violence.

Frida *was* frightened of Guillermo's epileptic attacks and the debilitating effect they had on this normally most self-composed of gentlemen, though she said later; "I learned to help him during his attacks." Epileptic seizures of the kind Guillermo experienced are characterized by wild, repeated, rhythmic movements. These could have been construed by the child Frida as those movements she might have glimpsed

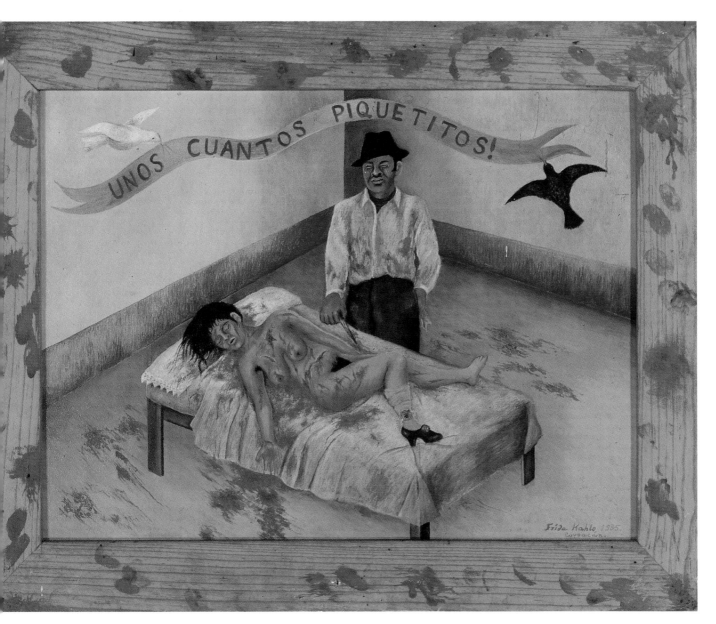

A Few Small Nips, 1935.
Oil on metal, 11³/₄" x 15³/₄". Dolores Olmedo Collection, Mexico City.

Preparatory Sketch for A Few Small Nips, 1935.
Pencil on paper. Frida Kahlo Museum, Mexico City.

in a "primal scene." Even if she never actually saw the intimate relations between her parents, she would have been curious, as are most children, about their private life, which closed the door on their children. The painting, spattered with gashes of blood and exuding a perverse erotic charge, seems to convey something of this disguised libidinal desire for her father. The shoe, which has been lost in the final painting, denotes something discarded and rejected, such as Frida herself in the secret world of her parent's bedroom.

Frida's great love for her father, unlike that for her mother, was always unconditional. In the painting *Portrait of Don Guillermo Kahlo*—painted in 1952, ten years after his death—she paints stern, dignified Guillermo set against a backdrop of bacteriological forms that look very like microscopic sperm penetrating ova—as in *My Parents, My Grandparents, and I* (page 58). The lens of the camera, which refers to her father's job, is an aperture which seems sexual as well as optical. The banner at the bottom of the painting reads: *"Painted for my father, Wilhelm Kahlo, of Hungarian-German origins, artist photographer by profession; in character generous, intelligent and fine; valiant because he suffered for sixty years with epilepsy, but never stopped working and he fought against Hitler."*

Wilhelm Kahlo had left Germany forever in 1891. He never returned, and he did not fight in the war with Hitler. For Frida, this was a mere detail. Her father was not a hero to the world, but he was to her. He belonged to her mother, and she could not have him. She would need a man who loomed large in the world to compensate for this loss. She would find him in a man twenty-one years older, 200 pounds heavier and seven inches taller than herself—Diego Rivera.

Portrait of Don Guillermo Kahlo, 1952.
Oil on Masonite,
23³/₄" 18¹/₃".
Frida Kahlo Museum,
Mexico City.

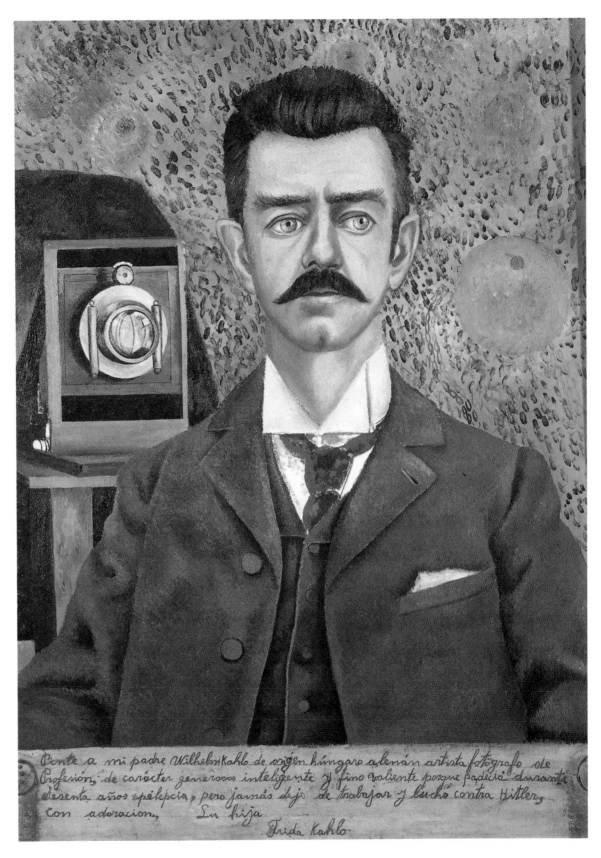

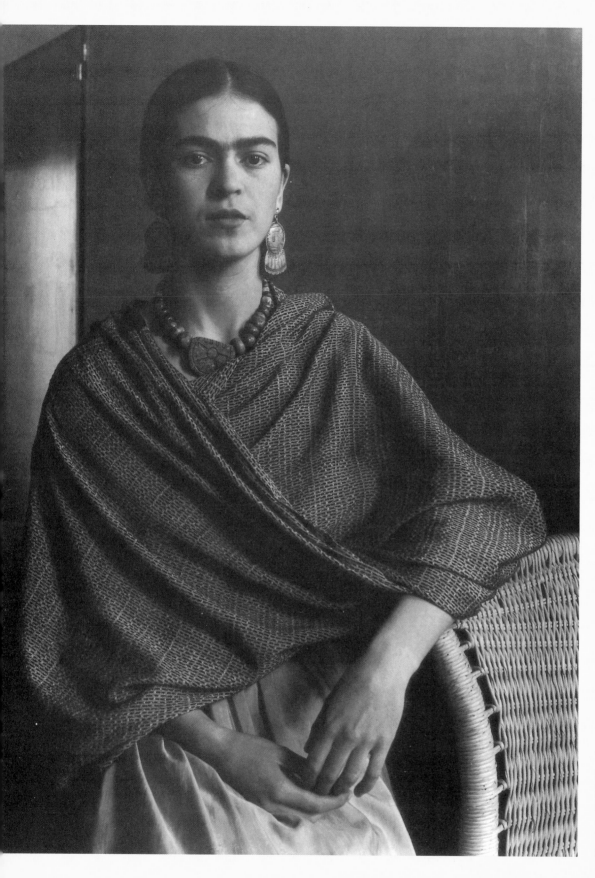

The young, newly married Frida Kahlo, photographed in San Francisco in 1930 by Imogen Cunningham. The Imogen Cunningham Trust.

CHAPTER 4

THE FROG AND THE SWALLOW

Frida and Diego

In 1913, when Frida was six years old, life conspired to turn her into an unwilling recluse. She contracted polio. The difficulties that she encountered at this vulnerable moment in childhood (which Freud defines as the "latency" period, a stage in the development of childhood identity when earlier psychic freedom is replaced by repression) had great bearing on Frida as an adult.

There is some doubt whether she actually spent as many as nine months trapped in her bedroom as she was to say later, but there is no doubt at all that this disease was traumatic to the young, sensitive child. She had been vivacious and sociable—a child who played well with other children in the neighborhood, as well as with her sisters and cousins. Suddenly, she found herself sequestered and sent into the exile of her sickroom. She was forced onto her own limited psychological devices, quarantined in her room, looked after by her hysterical mother, and visited in the evening by her beloved, taciturn father. Not only was she forced to endure the awful loneliness and psychological pain of illness—and to contemplate the mysteries of disease—but she had to endure terrible pain in her right leg, from the knee to the foot. This bout of polio would affect both her mental and physical health throughout her life. It is no coincidence that the polio attacked the part of her body that would be the site of trophic ulcers in later life. Tragically, her shin and right foot became so destroyed by the ravages of disease that it was eventually amputated in 1953, the year before her death.

The polio certainly left behind both physical and psychic scars, but while Frida was in quarantine, she managed to create a response to her predicament by communing with

> *"Almost everything that we call 'higher culture' is based on the spiritualization of cruelty."*
>
> FRIEDRICH NIETZSCHE

her imaginary playmate to console herself in her solitude. She felt ostracized because of the medical necessity to keep her apart from society and must have seen her polio and "exile" to her bedroom as punishment. She may have been frightened by her "bad" feelings towards her mother, and felt guilty about them. Children are capable of contemplating the most tragic thoughts, without self-pity, yet never asking for help. Often, they feel responsible for events beyond their control. This is especially true of children who have as vivid an imagination as Frida. She seems to have had very little help from either of her parents with the psychological aspect of the polio. Many of her strange adult obsessions seem to have been conceived at this age.

The polio affected Frida's life in other ways, too. It withered her right leg permanently, and she was always self-conscious about this. She had to wear orthopedic shoes, and she always had a slight limp. As a woman who took great pride in her personal appearance, she may even have taken to wearing her characteristic long dresses to disguise this very obvious imperfection in her body. (She also very rarely smiled with her mouth open in photographs because her teeth were in a very bad state and darkened by vast amounts of nicotine.) When she went back to school after the polio, her friends jeered at her, calling her "pata de palo," or peg-leg. She took to wearing three or four socks on the calf to disguise the asymmetry of her legs and must have loved it that her adored father spent treasured time with her on physical rehabilitation, supervising her in the traditionally male pursuits of wrestling, soccer, and boxing. The tomboyish ways she adopted now were to stand her in good stead later, and we can see from photographs how much she enjoyed playing the boy in the family. The androgynous, ambivalent Frida comes to life at this time. But, the polio was also Frida's terrible initiation into a world she was to inhabit almost all her adult life. This is the world of the invalid. Her self image as *in-valid* became entrenched at this early point in her life. So did her great courage.

In 1922, Frida, a very bright, precocious girl with a disarming manner, entered the prestigious National Preparatory School, proud to be one of only thirty-five girls who had passed the rigorous entrance exam in a student body of 2,000 young men. Her illness had delayed her school work,

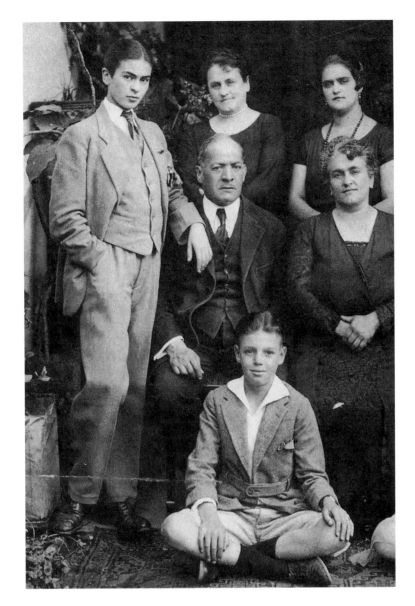

Photograph of Frida taken by her father, Guillermo, in 1926— with family, including her mother (seated right)—taken just months after her accident. Not only does Frida present herself as a man for the occasion, but she also appears remarkably well. Instituto Nacional de Belles Artes, Mexico.

and maybe this is the moment she decided to lie about her birthdate, making herself three years younger than she actually was. At this point, much to her parents' delight, Frida's plan was to pursue medicine eventually as a career when she left the Preparatoria.

The school, known affectionately as the "Prepa," was in the center of Mexico City, and Frida felt liberated. She was finally well away from the conformist pieties of her mother and the Blue House, and her fellow students were now romantic young socialists, who modeled themselves on the enlightened, postrevolutionary ideals of José Vasconcelos, who had been elected Minister of Public Education two years before. They endorsed his keen espousal of *Mexicanidad*

and dramatically adopted his motto, "The Spirit Shall Speak Through My Race." This is the moment when Frida first began to explore her Indian roots and to elevate them to a mystical means of identifying with a family. This was not the small family of Matilde and Guillermo in Coyoacán that she so derided for its bourgeois values, but the great Family of Mexican Man. Frida's lifelong socialism was born at the same time as this breathless discovery of her *raza*, and the political "mind set" of her adult self was forged. Frida was a woman who always defined herself politically—but she did not make political paintings. The French, Marxist, avant-garde director Jean Luc Godard's statement that "I make films politically, not political films" sums up Frida's philosophy very well.

Another momentous event happened to Frida at this time that was to radically change her life seven years later. José Clemente Orozco, David Alfaro Siquieros, and Diego Rivera, the three great painters of the revolution, known as *Los Tres Grandes*, were busy painting populist murals at the "Prepa." These murals were explicitly celebratory of Mexico's newly minted reformist soul, and were informed by a definite socialist agenda. The Mexican revolution, now "over" with the election in 1920 of the corrupt but resourceful General Obrégon, had created, through Vasconcelos (an appointment of genius on Obrégon's part) a "time of truth, of faith, of passion, of progress," according to Andrés Iduarte, a fellow student, who would later become very important in the 1950s. *Los Tres Grandes* were key members of the Mexican intelligentsia. Unlike other countries, artists were then—and are even now—unusually highly esteemed in Mexico, being in the vanguard of political and intellectual reform. Up on the scaffolding at the school was a huge bear of a man who would have as much influence on Frida's future life as her beloved father. He was an obese, friendly giant who spoke kindly to the young Frida, who said that she simply teased him from the floor below. She told her friends at this time (she said later) that one day she would have a child by this notorious womanizer. It was a premonitory statement, but not quite as accurate as she hoped.

Three years later, on September 17, 1925, Frida was returning home to Coyoacán from the center of Mexico City on the bus. She was working part-time in the city to help out at home. Guillermo, no longer employed by the Porfiriato, had been forced to mortgage the Blue House, and Frida was supplementing the family income. She was

sitting with her boyfriend, Alejandro Gómez Arias, whom she had met at the "Prepa." He had been a cherished member of her set at school, charismatic and handsome. She was deeply in love with him. It had been raining and the streetcorner of Cuahutemotzín and Calzada de Tlalpan was wet. As the bus turned the slippery corner in front of the San Juan market, an electric trolley car coming from Xochimilco went out of control and slammed violently into the side of the bus.

The next thing Alejandro knew was that he was under the trolley and Frida was nowhere to be seen. He managed to crawl out, and found Frida lying naked in the street. The crash had removed all her clothes. By some perverse and poetic quirk of fate, a packet of gold powder from the pocket of a fellow traveler had opened over her bloody body. Frida was conscious but in severe shock. At first she seemed to feel no pain, but Alejandro quickly realized that she was terribly injured. To his eternal horror, he found that she had a metal rod protruding from her abdomen. Unwisely, it was pulled out there and then by a well-meaning onlooker. Frida's screams were dreadful.

The Bus, 1929.
The blue-eyed capitalist "gringo" holding his bag of coins so obtrusively contrasts with the modest Indian woman with a bag at her feet— illustrating Frida's own political position blatantly and simplistically. Oil on canvas, 10½" x 22". Dolores Olmedo Collection, Mexico City.

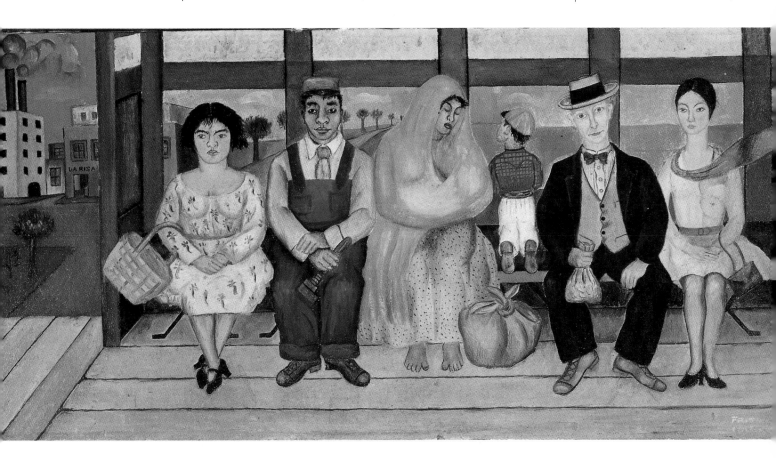

Frida had broken her spinal column, collarbone, two ribs, right leg, and foot. She also had a a fractured pelvis and a dislocated shoulder. She later claimed that her vagina had been punctured by the metal rod, and that the accident had robbed her of her virginity, but the testimony of Gómez Arias hints that this had been lost earlier: "The invention of a point of exit was to hide other things." It seems extraordinary that Frida would embroider so melodramatically upon her already dramatic symptoms and injuries. Perhaps this is the beginning of a later fixation. The unholy marriage of death and sex in her mind is something that caused Frida much mental anguish when she tried to have children.

Perhaps her invention of the "point of exit" is also a masochistic fantasy. She certainly saw herself as pierced by the arrows of suffering like a female St. Sebastian, or what she called "the sadistic Christ." She continually shows us her scars of torture like a saint or martyr parading his or her stigmata. Perhaps her fantasy is an attempt to cover up a "shameful" fact. It might be easily detected by the doctors that she was no longer an innocent virgin, and her puritanical mother and father would have been horrified at the thought of their young daughter sleeping with men outside of marriage. Perhaps the injuries were so frightening in their severity that she had to give them a biological meaning that would have a permanent effect on her life that she would be able to explain and therefore blame.

Frida's inability to have children was a source of extreme distress to her all her life. She always blamed this accident for her physical problems. However, though its effects were long-lasting and excruciating, it is by no means certain that it was the precise cause of the thirty-two operations she would undergo in her life. But the accident was certainly a painful trauma, both psychologically and physically. The nature of mental trauma is complex. An event in a person's life becomes traumatic only when it taps that individual's already established and unresolved source of distress. It can thus trigger a crisis. Frida's difficult, alienated relationship with her mother—exacerbated by the loneliness brought about by her bout with polio—might have been such unresolved sources.

The physical problems that were ostensibly caused by the accident may also have existed already. Her confidant, the esteemed San Francisco surgeon Dr. Leo Eloesser, was convinced early on in his examination of Frida's back that she had a congenital deformation of the spine. Salomón

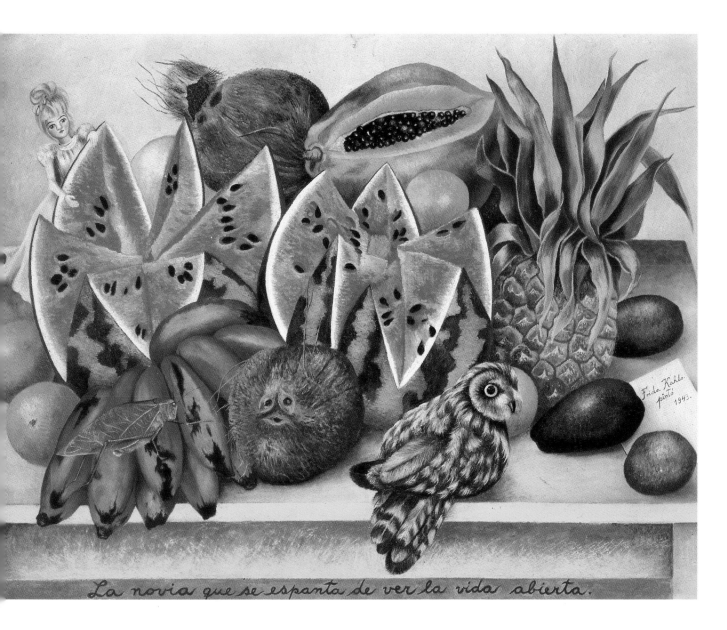

La novia que se espanta de ver la vida abierta.

Grimberg ascribes her problems to the early episode of polio and its weakening of her nervous system and skeleton. The Swedish surgeon Philip Sandblom believes that Frida suffered from an undiagnosed case of spina bifida, which occurs in the womb when the fetus's lower spine does not close properly. All these theories are fascinating. They are, however, ultimately as speculative, morbid, and unproveable as the current theories on why Vincent Van Gogh cut off his earlobe. Does it change our view of Vincent (who his worried housemate, Paul Gauguin, tells us in his journal was clearly very disturbed in 1888) or spoil our appreciation of his work, to be told that he suffered from a manic-depressive psychosis or epilepsy, or that he cut himself shaving?

The Bride Frightened at Seeing Life Opened, 1943.
Oil on canvas, 24³/₄" x 32". Collection Jacques and Natasha Gelman, Mexico City.

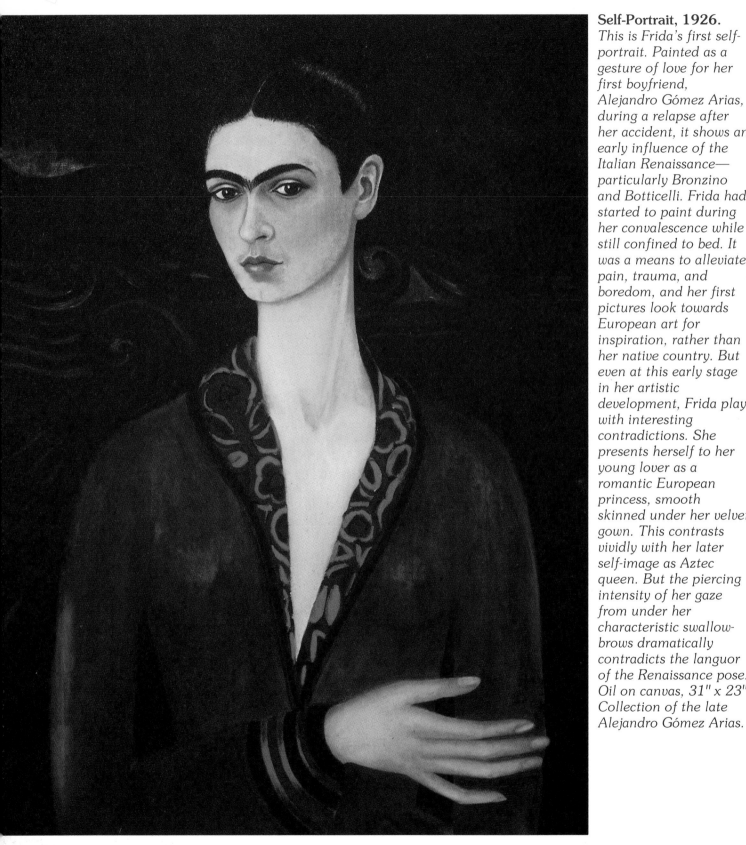

Self-Portrait, 1926.
This is Frida's first self-portrait. Painted as a gesture of love for her first boyfriend, Alejandro Gómez Arias, during a relapse after her accident, it shows an early influence of the Italian Renaissance— particularly Bronzino and Botticelli. Frida had started to paint during her convalescence while still confined to bed. It was a means to alleviate pain, trauma, and boredom, and her first pictures look towards European art for inspiration, rather than her native country. But even at this early stage in her artistic development, Frida plays with interesting contradictions. She presents herself to her young lover as a romantic European princess, smooth skinned under her velvet gown. This contrasts vividly with her later self-image as Aztec queen. But the piercing intensity of her gaze from under her characteristic swallow-brows dramatically contradicts the languor of the Renaissance pose. Oil on canvas, 31" x 23". Collection of the late Alejandro Gómez Arias.

Whatever the reasons for her later problems, it seemed very likely that Frida would die from the horrendous injuries sustained in the accident. But she didn't. Through force of character and sheer good fortune, Frida recovered from its immediate effects. She said later that neither her mother nor her father visited her in the hospital. They were too upset! Frida spent a month in the "filthy, piggy" hospital encased in a plaster cast before being allowed home to recuperate in bed. Her mother bought her a lap easel and she began to paint, eager for some activity to relieve the boredom of convalescence. She made rapid progress, showing an innate talent for graceful line and luminous color. Her first pictures were painted in oil paint on canvas—a long-lasting, "serious" medium that is attractive to young artists. Oil colors require a degree of formal control and organization that is very challenging, and it is certainly pleasing to hold a finished canvas, which has the feeling of an "object," rather than a projection of a mental image.

Frida was able to walk quite soon after the accident. But it seems that the medical attention she received during these early days was not all that it should have been. She had relapse after relapse, and what she called her "martyrdom" continued throughout her life, resulting in many operations on her spine and leg. Much of Frida's life was to be spent in the privacy of her bedroom, which was all too often a sickroom.

There are many versions of the story of how Frida met Diego again after the accident. One version has it that her new friend, the beautiful Italian Communist photographer Tina Modotti, introduced them. Diego had been one of the free-and-easy Tina's lovers in the past, and he had the rare and delightful knack shared by many men who really adore women of remaining friends with his ex-lovers. Frida, upon Tina's urging, had joined the Young Communist League and was, therefore, a "politically correct" potential companion for the noisy Communist that was Diego at the time.

Frida's favorite version of the meeting is somewhat different. When she had recovered from the accident, and had a small number of pictures to show the world, she took them to Diego for comment. He was a figure of enormous stature,

Portrait of Frida distributing arms at Ministry of Education. Diego Rivera, 1928.

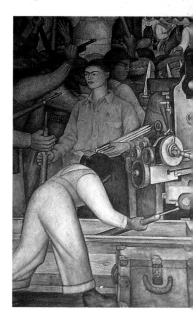

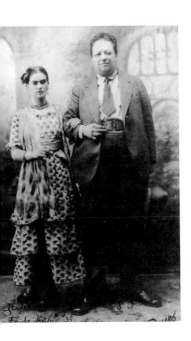

*Wedding phtograph of
Diego and Frida,
Mexico City 1929.*

in more ways than one. He was working on the scaffolding at the Ministry of Public Education on a cycle of murals. He remembered the little tease from her days at the Preparatoria—and he was single again. His relationship with the beautiful Lupe Marín (which had produced two daughters) was now over and Diego, never one to enjoy or survive celibacy, was looking for love.

The relationship of the "elephant" and the "dove" culminated in marriage on August 21, 1929. Guillermo and Matilde Kahlo were upset at first by Frida's choice of husband. Diego was old, fat, a Communist, an atheist, a womanizer, a father of three, and twice married (one civil ceremony, and one in church). Worst of all, he was an artist, albeit a *successful* one. But Herr Kahlo knew well that Frida was going to be a handful to whomever she married. He described her as an "occult demon" to her future husband (jokingly I'm sure). And he warned Diego that Frida "is a sick person and all her life she will be sick; she is intelligent, but not pretty." (I imagine that he meant physically sick, but it is unclear.) Guillermo knew that much as he loved Frida, he could not afford her future medical bills. He could also see that this was a real love match between "*Panzas*" (fat belly) and his frail, injured child with her bird-like eyebrows and bones. Frida was thus given over by her father to Diego's burly embrace.

Frida moved out of the Blue House to live with Diego in the center of the city after the marriage in a registry office, attended by her father—but not her mother—and a few witnesses. She wore clothes borrowed from the family maid. In her wedding photograph, she wears an incongruous mixture of indigenous and conventional European clothes. It's clear that Diego's passion for all things Mexican is already being acted on. Frida wears a *rebozo* over her dress. This is a trademark garment in later self-portraits. Diego was to use her almost as a still life, adorning her slender but curiously sensual figure with pre-Hispanic jewelry and the indigenous clothes of the Tehuantepec women. She was to maintain this image of herself throughout her life. I think we owe the glorious sense of style that we associate with Frida to Diego's influence on her as a young woman, establishing her mature sexuality and body image.

Diego was to have an impact on Frida's life in *every* sphere. They shared so much: *joie de vivre*, friendship, deep love, commitment to art, iconoclasm, and a ferocious passion for Mexico. They were one another's "smoking mirrors."

*"Diego was a
saint and a
monster."*

ELLA WOLFE

**Frieda and Diego
Rivera, 1931.**
*Painted after two years
of marriage, Frida has
enthusiastically adopted
a folk-art style of
painting and dressing for
this picture, which
conjures up the marriage
very succinctly. Diego is
the huge, untameable
bear of a painter, while
she sees herself as the
tiny-footed, docile dove,
hardly able to contain
his massive energy in her
little hand. The
whimsical inscription
reads: "Here you see us,
me, Frieda Kahlo, with
my beloved husband,
Diego Rivera. I painted
these portraits in the
beautiful city of San
Francisco, California, for
our friend Mr. Albert
Bender, and it was in the
month of April of the
year 1931." Frida had
not yet changed the
spelling of her name.
Oil on canvas,
39⅛" x 31".
San Francisco Museum
of Modern Art, Albert
M. Bender Collection.*

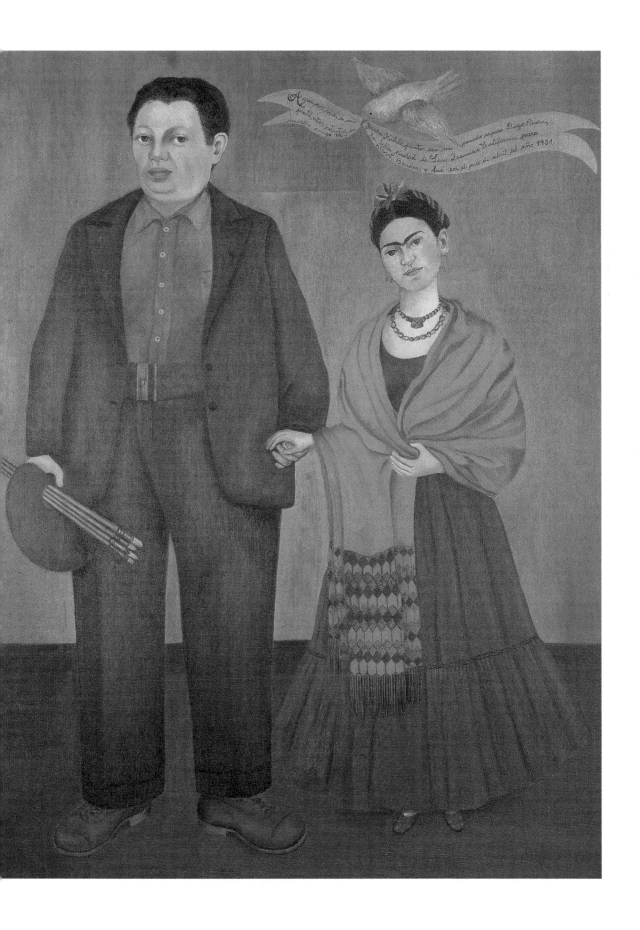

The relationship was very complicated. Who can look into another person's marriage and come up with a logic or reason for it? The bond between them seems to have been not only emotional but physical, too. Yet Diego did *not* take his marriage vows of monogamy seriously at all, and tended to view sexual fidelity as a bourgeois manifestation of pre-revolutionary mores. His friend Ella Wolfe, widow of Bertram Wolfe, his biographer, once said that, "For Diego, sex was like urinating."

Although complementary, their public personae were different, too. They were wonderful fun to be around, feeding off each other's witticisms and teasing each other mercilessly. At the beginning of their marriage, Frida would sit and smoke smolderingly, cracking jokes at her dear *caras-apo* (frog-face) "with the richest vocabulary of obscenities I have ever known" (Bertram Wolfe). She weighed ninety-eight pounds and he weighed almost three hundred, and they looked at this time like Beauty and the Beast. Frida had not traveled much and was quite a novice in the Bohemian world of the arts. She was not taken very seriously as a painter by anyone but Diego in the early days, but he genuinely encouraged her and seemed to delight in her tentative first works. He was to say, "Frida is the only example in the history of art of an artist who tore open her chest and heart to reveal the biological truth of her feelings."

Overwhelmed by Diego and his colossal energy, Frida painted very little in those first years of the marriage. Instead she spent her time traveling with him as he painted murals, being his decorative consort and learning how to cook—from Lupe Marín, his ex-wife, of all people. She was also trying desperately to get pregnant. She was to have her first therapeutic abortion in 1929, apparently because the fetus was in the wrong position. This is very unclear, as in normal circumstances a baby in the womb will often turn itself or can be turned later in the pregnancy, but it is what she says. It may also not be true. It may well be that Frida decided of her own accord to terminate the pregnancy—if indeed there really *was* one. Diego had already embarked on the first of his countless affairs during their marriage—this time with a young assistant. Diego was promiscuous to an unusual, possibly pathological, degree. He is known to have seriously asked a doctor for a certificate stating that he was congenitally incapable of being monogamous. Frida's many operations—both gynecological and skeletal—seem to tie in with the onset of Diego's affairs. It is possible that she timed them to cause

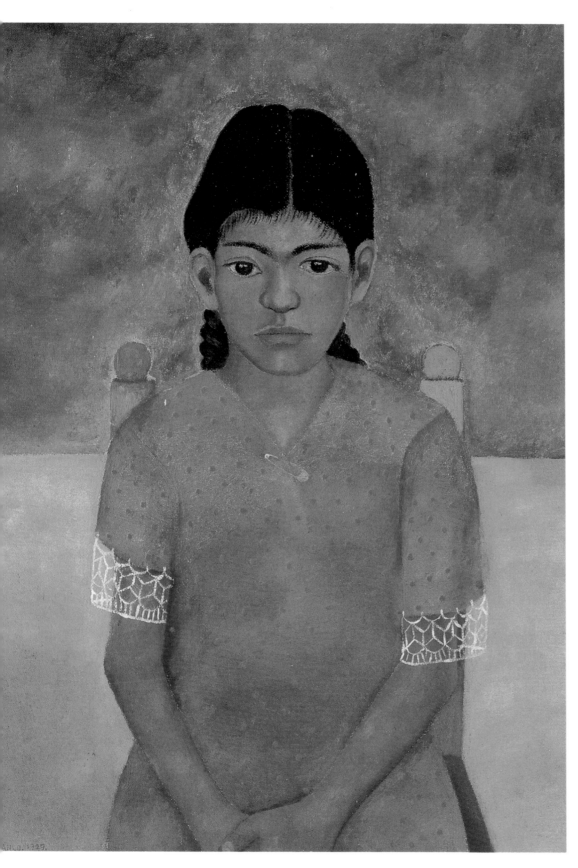

Portrait of Virginia, (Niña), 1929.
This picture has a simplicity that is very self-confident for a twenty-two-year-old novice painter who was virtually self-taught. Painted in the year of Frida's marriage to Diego, it shows evidence of his advice in its cool, clear handling of shapes and its evident pleasure in the non-European features of the model, whose huge, dilated pupils add an hallucinatory directness to an otherwise simple composition. Rivera was very interested in Frida's work from their first meeting, and his advice was invaluable to her. He pointed her in the direction of the folk-art of Mexico, and away from a European tradition that was fundamentally alien to Frida. She began to paint on metal and also enjoyed painting on Masonite, a form of composite board. It can be cut according to certain specifications, and this accounts for the idiosyncratic dimensions of some of her pictures. It is likely that she used off-cuts for many pictures. Oil on Masonite, 33" x 26³/₄". Dolores Olmedo Collection, Mexico City.

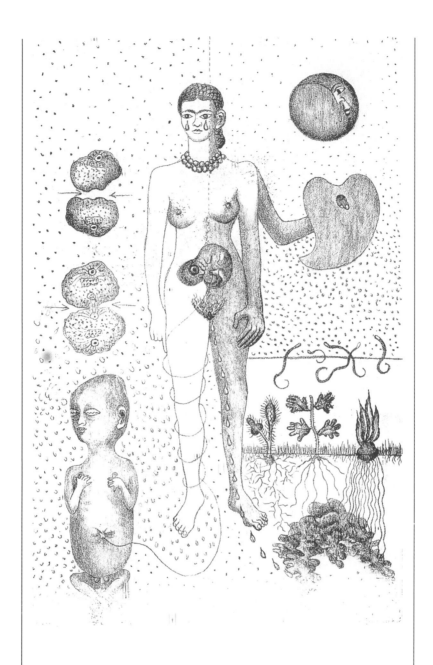

him maximum guilt. Martha Zamora, one of her biographers, says that "many of her operations were elective and occurred when she felt a new love in Diego's life."

But perhaps there is a deeper psychological reason behind the operations. As Hayden Herrera asserts in her biography of Frida: "A surgical incision is a sure thing." In a lifetime of insecurity that had its source in the earliest moments of childhood with the failure to bond with her mother in "the primordial mirror," Frida was never sure *what* the next trauma would be. She must have felt like a person ducking a volley of plates coming at her head. An

Frida and the Miscarriage, 1932.
Lithograph, 2nd impression, signed "Frieda Rivera." Dolores Olmedo Collection, Mexico City.

86

elective operation is at least one way of controlling one's own destiny. Projecting the inner pychological and physical pain outwards towards the world and the operating theater is a way of distancing oneself from the pain. This may be one of the main reasons why her most passionate work is to be found in her self-portraits. The reflection in the mirror has no pain and is intact and uninjured. She is impassive and in full control. To go confidently into an operating theater for restorative surgery is much like the operation of painting. It proves conclusively that you are not dead—yet.

Diego had had four children by the time he married Frida. The eldest, by his first (common-law) wife Angelina Beloff, was a son, Diego junior, who died as an infant in Paris in 1910. An early affair with Marievna Vorobiev in Paris produced a daughter, Marika (not acknowledged for years), and Lupe Marín, his second wife, had had two more daughters, Lupe and Ruth, in Mexico. He didn't want any more children. He wanted to be the only child in the relationship. He was extravagantly extrovert and needed all the attention Frida could spare him. In some ways, by marrying Diego, she seemed to be marrying a father figure, older than she and full of experience of life and art. He called her his "little Fisita, child of my eyes, love of my life" and "my beautiful little girl." But in other ways, he was an utter baby. He was a spoiled artistic prodigy. His mother had had many miscarriages, and his twin, Carlos, had died when Diego was two, so he had been the overprotected apple of his parents' eyes. He was totally dependent on receiving attention, especially from women. "Diego is not anybody's husband and never will be, but he is a great comrade." said Frida. But sometimes she wished for more than this. His biographer and friend Bertram Wolfe, who was also a great friend to Frida, has written: "To him she came first after his painting and after his dramatizing of his life as a succession of legends, but to her he occupied first place, even before her art."

Despite his streak of infantilism, Diego was an extraordinary man, capable of great affection and warm generosity to those he loved. Ella Wolfe recounts that on one visit to Mexico, she was met off the train from New York by Diego with a whole band of Mariachi players to welcome her. As if this wasn't wild enough, Diego was wearing his ten-gallon hat, had a bandolier of live ammunition around his paunch, and was carrying a gun! He had a streak of iconoclasm, too. He loved to shock, inventing stories of such arcane balder-

Wood Mariachi band. Oaxaca, nineteenth century.

dash that he would leave his audience—and Frida—gasping. It's amazing that he was ever taken seriously.

It is also not surprising that his politics were considered ill conceived and naive by the Mexican Communist Party, which he had joined as a youth and which had rejected him the year he married Frida—and was to do so repeatedly. Diego was a curious specimen of Communism, as was Frida. Her volatile adoration of such figures as Lenin, Marx, Mao Tse Tung, and Stalin was certainly heartfelt, springing out of a deep moral commitment to socialism, but these grand men of politics were romantic heroes to her rather than real role models. As a Communist, Diego had no compunction about working for capitalist barons at all, and gaining Yankee dollars, and Frida seems to have accepted this glaring inconsistency with ease. She never complained. Diego could not see the obvious conflict of interests in his working practices. He seemed genuinely affronted when his Marxist iconography was politely (and later dramatically) rejected by his admiring patrons, such as Nelson Rockefeller in 1933. At the last minute Diego had surreptitiously sneaked a head of Lenin into a mural for this "Yankee Baron" commissioned by Radio City in New York. The mural was to be called by the amazingly and typically ambitious title of *Man at the Crossroads Looking with Hope and High Vision to the Choosing of a New and Better Future*. It was destroyed nine months after its completion.

Diego loved to engage in what contemporary psychologists like to call "acting out." A favorite party piece of his was to tell fabulous, shocking tales to visiting tourists, gullible female admirers, and sycophantic collectors. A visit to Diego's studio was *de rigueur* for any visiting V.I.P.s from North America and Europe, and he held court after work with these—usually female—listeners. Frida enjoyed these sessions, until she found out that when she had drunk enough and had toddled off to bed, Diego was doing the same thing in his studio, but not alone.

Diego's tall tales ranged from accounts of his personal enjoyment of cannibalism to idiosyncratic explanations of pre-Hispanic history that were completely fabricated in the hothouse of his fevered, boyish imagination. For example, he would explain that the surfeit of disembodied clay heads of gods in the museums was explained by Aztec economics—the Aztecs would break off the heads to give as change when they bought food in the market. The painter Rina Lazo, who acted as his assistant, recalled that once, in the company of some matrons from over the border, he was

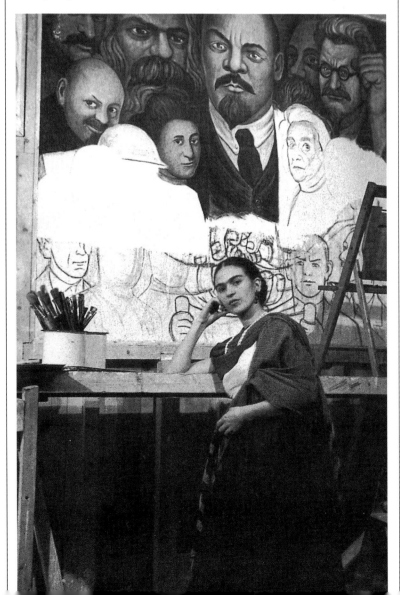

Frida leaning on a scaffolding, 1933, at the New Workers' School, New York, beneath one of Diego's magisterial portraits of Lenin. Photograph by Lucienne Bloch.

suddenly disturbed by the frantic buzzing of a fly. He swept his porcine fist to the spot where the insect had alighted and brought its agitated contents to his mouth and swallowed. How they loved that!

But he was not all jokes and frippery, and to my mind, he is the greatest monumental mural painter of this century. Frida thought so, too. She admired his work beyond anything else and valued his opinions of her own. He was deeply respectful of her growing style and was the first person to suggest to her that she paint on wood and tin instead of canvas, in the style of the *ex-voto* (or retablo) painters of the past. (An ex-voto painting is a small picture made in desperation, begging God to answer a prayer or to thank him for doing so. They are usually found in churches, but Frida and Diego amassed a huge collection of them, and they are to be seen in the Blue House.) This showed great insight, for this miniaturized form of painting was eminently suitable to Frida's love of detail in her work. This art form also had the added advantage of being easily portable. Frida was never physically very strong, there are few large paintings in her *oeuvre*. By painting on a small scale, she could also distance herself from the massive, sculptural manner of painting adopted by Diego, both in his mural work and in his easel painting.

It is no wonder that his larger-than-life reputation preceded Diego when, in 1930, he left Mexico with Frida for two years, on and off, to work on several commissions in the United States. The first, in San Francisco, turned Diego into a social lion on foreign soil for the first time. Frida began to enjoy her role as queen consort to a great man, though her opinion of *gringos* was not so complimentary: "They all have faces like unbaked rolls." They had a wonderful time, and Frida was quite a hit in her exotic clothes, jewels, and headdresses. But her right foot was beginning to worry her. It had a way of turning out to the right, which made walking difficult. She consulted Dr. Eloesser, her life-long confidant and surgeon, and began to paint seriously during her stay in the United States. With Frida still in pain, she and Diego returned briefly to Mexico, and then set off to New York, where Diego had a major retrospective at the Museum of Modern Art, and then on to Detroit, for Diego to paint a new cycle of murals.

All this traveling took its toll on Frida, and 1932 was a terrible year for her. Her foot was still painful and a trophic ulcer was diagnosed. She was also two months pregnant.

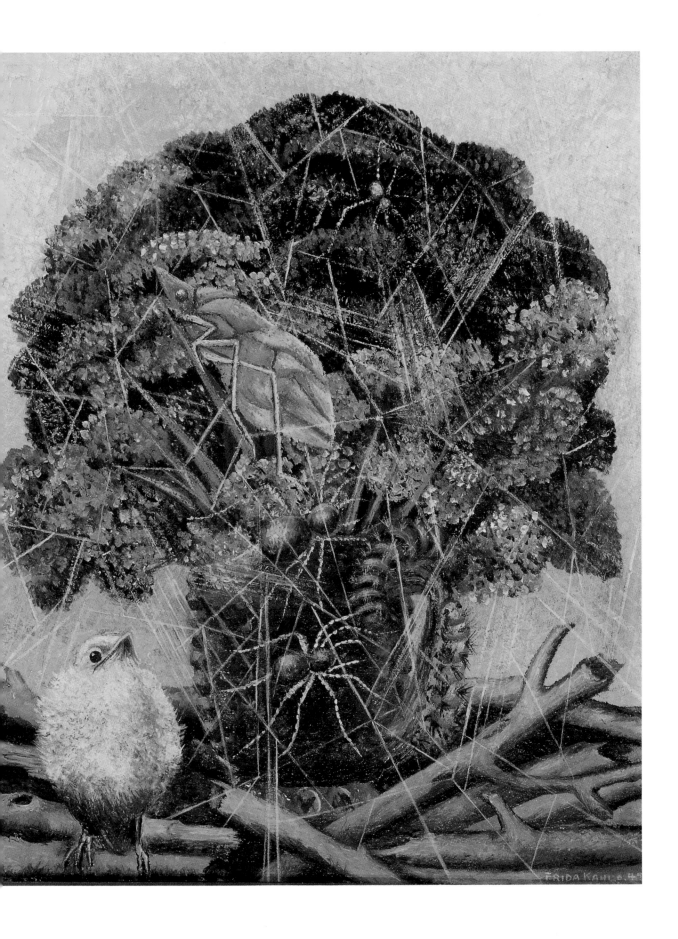

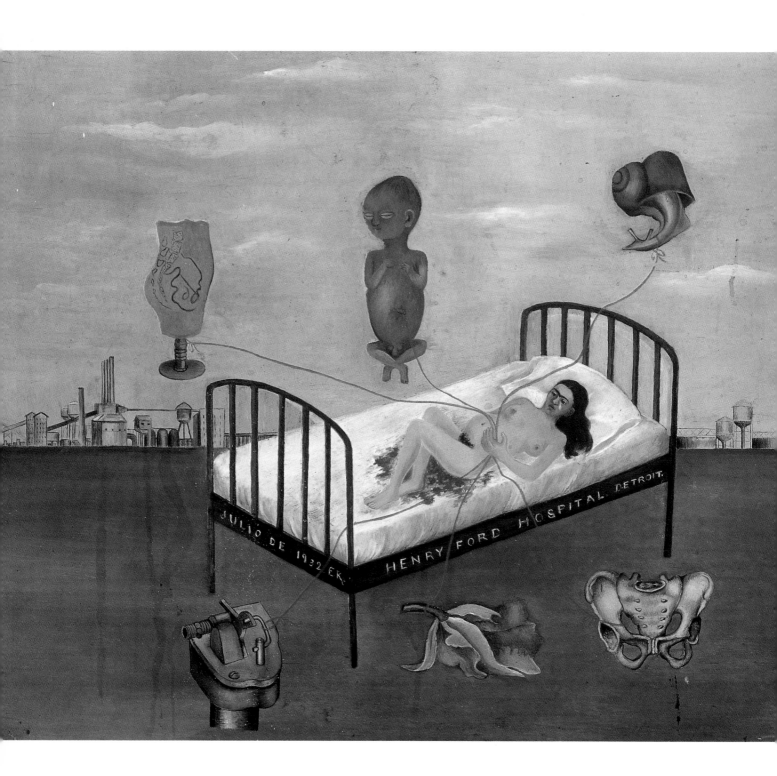

She decided on yet another therapeutic abortion—why is another mystery. It is clear from a letter to Dr. Eloesser that she was worried about her heredity (because of epilepsy), her physical condition, the timing of the baby's birth with regard to Diego's working schedule, and his reaction to another child. However, the dose of quinine she was given by another doctor to end the pregnancy was ineffective. She began to wonder if she could indeed have the baby after all. Her letter asking for advice from Dr. Eloesser is very confused.

Having finally decided to try and rest and keep the baby, Frida's behavior seemed designed to sabotage her deepest wish. Diego had come around to the idea of a child. He tried—with the help of their mutual friend Lucienne Bloch, who was visiting from New York—to persuade Frida to have complete bed rest. She took driving lessons instead. Frida was rushed off to the Henry Ford Hospital on July 4, 1932, where she lost the baby. Both Diego and she were desolate. The painting *Henry Ford Hospital* is about this experience. Frida's reaction to her ordeal was to paint it. The image of a flower has sexual connotations, and looks womb-like in Frida's picture, but it also evokes the symbolic gifts that one is given in hospital.

Diego gave the orchid to Frida. She lies bleeding on her hospital bed, connected by vascular tubes to her imagery: a much-desired male fetus, an imaginary model of a woman's insides, a snail symbolizing the slowness of the miscarriage, an autoclave for sterilizing surgical instruments, and a medical diagram of a pelvis. This was a dreadful period for Frida. She felt that her damaged body had let her down once more, but was well aware by now that painting could be cathartic, and that she could use it to pull herself through crisis. The analyst Danielle Knafo has said of Frida Kahlo: "Through their creations, artists, like children at play, succeed in converting passive grief and helplessness into active mastery." While no "master" of her fate, Frida Kahlo was beginning to be mistress of her art.

Henry Ford Hospital, 1932. *This is an early example of Frida's developing interest in painting on the smooth surface of metal, rather than on the woven surface of canvas. It is ideal for small pictures but not suitable for large paintings where canvas is stronger and less pliable. Oil on metal, 12¼"x 15½". Dolores Olmedo Collection, Mexico City.*

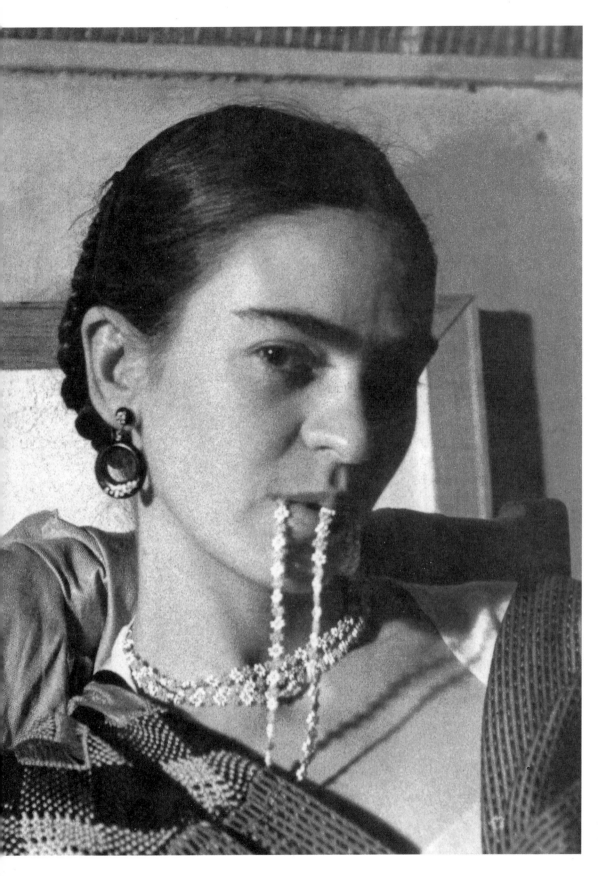

Portrait of an insouciant Frida by her friend Lucienne Bloch.

CHAPTER 5

FOLLY AND FAME

A Career in Art

Diego Rivera was certainly not a bad man, but in the event, he did turn out to be rather a bad husband for someone of Frida Kahlo's sensibilities. He was so enthralled by the trappings of his burgeoning fame and notoriety in the United States that he was very reluctant to return home to Mexico, which she found that she was missing more and more. The decision to work in the States had never been intended as a permanent arrangement. Frida's miscarriage at the Henry Ford Hospital had damaged her in more ways than one—it had affected her sense of confidence and self-worth. She felt increasingly alienated from the world, her friends in the States, and Diego. He was having the time of his life; both on the scaffolding and in bed with various admirers, and was reeling recklessly from one major commission to another in very quick succession. He loved being so busy, but his energy levels drained her. In Detroit, he had finally decided to lose weight, and had been prescribed amphetamines. Living with an already energetic man cruising on large doses of "speed" so soon after such a major blow to her own health made Frida feel that she needed to return to her roots. She became increasingly negative about life in America, where she was—despite herself—to spend four years of her life. Her letters confirm her prejudices about " ... their system of living (which) seems to be the most repugnant, those damn parties, in which everything from the sale of a painting to a declaration of war is resolved after swallowing many little cocktails " To Diego, the lure of Mexico City was minimal. It seemed provincial after the United States. He cherished the dramas of his professional life, such as the debacle of the Rockefeller Center commission, but Frida was homesick. She never really liked "Gringolandia."

The miscarriage in Detroit was one of the lowest points in Frida's life. Both Lucienne Bloch and Diego, who seems

Dorothy Gale from Kansas to the little man behind the screen: "I think you are a very bad man."
The little man to Dorothy: "Oh, no, my dear. I'm a very good man, but I'm a very bad wizard."

L. FRANK BAUM:
THE WONDERFUL WIZARD OF OZ

to have been affected by Frida's grief, tried their best to comfort her. But the realization was beginning to dawn that she might never give birth to a live child. Her proximity to death was to become more intimate. On September 3, 1932, while still living in Detroit, she received a telegram informing her that her mother was dying of cancer. In a state of near emotional collapse, she set off on the long journey by train to Mexico City with Lucienne, leaving Diego behind. Matilde died on September 15th. Frida was working on *My Birth* (page 62). It was related to her own sad experience of childbirth, but she said at the time: "My head is covered because coincidentally with the painting of the picture, my mother died." The covered body is both Frida and her mother, Matilde. Her soul-destroying ambivalence about Matilde is resolved pictorially, if not experientially. She has bonded with her mother through the catharsis of death, and it is as though she can now properly love her mother, as she would have loved her baby. It is a picture about the loss of self—of child and of parent simultaneously. What greater grief can there be?

When she returned to the United States, the Riveras moved to New York. At first, trying to escape the onerous weight of grief, Frida enjoyed this period of her life. While Diego was hard at work on the ill-fated Rockefeller mural followed by the mural for The New Workers' School, Frida went out on the town. She was feverishly sociable, became addicted to the cinema, and indulged in marathon shopping sprees around Manhattan. She put her *huipiles* and *rebozos* aside, and wore chic designer clothes. She was seen everywhere—at parties, galleries, the theater, and concerts. She became, albeit briefly, *une vraie mondaine*, a very worldly lady. Diego immersed himself in the sophisticated social life of New York. He was the center of attention in the radical art world for his "principled" stand against his capitalist patron, and there were many beautiful ladies who were all too willing to share his notoriety and his bed.

It had to end. In December 1933, bowing to Frida's wishes, they finally returned to Mexico City, and settled into two modern houses in the suburb of San Angel, designed by their friend the artist Juan O'Gorman. Diego's house and studio was a large pink box linked to Frida's, which was smaller and blue. A fence of organ cactus surrounded the houses, which were symbolically separate, but linked—a metaphor for the state of their marriage at the time. Diego became utterly unhappy and bored in Mexico City, and Frida

Self-Portrait with Heavy Necklace, 1933.
This self-portrait is probably the simplest, least dramatic that Frida was ever to paint. She wears her favorite pre-Hispanic jadeite jewelry given to her by Diego, but her hair is modestly pulled back from her face and her clothes are restrained. As usual, she has emphasized her faint mustache and her swallow eyebrows.
Oil on metal, 14" x 12".
Collection Jacques and Natasha Gelman, Mexico City.

*Photograph, 1933, by Lucienne Bloch of Frida sitting below her **Self-Portrait with Heavy Necklace**, painted in that year.*

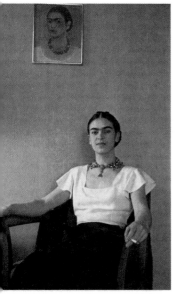

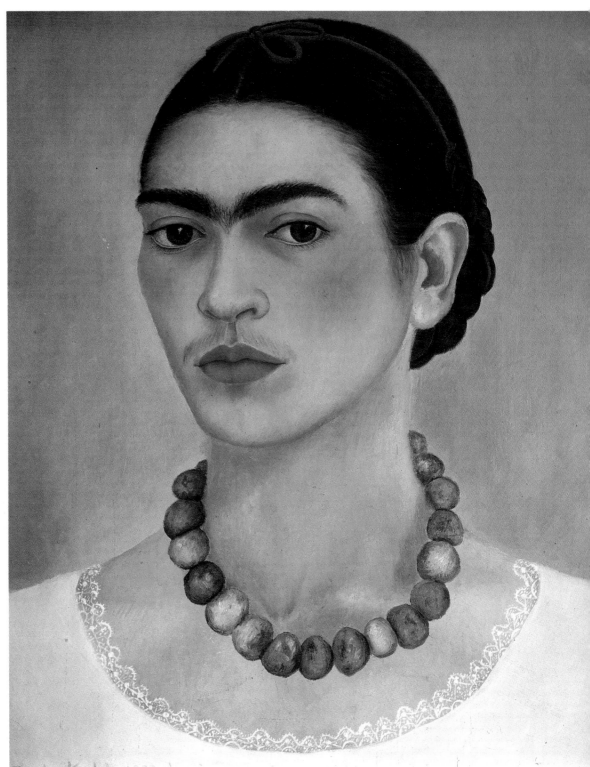

was understandably depressed. For Diego, life just did not have the sparkle of life in Manhattan, where he was a celebrity. Following his normal practice when suffering from boredom and *anomie*, Diego turned to a new love affair to give him the injection of energy he needed to make art. Unfortunately, he did not look far enough from home.

Frida's younger sister Cristina was his choice of adulterous partner, and this treacherous behavior was almost to destroy Frida. Both the Riveras were low. Diego's drastic diet was causing glandular problems. He was stressed, hypochondriacal, needy of Frida's attention, and prone to infection. Frida felt dreadful, too: "I am in such a state of sadness, boredom etc. etc. that I can't even do a drawing . . . " she wrote to Dr. Eloesser. Things began to unravel very quickly between the couple, and Frida found she could no longer tolerate Diego's infantilism and infidelities. She was more prepared to forgive Cristina than Diego, and did so; but she found that she could no longer bear to be with her husband. She moved out to an apartment, and then left for New York.

However, her determination to separate herself from him was shortlived and unsuccessful. In a matter of weeks, she was writing dismissively and forgivingly of his "liaisons" and "flirtations" and was telling him of her love, which went "deeper than her own skin." Their reunion in San Angel was sweet, but things had really changed between them forever. The innocence and joy of their union soon lost its zest, and they became disappointed in themselves, and in one another. I think that Frida had never really understood the intensity of Diego's need for attention. Nor do I think that she had *ever* truly contemplated how corrosive this need might turn out to be to their marriage. Diego, in turn, had never really appreciated just how vulnerable and damaged his young wife was, nor how crucial was her desire for his fidelity, and for a family.

Frida, disillusioned and cynical, began to dally with other people over the next few years. She seems to have been attracted to both men and women as lovers, though many of her friends disagree that Frida was ever an active lesbian. I believe that she was bisexual, and sought in relationships with women the tenderness that she found lacking in her husband and all of his sex.

The painting *What the Water Gave Me*, painted in 1938, and much admired by the Surrealists, is a direct reference to her physical love for her own sex. In a work which

98

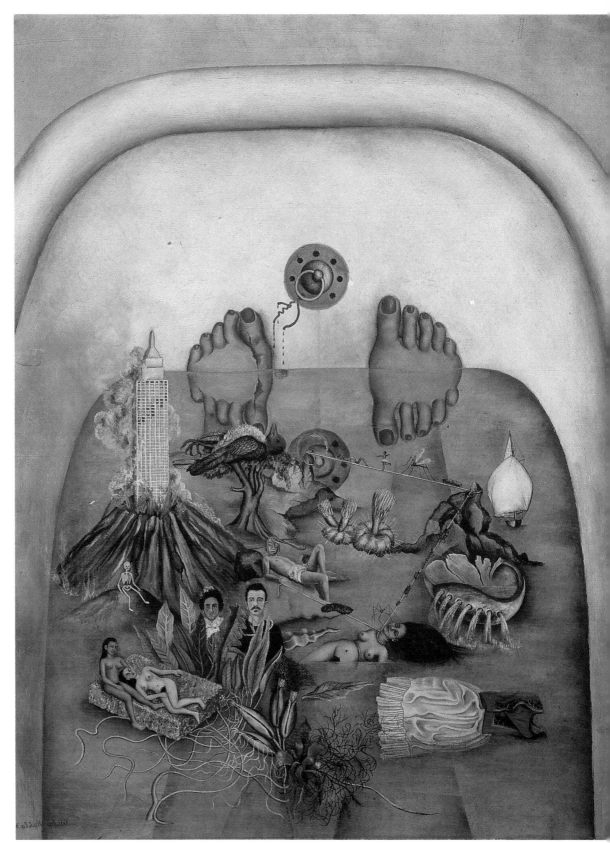

What the Water Gave Me, 1938. *Oil on canvas, 38" x 30". Dolores Olmedo Collection, Mexico City.*

owes a considerable debt to Hieronymous Bosch, the iconography is as dreamlike and sexual as that most excessive of painters. The picture has a gothic horror that owes much to her favorite contemporary art form, too. We know how much Frida loved the cinema, and this picture gives more than a nod in the direction of the silent expressionist horror films of the 1920s and 1930s, most notably Murnau's 1922 film, *Nosferatu.* In the painting, her maimed feet lie in a bathtub of nightmares. She talked about this picture in terms of a child's daydreams in the bath, playing with toys, and how the adult's reveries in the bath focus on sadness and pain. She has transposed her ulcerated foot from right to left, (possibly because she painted her own reflection in the mirror) and repeats the imagery of injury in the depiction of the dead bird, which lies in rigor mortis, red claw extended. A woman is strangled, possibly by her own libidinous desires. Death sits casually on a rock beneath the exploding, phallic Empire State building. A couple of female lovers—the dark figure is Frida—lie stranded on a sponge overlooked by the puritanical gaze of her parents. A Tehuana dress floats eerily on the water. There is a potent, rather repugnant atmosphere of tension and fear in this painting. It seems to want to reveal a filing cabinet of personal information to the viewer, but is actually hermetically sealed and self-referential, exposing only an overly explicit ambivalence about her sexuality.

Upon her return to Mexico from New York, Frida took on a new persona. She began to act like a predatory, female version of Don Juan, in spite of her disdain for Diego's priapic approach to life. She may have felt that she had no choice, and the frenetic quality of her life at this time seems rather desperate. Diego made the rules of the game, laid them out for her, and set the pace of their lives. They resumed their open-plan design for living in the two houses at San Angel, cohabiting in a fashionably iconoclastic, Bohemian "open marriage." Frida, despite her contempt for Diego's habits, started to conduct her affairs in the same brazen manner as her husband. Their home was always full of people, and intimacy—long gone in the public lifestyle espoused by Diego—became a thing of the past. She hardly painted. Writers, artists, movie stars, and *politicos* drank their booze. Frida was still deeply involved with Diego, but she was hurt by her body's failure and by his rejection of the marriage, which she had assumed was a contract for having children. She began to drink a lot of cognac and tequila and

lose her composure at parties. Her use of profanities became legendary with her friends. Her life with Diego had a superficial patina of camaraderie; they appeared reasonably content to the outside world. He seems to have turned a blind eye to her homosexual affairs, even encouraging them. He was less tolerant of her heterosexual ones, and she was forced to use elaborate subterfuges to see her male lovers. It was becoming increasingly obvious that the relationship was going to break under the strain. Frida was disillusioned and looking for some answers.

The answers turned out to be political, not personal. The Spanish Civil War broke out on July 18, 1936, and Frida reacted to it, as did so many Mexicans, as a cause for concern, jubilation, and *agitprop* in equal measure. She became active on behalf of her "Spanish comrades," trying to raise money from many of her friends and Diego's patrons for the Republican cause, which to her and many others was a courageous stand against fascism.

Politics entered her life from another quarter, too. In 1933—the year Diego and Frida had moved back to Mexico—Russia had become polarized by a split within the Bolshevik movement. Rumors of Stalin's purges had reached the Stalinist Mexican Communist Party but, as in so much of the world, they were ignored. When Leon Trotsky rebelled against Stalin's despotism, forming the Fourth International, Stalin put him on his hit list. Trotsky was sent into exile by the Fifteenth Congress of the Bolsheviks, and spent nine years in the wilderness. In November 1936, soon after the beginning of the civil war in Spain, Diego—who had left the Mexican Communist Party in favor of the Trotskyite splinter group, the International Communist League—was asked to try and use his influence with President Cardénas's government to secure asylum for Trotsky and his wife, Natalia. This he duly did. The desperate Trotskys had moved around the world in their exile—from Soviet Central Asia to Turkey, France, and Norway. When they finally arrived in Mexico in January 1937, they were in a palpable state of paranoia. Stalin's agents were one step behind them.

Frida offered them the Blue House in Coyoacán. She was installed in San Angel and her father, Guillermo, now widowed, had moved out of the family home to live with another daughter. The Russian couple remained at Coyoacán for two years, rent free. It was terribly exciting—like a spy novel—and Diego, ever one for melodrama, enjoyed the setting up of elaborate security devices to protect

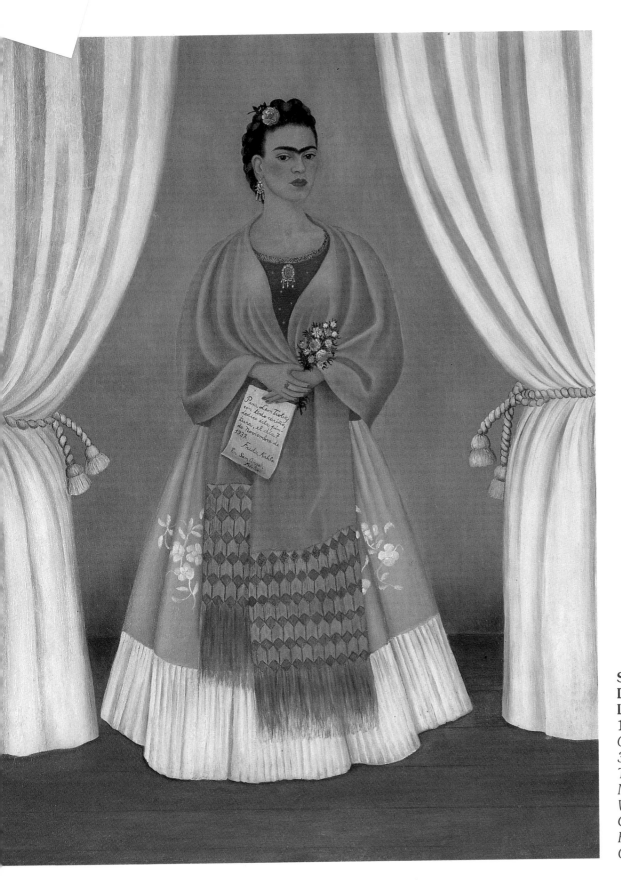

Self-Portrait Dedicated to Leon Trotsky, 1937.
*Oil on Masonite, 30" x 24".
The National Museum of Women in the Arts, Gift of the Honorable Clare Boothe Luce.*

his mentor from Stalin's accomplices. No two people could have been more different from Trotsky and Natalia than Diego and Frida. The Russians were reserved and formal, the Mexicans were noisy and anarchic. It was a doomed relationship, born out of expediency on one side and awe on the other. After all, Trotsky had *known* Lenin! But Trotsky suffered from an unpardonable sin in Diego's book. He had no sense of humor—at least it was not the same as Diego's. He was not amused one bit when Diego brought him a sugar skull on the Day of the Dead, November 2, 1938, with "*Stalin*" written in icing sugar on its brow! The relationship understandably cooled when Diego ultimately resigned from the renegade Fourth International, and Trotsky moved out of the Blue House in April 1939 to another house nearby in the Avenida Viena. This is where he was murdered on August 20, 1940, by an agent of Stalin. The assassin was Ramón Mercader, who turned out to be an acquaintance of Frida's. She was interrogated by the police for twelve hours in connection with the assassination.

It is often said that Frida and Trotsky began a passionate illicit relationship at the beginning of Trotsky's stay in Mexico. Certainly the Russian couple seem to have had marital problems at the start, even separating for a few weeks in the summer of 1937. But Trotsky had more on his mind than dabbling in adultery. There must have been a lot of readjustment necessary for this pair of serious Russians to learn the strange Mexican ways. Leaving the climate of Norway for that of Mexico cannot have been without its difficulties, and living in a constant state of siege must have been extremely stressful. This so-called "affair" is more likely to have been platonic, based on mutual fascination. I suspect that the fifty-seven-year-old Trotsky was strongly attracted to the flirtatious twenty-nine-year-old Frida, and that she, in turn, experienced a serious bout of hero worship. The self-portrait that Frida painted for him in November demonstrates comradely affection rather than disappointed love. Jacqueline Breton, the wife of the Surrealist painter André Breton, who visited Mexico in 1938, described the Russian as "very strict... very old-fashioned"—not at all Frida's type.

This painting—which Frida gave to Trotsky—is interesting. Frida portrays herself as a docile, golden beauty. Her expression is accommodating, without the brazen carnality of the many self-portraits that would soon follow in a great burst of creativity. She seems settled and calm, the perfect, dignified companion to a Great Man. There is no hysteria in this

Judas figure, papier-mâché, Mexico City.

Judas figure, clown, papier-mâché, Mexico City.

A Judas figure in the form of a red devil, papier-mâché, 8".
All Private Collection.

picture, but there is also no dynamism. Even her hair, which usually appears pulled sharply and painfully into a tight braid, threaded with flowers, seems less tight than usual. There is a pleasant, theatrical vacuousness in this picture, which in the context of Frida's other work of the period is actually quite terrifying. She is acting out a masquerade. She is announcing that she is in control. She stands between the curtains, clutching her dedicatory note to Trotsky, an actress upon a stage. But Trotsky did not keep this supposed token of love. He left it behind, along with other gifts from Frida, when he moved out of the Blue House.

Frida was not as happy as she pretended at this time. In 1937, she painted some truly powerful pictures of despair and disillusion. *My Nurse and I* (page 65) comes from this period, as does an extraordinary painting called *The Four Inhabitants of Mexico*. This picture is often thought to be a celebration of her Mexican roots, but I do not see it this way. It seems to be a question about men. In it, she is asking a question—what *are* men about? Frida paints herself as a child, sitting in a large empty space like the central *Zócalo* in Mexico City. To our extreme left we see a huge Judas figure, wearing Diego's overalls, rigged with firecrackers. These Judases, part of a much-loved custom in Mexico, are made of papier-mâché. They are ceremoniously blown open on the Saturday before Easter because they symbolize the betrayal of Christ. Frida and Diego had a marvelous collection of these figures. They are charming in a terrifying way. They are empty and useless except for their surreal humor, their decorativeness as paper statues, and the explosive fun of blowing them up.

The child sits next to a fecund pre-Hispanic Nayarit figure that seems fertile but is really utterly powerless, having no feet to carry her. (Frida was again plagued by trophic ulcers on her foot at this time, and required medical attention.) The ironic skeleton lightly nods his wire neck and laughs at Death. He is a *calavera*, another favorite toy of the Mexicans. Skulls, too, are treasured, often made of sugar, and eaten on the Day of the Dead on November 2nd. Frida loved these and was the photographed with one with her name emblazoned upon its brow (page 125).

The figure riding into the painting from the right is a *piñata*, another traditional Mexican toy. It is made of straw, and is customarily beaten by children with long sticks until it bursts open to reveal innards of candy. Perhaps Frida is questioning the durability of men's love in this picture. To

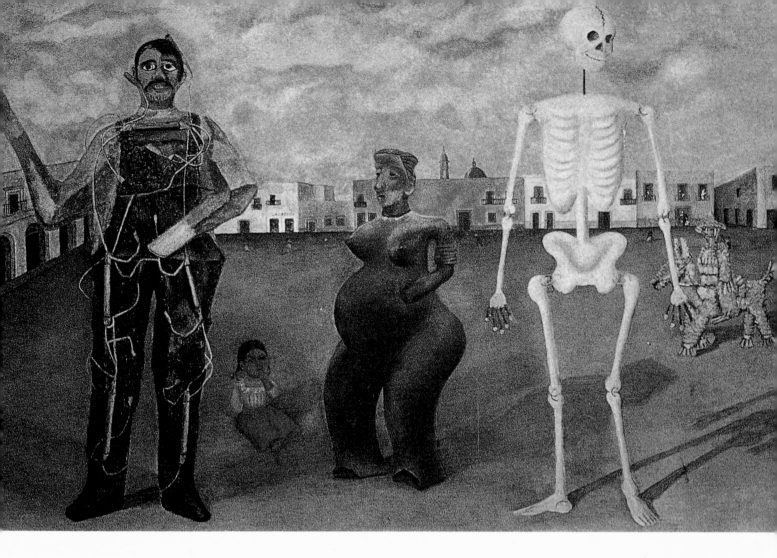

The Four Inhabitants of Mexico, 1938.
*Oil on wood panel,
12¼" x 18 ¾".
Private Collection,
Palo Alto, California.*

Calavera figure, papier-mâché and wire coat-hanger.

*Hand-cut paper
skeletons celebrating
Day of the Dead, Taxco.*

her cynical eyes, men are ephemeral creatures, made of paper, straw, or sugar and ultimately insubstantial. Is Frida's knight in shining armor only made of straw? Are men empty, full of bluster, noise, and fire?

There is some evidence that Frida lost another child at this time, but whether through abortion or miscarriage is unclear. She is probably referring to this death in her depiction of the pregnant figure. At this time, she also painted *The Deceased Dimas*, a portrait of Dimas Rosas, the three-year-old godson of Diego. It is ostensibly a tribute to the dead child and to the long-standing Mexican tradition of postmortem portraiture. Frida owned a picture of this type, but her own interpretation shows the child with a trickle of blood running from his open mouth. The child's eyes are milky and unseeing. It is a terrible image of loss.

By the end of the 1930s Frida had begun to achieve some critical and material success. In 1938, on Diego's urging, she entered her pictures into a mixed show for the first time, and they were noticed. Soon after this she made her first, important sale—of four pictures at $200 each—to the movie star Edward G. Robinson. Her self-confidence was boosted even further by an offer from a New York dealer, Julien Levy, to give her a one-woman show in the autumn of 1938. She was painting prolifically and well. The French Surrealist André Breton had visited the Riveras during the same year and told a sceptical Frida that she was definitely a Surrealist herself. He loved *What the Water Gave Me* (page 99) and invited her to put on a show of her work in Paris, offering also to write the catalogue for her New York show. He described the essence of Frida's work when he wrote the oft-quoted phrase about her work being "a ribbon around a bomb."

A bizarre group including the Trotskys, the Riveras, and the Bretons took a trip together to the marvelous town of Pátzcuaro, in Michoacan, where Frida finally grew bored with Trotsky's sententious speeches on Life and Art. She played a silly game with Jacqueline Breton that she loved all her life. It seems to sum up her relation of mind-self to body-self. It is called *Cadavre Exquis,* or Exquisite Corpse. Each player draws a section of the body, folds it over and passes it on. Frida's contributions were invariably obscene.

New York was a personal triumph, even if the critics were patronizing about her work, calling her "Diego Rivera's German-Mexican wife" and "Little Frida." Diego had sent Frida off to New York armed with a guest list for her show,

Straw crucifix from Patzcuaro Michoacán.

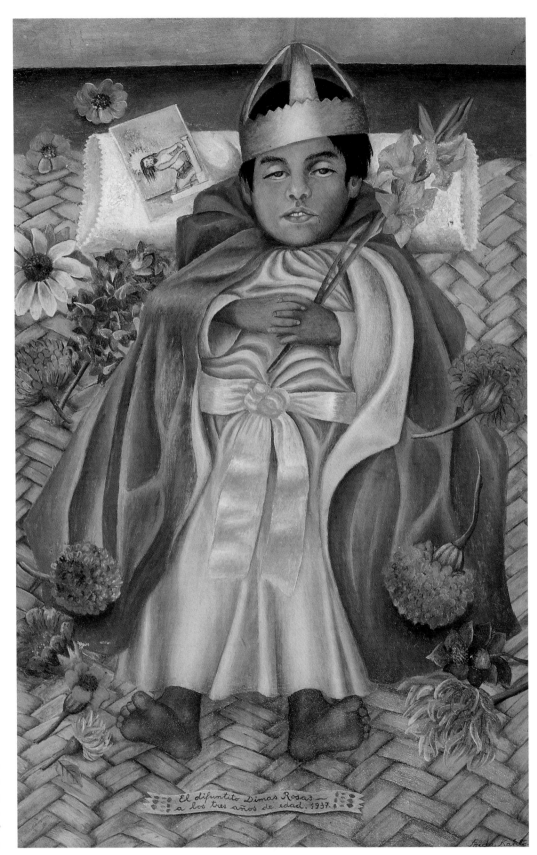

El difuntito Dimas Rosas —
a los tres años de edad. 1937.

Frida Kahlo

**The Deceased Dimas,
1937.**
*Oil on Masonite,
19¹/₆" x 12³/₄".
Dolores Olmedo
Collection, Mexico City.*

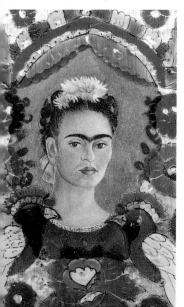

ranging from museum curators to millionaires, that would make the most successful social climber green with envy. She was seeing several other men at this time and felt empowered and out from under Diego's once-more-gigantic shadow. She sold quite well, though not as well as she later pretended. *Tunas; My Parents, My Grandparents, and I (page 58); Fulang-Chang and I;* and *What the Water Gave Me (page 99)* were among the paintings sold, and she received some important commissions. She was enjoying herself, immersed in a love affair with the Hungarian photographer Nickolas Muray, missing Diego, but feeling psychologically stronger than ever. Her right foot was still a problem, and walking any distance was painful for her spine, too. Diego wrote her supportive letters at this time, signing himself affectionately her "No. 1 Toad Frog."

In January 1939 Frida set off for Paris. She stayed at first with the Bretons, sleeping in the same room as their daughter, which was difficult for someone who cherished her privacy. She quickly lost her patience with the Parisians, and profanity crops up again and again in her correspondence. She moans about Breton, the "S.O.B." who had organized the show. She hates the Surrealists ("coo-coo lunatic sons of bitches"), and the sour tone of her visit seems to set in from this inauspicious start. She became ill with a kidney infection in "vile" Paris. Her views were forthright as always. "I'd rather sit on the floor of the market of Toluca and sell tortillas, than to have anything to do with those artistic bitches." But she did make some friends. Picasso liked her very much and gave her the Surrealist hand earrings worn proudly in the *Self-Portrait Dedicated to Dr. Eloesser and Daughters* (1940). She knew and liked Marcel Duchamp, too. The show, called *Mexique,* was not a success, though the self-portrait *The Frame* was bought by the Louvre. Frida sat uncharacteristically quietly in a corner at the opening of the show and turned off her charm. She wore her wild Mexican clothes, which inspired Elsa Schiaparelli, the great Parisian designer, to design a gown, *Madame Rivera* (not *Frida Kahlo).* Her hand, covered with rings, was featured on the cover of French *Vogue.* Her impact on Paris in 1939 seems to have owed more to her fashion sense than to her art. And indeed, nothing has changed—*Vogue, Elle,* and interior decorating magazines frequently run features on the *beau idéal* of the Frida Kahlo style today.

But 1939 was a terrible year for Frida Kahlo and for the world. The Republicans in Spain were defeated, and Hitler

Self-Portrait Dedicated to Dr. Eloesser and Daughters, 1940.
Picasso gave Frida these marvelous, surrealist earrings on her trip to Paris in 1939. She shows herself as a martyr, dedicating the picture to "my doctor and my best friend with all my love." During this period, Frida was separated from Diego and her life felt as though it were nipped in the bud, cut off at the hands and chopped in two. This is literally what she has painted. Where in some pictures, the vegetation reaches far beyond the confines of the edge, she has cut off the twigs abruptly here and a pink, slightly nauseating, headachy sunset looms behind her flowery headdress. Oil on Masonite, 23½" x 15¾". Private Collection, U.S.A.

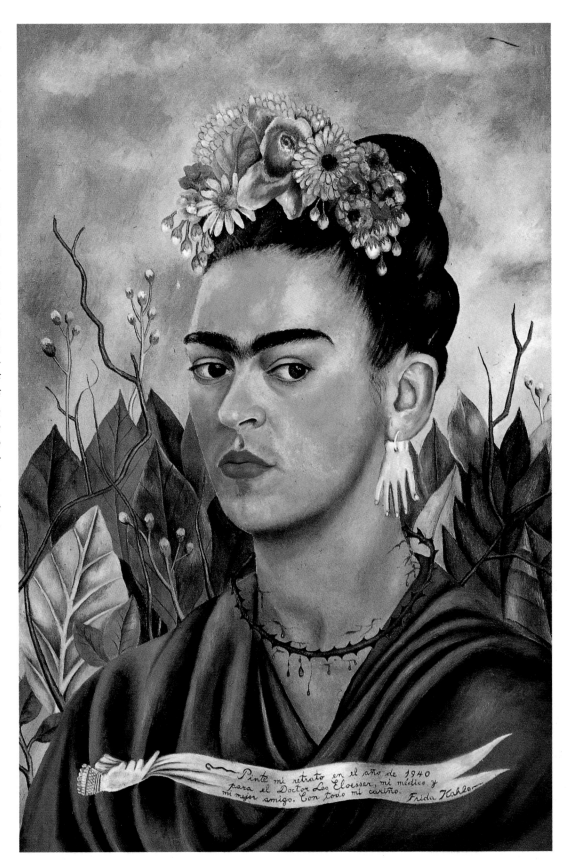

invaded Poland. Another war of sorts awaited Frida at home. She returned in April to find Diego pleased to see her but wanting a divorce. She was stunned, and could not understand his reasons, which are still unclear today. When asked about this now, their friends tend to smile sheepishly and shrug their shoulders as if to say, "You know...Diego...." Although Frida had been deeply in love with Muray, she had never imagined that Diego would be put out by this infidelity. After all, he was carrying on quite publicly with Paulette Goddard, the Hollywood star. Frida was shocked and mystified, but she gave him his divorce. Diego was uncharacteristically cruel over it. When asked the reason for the divorce, he gave an extraordinarily facetious answer. Bertram Wolfe, his biographer, had just written a eulogistic book containing the lines: "Diego grows more and more dependent upon his wife's judgement and comradeship...." At the party celebrating his divorce, Diego told a friend, "Tell Bert that I have divorced Frida to prove that my biographer was wrong." Ella Wolfe told me in 1985 that she and Bert were both very upset by this strange display of macho bravado.

Frida painted *The Two Fridas, Self-Portrait with Thorn Necklace and Hummingbird* (page 116), *Self-Portrait Dedicated to Dr. Eloesser and Daughters* (page 109), and *Self-Portrait with Cropped Hair* (page 112) at this time. All are desperate pictures. Thorns dig into her "martyred" flesh, and death lurks in the form of a dead hummingbird. In *The Two Fridas*, Frida sits with her alter ego holding her hand. The "Indian" Frida on the right clasps a tiny photograph of Diego as a boy. Her heart is whole, and pumping with blood. The other, "Colonial" Frida in her Spanish, high-necked blouse, is bleeding, unable to staunch the flow from her wounded, sliced heart. The purity of the white gown is sullied by the blood of miscarriages and the abortion of Diego's babies. Frida seems very alienated in this picture. Not only does she feel herself to be exposed, but she is unsure *who* she is, without Diego, whose image sits in her lap like an embryo. It is as though her personality has multiplied like the first cells of a fetus. She had a large collection of textbooks on midwifery, obstetrics, and gynecology in her library, and later she aquired a real human fetus preserved in formaldehyde and kept this small failed life in her studio, as if to remind herself of her body's own failure.

The *Self-Portrait with Cropped Hair* is a vengeful picture. She holds the scissors in front of her genital area with intent, in fantasy, to maim her betraying husband, whose

The Two Fridas, 1939.
*Oil on canvas, 67" x 67".
Collection of the
Museum of Modern Art,
Mexico City.*

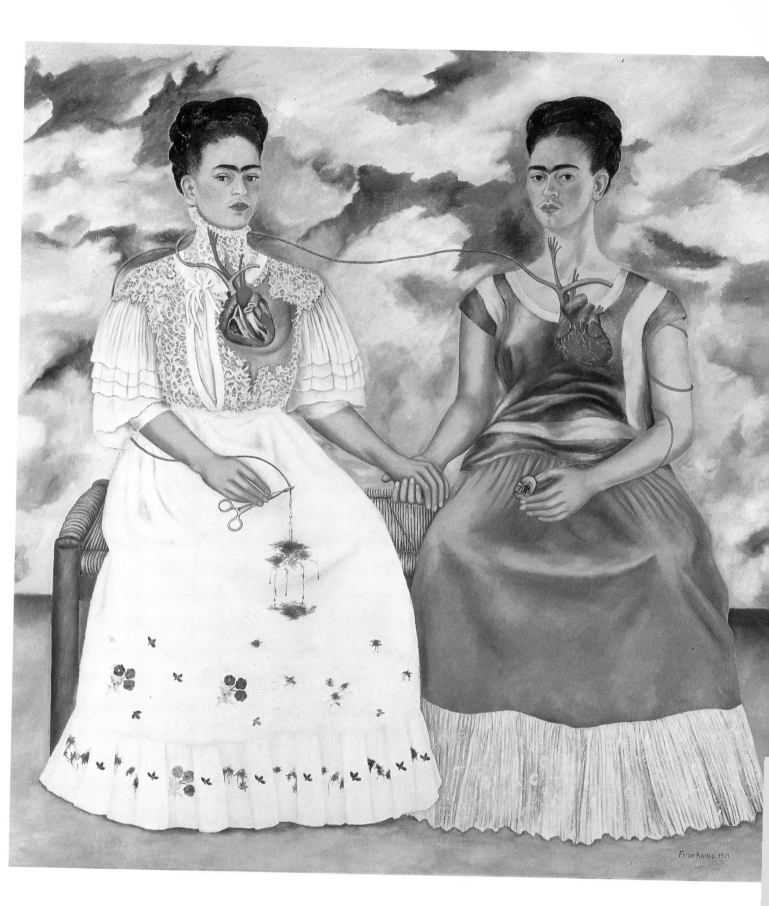

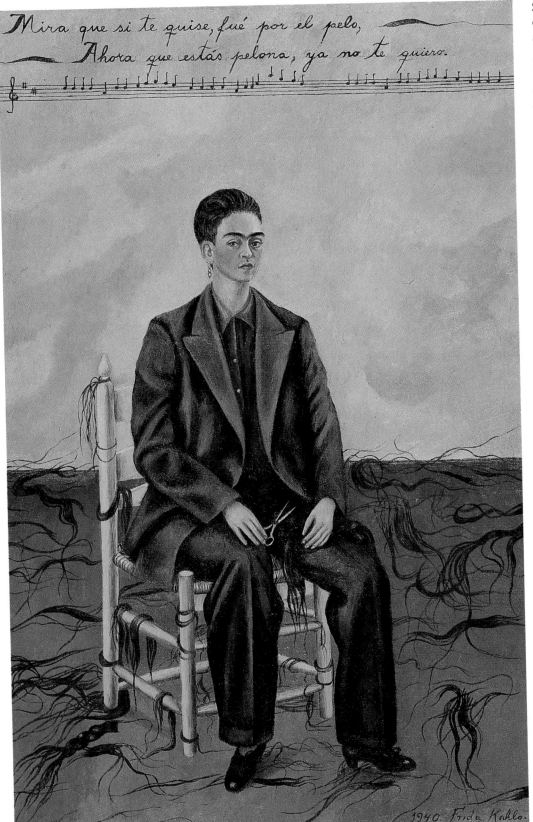

Self-Portrait with Cropped Hair, 1940.
Oil on canvas,
15¾" x 11".
The Museum of Modern Art, New York. Gift of Edgar Kaufmann, Jr.

enormous suit she wears. The words, set to music, read: "Look, if I loved you, it was for your hair. Now that you are bald, I do not love you anymore." Her hair had clearly been a source of her own feelings of sexuality and strength from her earliest days. She adored it, spending hours plaiting it and braiding it with flowers. Here, it is all over the floor, like spilled blood. She looks out of the painting at Diego with a slight smirk on her face. He, too, loved her hair, and now, like him, it is gone. She has become a man without her man. (I once saw a strange homage to Frida. In 1985 I came upon it looking for the fresco by Diego that is hidden away in the San Francisco Art Institute. It consisted of a yellow chair, and strewn about it were pieces of human hair. It was truly gruesome. Frida would have loved it.)

Frida was now considered to be a Surrealist in art circles, but it was merely a handy tag and her work never really fit the Surrealist manifesto, which took its cue from Apollinaire. Breton redefined it as, "Pure, psychic Automatism, by which it is intended to express verbally, in writing or in any other way, the true process of thought. It is the dictation of thought, free from the exercise of reason, and every aesthetic or moral preoccupation." This has little to do with Frida's approach, which is predicated on moral preoccupation, but it didn't stop the critics from branding her bizarre, post-Freudian paintings with this label. She was to say: "I hate Surrealism I never painted dreams, I painted my own reality."

In September 1940, Frida was having problems with her health again, no doubt exacerbated by the large amounts of alcohol she was consuming. The Mexican doctors she consulted gave her a variety of reasons for the pains she complained of in her back. She was told that she had tuberculosis and that she must remain in a corset, in traction, for three months flat on her back. She did this. "I got scared that I was sure that I was going to die."

Diego was in San Francisco, painting a mural (now in City College) for the International Exposition (page 55) and avoiding the suspicions of those who thought that he had been involved with Trotsky's assassination in August. He was having public doubts about his Trotskyite heresy by this time, and wanted desperately to be readmitted to the Mexican Communist Party, which was firmly Stalinist.[1]

[1] The following February, he unsuccessfully petitioned for readmission. He was to reapply again in 1946, 1949, and 1952, and was finally readmitted on September 25, 1954, two months after Frida's death. Frida herself had been reinstated, to her great pleasure, in 1949. A portrait of Stalin was on her easel when she died.

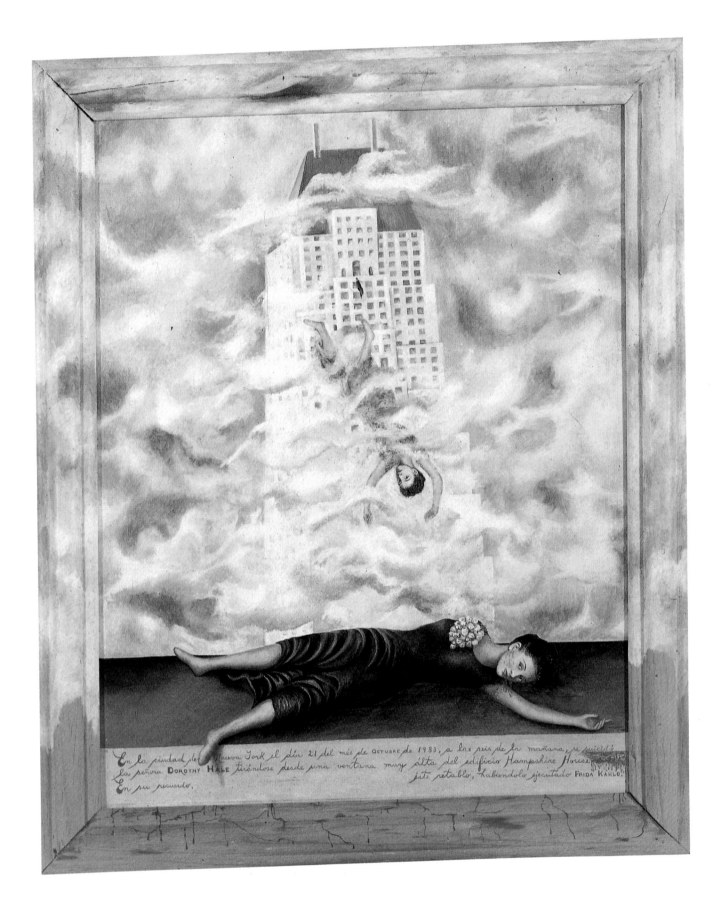

En la ciudad de Nueva York el día 21 del més de Octubre de 1938, a las seis de la mañana, se suicidó la señora Dorothy Hale tirándose desde una ventana muy alta del edificio Hampshire House. En su recuerdo. éste retablo, habiendolo ejecutado Frida Kahlo.

Frida, back in Mexico, was in contact with her old friend Dr. Eloesser in San Francisco. He wrote to her and invited her to join Diego in California, where she would benefit from the most up-to-date medical knowledge. He also told her that Diego still loved her, and admonished her to "accept the facts the way they are" regarding Diego's promiscuity. He was expressing his concern about the quality of medical advice available to Frida in Mexico—and playing Cupid at the same time.

She flew to San Francisco and was put into the hospital for a month for tests. She was found to have osteomyelitis and a "crisis of nerves," but there was no evidence of tuberculosis. In the hospital, she began a passionate love affair with the young art collector Heinz Berggruen, who had been introduced to her by Diego and who had taken to visiting her as she recovered. Berggruen's impression of the relationship between Frida and Diego was entirely negative, and he sensed—perhaps self-servingly—that they were deeply unhappy. When she was well again, Frida went off on a jaunt to New York with her new lover. But the affair was short-lived and came to an end when she accepted Diego's renewed proposal of marriage. They remarried on December 8, 1940. It was a Sunday and Diego's fifty-fourth birthday. The groom went back to work on his mural later in the day! Two weeks later, Frida returned to Coyoacán, to the Blue House. She was very optimistic—it seemed that a new life was starting for these battle-scarred warriors in love.

The second marriage, in 1940, of Frida and Diego, which took place in San Francisco. Photograph Instituto Nacional de Belles Artes, Mexico.

Self-Portrait with Thorn Necklace and Hummingbird, 1940.
*Frida sold this picture to an important person in her life—the Hungarian photographer Nickolas Muray, who was her lover at this time. She looks out of the picture with slightly rheumy eyes, as if she has recently wept, and her pet monkey Caimito de Guayabal and her cat sit on her shoulders like twin aspects of her soul. Both animals connote sexual promiscuity and depravity, and the hummingbird impaled upon the necklace of thorns is the fabled tzintzuntzan of the pre-Hispanic peoples, the mythical reincarnation of dead soldiers. The cat seems to want to lunge at the bird, but we know the poor creature is dead already. The fruitlike dragonflies seem to be the product of some unearthly congress between animal and vegetable, and the butterflies evoke the mythical holy papalotl of the Aztecs.
Oil on canvas,
24¹/₂″ 18³/₄″.
Iconography Collection, Harry Ransom Humanities Research Center, University of Texas, Austin.*

CHAPTER 6

DEATH AND LAUGHTER

The Last Years

Frida's new marriage had all of the problems of the old one. Diego was his habitual goatish self, and her health problems were still grave. Every day brought more depressing news from Europe, which dragged their spirits down. Frida had stipulated to Diego that their new marriage would be founded on more egalitarian principles, and they would be like two comrades living together in her Blue House. Diego had designed and commissioned a large new studio extension for her and built an amusing *echt*-pre-Hispanic pyramid in the garden for her pleasure. She would live here in peace, in her birthplace, and he would work and see his friends (both male and female) in the privacy of his old pink studio at San Angel. They would share the household expenses now that Frida had a moderate amount of her own money from sales, but the marriage bed would not be shared. Frida said that she was unable to sleep with Diego because of all the "images of all (his) other women flashing through her mind." Diego seems to have accepted this—at least at first. He was prepared to agree to anything to have her back. However, it is doubtful whether this agreement lasted very long. Friends of the couple speak openly about what seemed a perfectly normal marriage from the outside, and delightful home movies made at this time show two people who are physically involved with one another. The tender love with which Frida strokes Diego's brow and kisses him and his visible rapture show affection expressed freely and generously.

Despite the war, illness, and marital stresses, life was reasonably content. In a typical day, Diego worked in his studio at San Angel in the morning, and joined Frida for lunch at Coyoacán. Their meal was usually a steaming plate of fresh

"Oh Valentin, Valentina I too know how to die. But if they're going to call me tomorrow, Why don't they kill me now?"

MEXICAN POPULAR SONG

tortillas, with an avocado *guacamole*, and the corn specialty *huitlacoche* accompanying a dish of meat. After lunch, Frida sat in the garden, drank, and desultorily smoked before her siesta. Diego would return to the studio, where he remained until evening. When the working day was over he'd return home to Frida to eat the traditionally light evening meal of *pan dulce* and hot chocolate. She would sit and smoke endless cigarettes. They would go out, often without the other, to spend the evening in their own chosen ways. There was a mutual acknowledgement that they were together now, but separate. Frida liked boxing matches and going to the movies. She loved to listen to the romantic, sentimental ballads of the local *Mariachi* singers, singing along with them in her lovely voice. Diego, on the other hand, preferred classical music and work, work, and more work, interspersed with the occasional sexual dalliance. They had reached a period of mature accommodation. Frida

Still-Life, 1942.
Frida's patrons were not always pleased with the blatant sexuality of her still-life paintings, which were often commissioned to adorn the walls of elegant Mexican dining rooms. One such painting, the tondo known as the Still-life of 1942 was commissioned by Mrs. Camacho, the President's wife, and rejected because the fruit and vegetables depicted assume the unmistakable forms of the human body—male and female—and are blatantly designed to disturb the viewer with their aggressive vulvic and phallic symbolism. 24³/₄" diameter (tondo). Frida Kahlo Museum, Mexico City.

would tease him now about his proclivities, rather than crumble into despair. She had other fish to fry. She had friends and lovers. Diego, too, was a cherished friend now, and sometime husband, but no longer the intense focus of her innocent, youthful dreams.

Frida painted prolifically, too. She wandered around the street markets in her long Indian skirts, limping slightly, looking for subjects, chatting to the stall holders, whom she knew well and to whom she was personally very generous. They loved her, and she was curious about their lives, which made her many friends. She was enthralled by family arguments and dramas, and playfully indulged her love of gossip. She liked the market life, the haggling, the noise, and the pungent, blended perfume of corn dough, chilies, and fresh coriander that is the hallmark—even today—of the typical Mexican market. She adored the brilliant artistry of the crafts lying at her feet: the toys, curios, dolls, and bits of folk art that she collected by the hundreds for her home.

Going to the market almost anywhere in Mexico is still one of life's greatest incidental pleasures. Walking into a Mexican market is like walking into a painting. Everything is arranged superbly by the stall holders, with a casual nod to symmetry and oozing a natural elegance of composition. Fruit is carved into delicate flowers for the delectation of the shopper. Many different kinds of bread steam fragrantly in colored baskets from Oaxaca. Nature seems endlessly abundant. A pyramid of yellow papayas, red mangos, orange guava, and green limes is one of the visual wonders of this world—a sight for sore eyes. Even plastic looks appealing. The vibrant crimsons, zingy pinks, and dazzling blues of plastic buckets stacked high are bright enough to awaken the dead.

Frida loved all this. She would buy anything from fresh flowers to pottery, toys for her sister's children and for herself, and trinkets for the Blue House. This soon became a work of art in its own right, and almost like a child to her. It was alive with the wild sounds of the countless animals she

Candelabra—ceramic, Adam and Eve, Puebla.

119

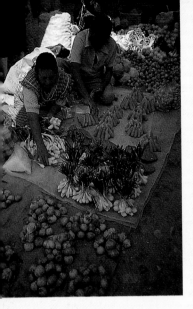

Market in San Miguel
Allende.

Market at Oaxaca.

Market at Patzcuaro.
Photographs by Robin
Richmond.

Mexican still-life.
Photograph by Alex
Saunderson.

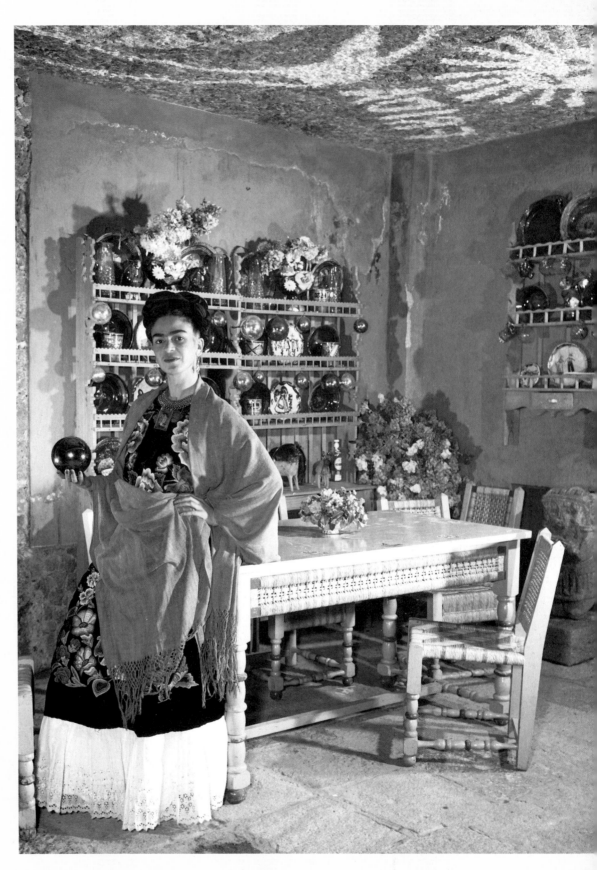

Frida standing in the kitchen of the Blue House. Photograph by Juan Guzman, courtesy of Arturo García Bustos.

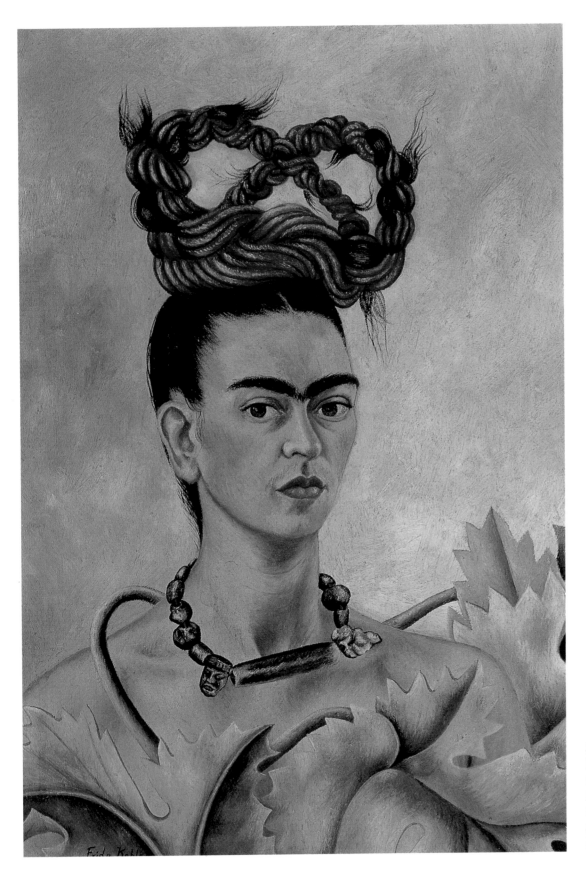

**Self-Portrait with
Braid, 1941.**
*Oil on canvas,
20" x 15¼".
Collection Jacques
and Natasha Gelman,
Mexico City.*

collected. The lovely garden, filled with cacti of *every* variety, was a jungle for her beloved pet monkeys, Fulang Chang and Caimito de Guayabal; a hairless Aztec *ixquintle* dog, Señor Xólotl; countless doves and parrots; her delicate fawn Granizo; and an eagle which rejoiced in the name of Gertrudis Caca Blanca (Gertrude White Shit). The couple's mutual passion for *Mexicanidad* was given full sway in their new home, and the house was a marvel of riotous colour.

The kitchen was particularly wonderful—and still is—with its festive array of pots and its yellow, blue, and white tiles. The floors were simply covered with straw mats known as *petates* and brilliantly painted with an indigenous yellow paint called *polvo de pongo*. The house was a miracle of serendipity; a real blend of art and culture, both sophisticated and simple. Everyone loved it. They couldn't stay away.

Frida's much-loved father, Guillermo, died, aged sixty-eight, the summer after her return. Her sense of stability took a great knock, but she managed to overcome her grief. She is extremely stoical in a letter to Dr. Eloesser written at the time. Unlike her feelings about her mother, there seemed to be less confusion in her feelings towards her father, so Frida was able to incorporate this death more calmly. Her grief was certainly deep and strong, but at least it seemed clear to her. Death often occupied her thoughts, and over the next three years she painted a series of self-portraits that transform the subject in various forms. She painted *My Parrots and I,* the *Self-Portrait with Braid* (probably made from the hair she had cut off the year before), *Diego in My Thoughts (page 14), Thinking About Death,* and many others. It seems as though being made an adult orphan was a sort of liberation to her. Her relations with Diego were no longer so dependent, either, and she felt more autonomous. In *My Parrots and I,* she looks terribly powerful. The birds grip her slim, white shoulders with their sharp, rapacious-looking talons, but she stares out at herself—and us—with a cool, brazen look, a lit cigarette in her beringed hand.

However, Frida's health began to deteriorate over the next few years. Although full of *allegría*—that indefinable sense of infectious fun that endeared her to most people, from her extended family to her servants, friends, and eventually her students—she was forced to spend an increasing amount of time in bed. Her back pained her dreadfully and she experimented with a variety of plaster orthopedic

corsets to hold her spine firm. She would decorate them with the same devotion to detail found in her easel pictures. One was decorated with a fetus. Another corset was decorated with the Hammer and Sickle. She must have looked marvelous in this! One corset sits on her bed at the Blue House today. It is a moving, sad and *eerie* husk left behind by the noisy, vibrant person it once entrapped. *The Broken Column* (page 21) comes from this period.

Until shortly before her death, when she was just too weak to manage, Frida never stopped her ritual act of dressing up in elaborate Tehuantepec and Oaxacan costumes, which still hang in the cupboard at the Blue House for visitors to admire. Her "masquerade" of dress and *maquillage* was a source of pure physical pleasure to her, according to her friends. It was part of her personal drama, her production of herself for her own enjoyment. Doubtless it gave a carapace of definition, an outward shell to her inner feelings of uncertainty. In her glorious clothes she looked whole and confident. Underneath them, she must have felt contingent and vulnerable. She was so obviously *not* the Aztec queen she liked to pretend she was, limping as she did on her shriveled right leg, captured in an orthopedic corset, missing five joints on the toes of her right foot, amputated in 1934.

On November 2nd, the Day of the Dead, gifts of skeletons and sugar skulls are exchanged between friends and family. It is a day of celebration rather than mourning, when the dead are fêted and remembered fondly. Sugar skull, 1950s, (left). People give these outrageously decorated confections to one another as gifts on the Day of the Dead. Sometimes, the skull has the recipient's name inscribed upon its brow. Trotsky was not a bit amused when, on November 2, 1938, Diego gave him a skull with Stalin's name on it.

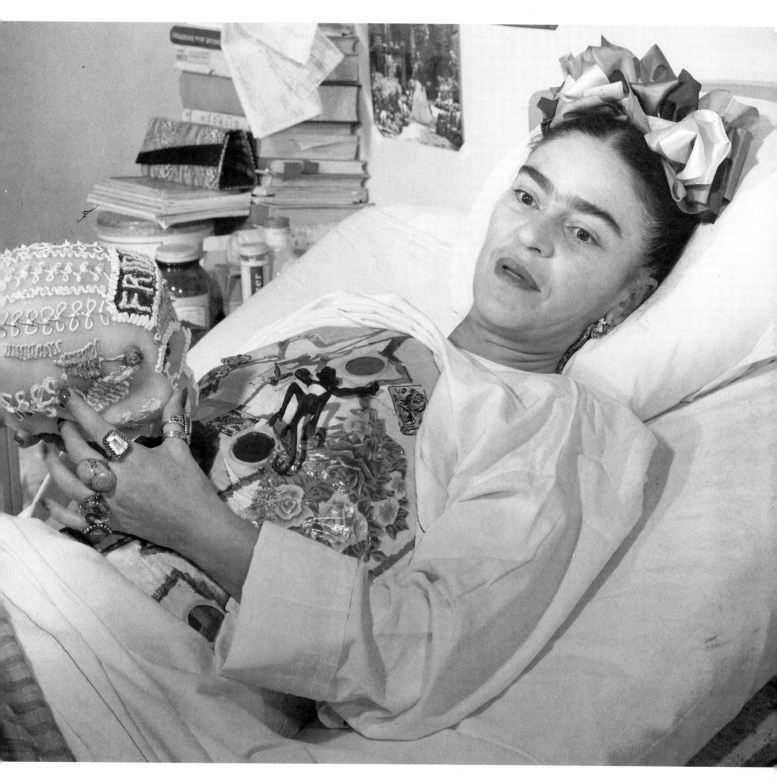

Frida in the hospital holding a sugar skull. Photograph by Juan Guzman, courtesy of Arturo García Bustos.

Self-Portrait with Monkey and Necklace, 1938.
The theme of connection and disruption in Frida's work is very clear here. Fulang Chang's beady eyes stare impassively from beyond her right shoulder. He is bound to her by a ribbon of slimy green, but of his own volition. His proprietary paw snakes around her long, muscular neck in a gesture of willing bondage. Her own enthrallment to her injuries is emphasized by her sinuous necklace, which seems to choke and adorn simultaneously. Her eyes glare with glacial impassivity as though in proud denial of the claustrophobic vegetation that threatens to engulf her.
Oil on Masonite, 16" x 12".
Albright-Knox Art Gallery, Buffalo, New York. Bequest of A. Conger Goodyear, 1966.

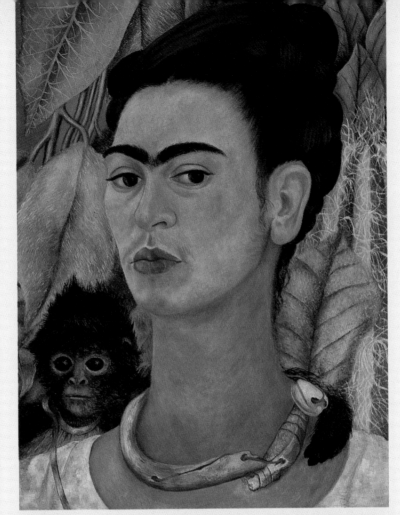

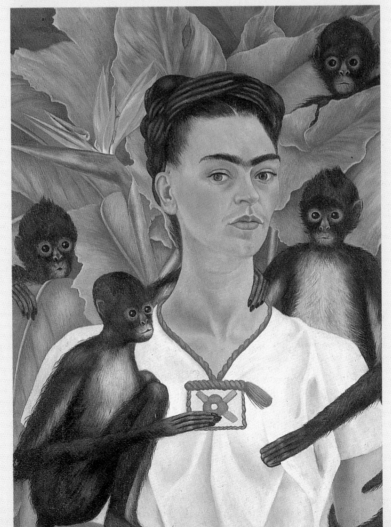

Self-Portrait with Monkeys, 1943.
This picture shows us Frida as the sexual victim. Her pet monkeys encircle and cling to her. The Bird of Paradise flower to the left of her head opens itself to the air in a voluptuous parody of sexual abandon.
Oil on canvas, 32 1/3" x 25 1/6".
Collection Jacques and Natasha Gelman, Mexico City.

Self-Portrait with Small Monkey, 1945.
Frida uses a favored device of winding ribbon to link and identify herself with her environment. It hangs about her neck loosely, but conveys a premonitory anxiety. One sharp tug and she might choke on her own life. Her face has aged, and there is a hint of grayness at her temples. She places herself at the center of her past and present, umbilically tied to her "babies," her pets. The slightly sinister crouching terra-cotta idol is a symbolic nod towards her cherished Indian roots.
*Oil on Masonite,
22" x 16¼".
Dolores Olmedo Collection, Mexico City.*

Self-Portrait with Monkey, 1945.
The psychological terrain that Frida negotiates as an artist, oppressed by heavy, painful burdens, is a dense and steamy place. In a metaphor for depression that is instantly recognizable, her pet monkey clings to her queenly bodice with tiny possessive paws, gazing out at us with hostile, empty eyes. The claustrophobic, truncated vegetation that meanders through her personal, jungle landscape here appears dead and dry; no nourishment remains in the world inside the frame.
Robert Brady Museum, Guernavaca, Mexico.

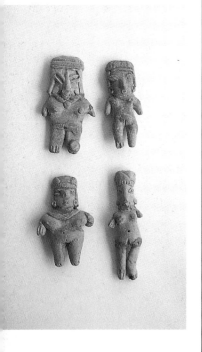

Ceramic figures, c. 1500 B.C. Chupícuaro, Michoacán, 4" tall.

Her dress was not the "political project" ascribed to her by certain critics. They misunderstand the nature of Frida's life and work when they operate a personal agenda, writing about her in such terms as: "The patterns of resistance and connivance in her marginalization help to situate the effects of trajectories of the Modern in a way different from the usual foci on either a modernist paradigm or one purposely standing for realist opposition" (Terry Smith, *Block,* 1983). This seems to have little to do with the Frida who liked nothing more than to debunk mystification. She was an irreverent High Priestess of Art, cloaked in magical raiments, who giggled behind her mask and fidgeted under her robes. She laughed at the intellectual puritanism of others, and was faithful to her own image—some would say *too* faithful.

Her long day at the Blue House began with a personal beauty ritual that many feminists today would find politically very incorrect. Her levée was like that of the Sun King, though aided only by a maid, rather than dozens of flunkeys. She would sit up in her canopied bed, even if she were going to remain in it all day, and surround herself with *things.* There were photographs of her loved ones; portraits of Lenin, Stalin, Mao, Engels, and Marx; her diary; fresh flowers; paint; and mirrors. There was a life-size papier-mâché skeleton whom Diego referred to as her "lover" lying on the top of her canopy bed. She would perfume herself, paint her face, apply lipstick and do her bright red nails, braid her hair with flowers and ribbons, and prepare herself for the stream of visitors. When she wasn't entertaining, she painted pictures.

Diego did not spend much time at the Blue House. He was deeply involved in his painting, and in 1942 had begun the construction of *Anáhuacalli,* his temple of pre-Hispanic art built on Frida's land in the Pedregal district, which stood on the lava beds near Coyoacán. Diego had been obsessed with this ancient period of his country's art all his life. He had always spent what little money he had managed to save on purchases of "idols," as Frida called them. These archaeological artifacts form a very important collection. They were so great in number that they required a museum to house them. He began construction on his strange, dark, gloomy mausoleum, and it progressed in fits and starts. Frida loved the idea of *Anáhuacalli.* She compared Diego's efforts to bring the pre-Hispanic era to the twentieth century to the Aztec goddess Coatlícue, saying the ambitious project had the essence of the famous dualistic goddess—encapsu-

Frida and Diego's garden at the Blue House, Coyoacán (right). Frida's bed and crutches (below right), and her studio (below left). Frida Kahlo Museum, Mexico City. Photographs by Robin Richmond.

lating both life and death in its scope. Little did she realize that this would prove truer than she thought. *Anáhuacalli* would not be completed until 1964—seven years after Diego's death.

Frida began teaching in 1943 at the Ministry of Public Education's new school of painting on Esmeralda Street. She was a very popular and accessible teacher, arriving for classes in all her customary finery—bejeweled, swathed in a *rebozo* and an embroidered *huipil*. Her students were drawn mostly from poor working-class families, who had never seen as brilliant or eccentric a personality as Frida and marveled at her like some exotic butterfly or hummingbird. These teenagers were given free art supplies and the tutelage of some of Mexico's finest artists and art historians at *La Esmeralda,* as it became known. Ill health forced Frida to give up the teaching at the school after only a few months, but she continued to teach four of her best students at home at the Blue House, and these four became known as *Los Fridos*. In 1943, she supervised a mural that they painted on the walls of the *Pulqueria La Rosita*, a tavern in Coyoacán. A year later, they all cooperated on another joint project.

These four artists were to become Frida's heirs. One of these young people was Arturo García Bustos, who remem-

"La Maestra" Frida Kahlo with her young student, "Bustitos", c. 1944. Photograph courtesy of Arturo García Bustos.

Diego Rivera with his assistant, Rina Lazo, 1955 (above). Diego and Rina painting together (right). Photographs courtesy of Rina Lazo.

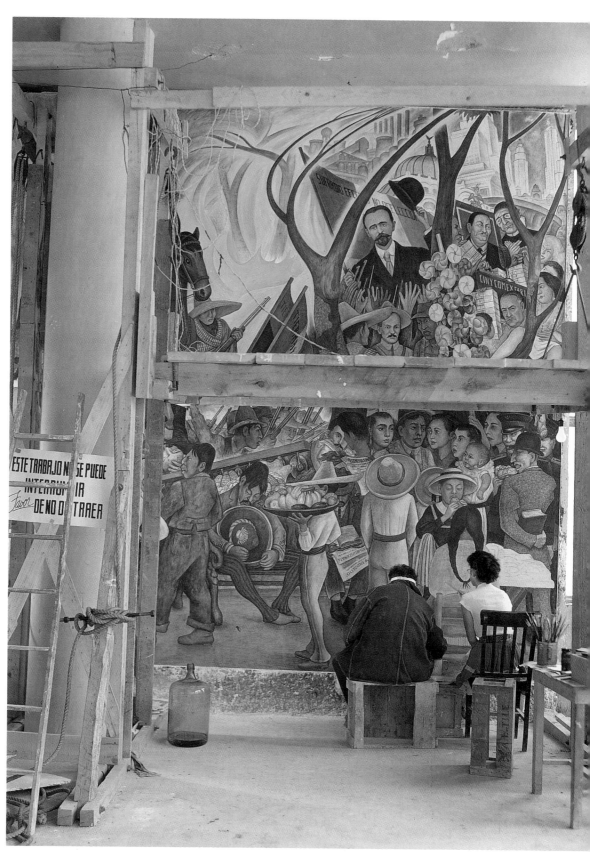

Rina Lazo,
**Bananas and
Watermelons in the
Window.**
*Oil on canvas. Courtesy
of Rina Lazo.*

bers his *Maestra* Frida Kahlo today with the deepest affection and respect. He was the grandson of the very great nineteenth-century Mexican painter Hermenegildo Bustos, but his own career as a muralist and easel painter was nurtured by Frida like a mother hen with a chick. Never able to have her own children, she was actually capable of immense tenderness towards other people's youngsters. Arturo's face still lights up with pleasure when he speaks of her sense of poetry and her delightful, amiable personality. Her generosity as a teacher seems to have transcended the normal bounds of what most teachers are prepared to share with their pupils. She had no snobbery, she was utterly unshockable, and she was completely *autentica* with her little eighteen-year-old *Bustitos*. Arturo was to meet his future wife through Frida. Rina Lazo, the Guatemalan painter, was assisting Diego at this time, and the four of them would often sit together after a hard day's work in their respective studios and play a riotous game of Exquisite Corpses. Rina and Arturo often reminisce about the complicated relationship between Diego and Frida. They feel that these two great icons of recent Mexican cultural history have been much misunderstood and misrepresented. They say that the *Maestro* was *La Maestra's* "greatest admirer."

In the mid 1940s, Frida spent four months in bed with spinal problems, fatigue, pain in her right leg, and a fungal growth on her right hand that would not heal. She painted *The Little Deer* (page 134) about her predicament. She gave it as a gift to her friends Arkady and Lina Boytler with a poem that contains the following lines:

> *"I leave you my portrait*
> *so that you will have my presence*
> *all the days and nights*
> *that I am away from you."*

These lines tell us some of her reasons for painting so many self-portraits. If a person is doubtful about his or her identity—and hold on life—a self-portrait is a means of ensuring that one exists in the real world, and that this existence will live on in the memory of others. *I paint myself, therefore I am.* In Aztec mythology and iconography, the image of the deer stands for the right foot, and it was this part of Frida's body that was now full of pain.

In 1946, she went to New York with her sister Cristina for another elective operation—to fuse four vertebrae with a piece of her own bone and a metal rod six inches (fifteen

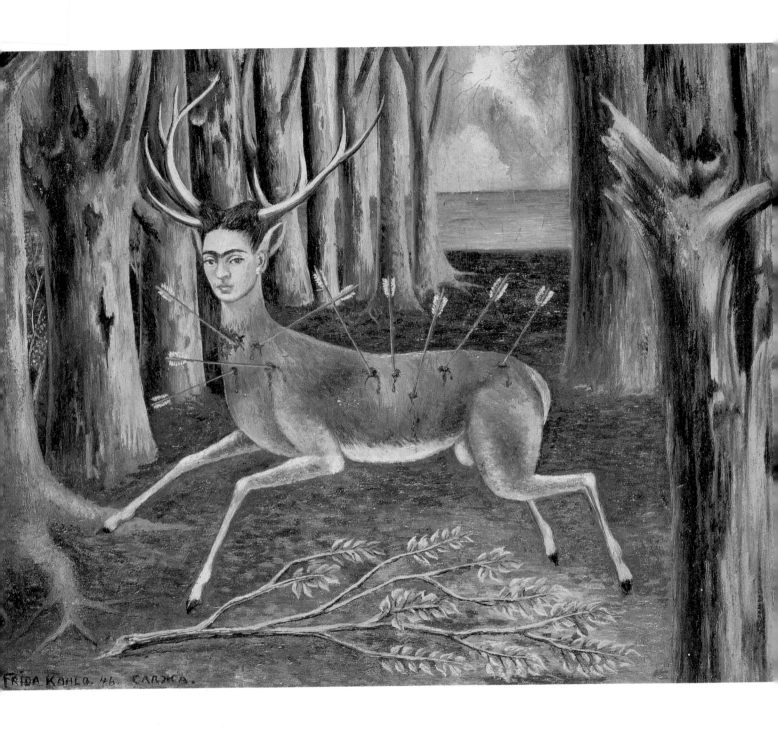

The Little Deer, 1946.
Oil on canvas,
8⅞" x 11⅞".
Collection of Carolyn
Farb, Houston, Texas.

centimeters) long. She spent two months in the hospital and was given morphine to alleviate the intense pain. When she returned to Mexico, she painted *Tree of Hope, Stand Fast* which refers directly to this surgery. The title comes directly from a folk song that she loved and sang often: "*Arbol de la Esperanza, mantente firme.*" After the surgery, she became depressed. The surgery was not a success, and had been, in fact, unnecessary. Her "calvary" began at this time. She was forced to convalesce in bed, and the ill effects of the operation forced Diego to pay her close attention. This may well have formed part of her unconscious goal. Her suffering had now put her beyond criticism. She stepped up her alcoholic intake at this time, and apparently began to dose herself liberally with painkillers such as Demerol. Diego was very worried about her, and as a consequence he was very good to her. He entertained her in her bedroom with inane songs in Russian and French, and he danced—all three-hundred pounds of him—with a tambourine. He was prepared to do almost anything to cheer her up.

But he, too, was exhausted. *Anáhuacalli* was proving to be an emotional and financial drain on him, and Frida's medical bills were enormous. He was painting—too much and too rapidly—and entirely to make money. This is always a depressing state of affairs for an artist. He also was spending his valuable time lurching from one infatuation to another. Frida was now fully resigned to this. She managed the paperwork in the household and had calmly marked a file, "Letters from Diego's Women." But the marriage came under the greatest stress during this period of Frida's acute illness when Diego began a very public affair with the famous Mexican movie star Maria Félix. Frida was heartbroken, for the actress had been a good friend to both the Riveras. Frida painted *Diego and I* (page 8) in 1949 during this threat to her happiness. In it, her hair swirls round her neck like malleable barbed wire, and she clearly feels trapped by her overpowering emotion. Diego is credited with a Third Eye, as though he sees beyond the skull, and perhaps he *did* begin to suspect around this time that Frida would never really get well. If he did, he kept this tragic knowledge to himself, but it must have been a heavy burden for him, despite the carnal consolations of beautiful companions.

In 1950, her doctor in Mexico, Dr. Juan Farill, decided that Frida needed another operation. He implanted a bone in her back at the British Hospital in Mexico City. This bone graft resulted in a serious infection, and Frida was forced to

"*Arbol de la Esperanza Mantente Firme.*"
Tree of Hope Keep firm.

FRIDA KAHLO

135

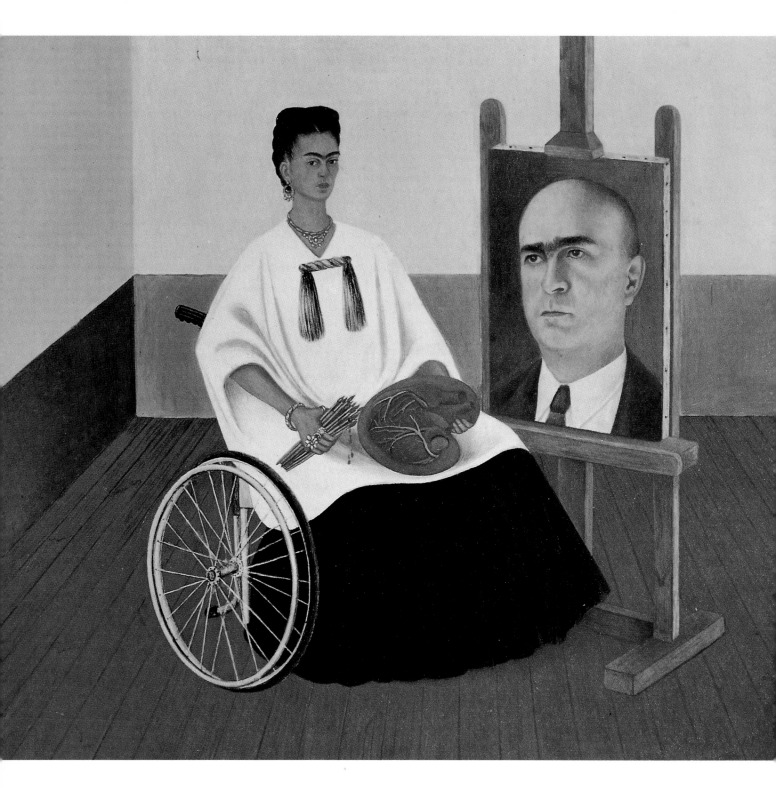

Self-Portrait with Dr. Juan Farill, 1951.
Oil on Masonite, 16½" x 19¾". Private Collection, Mexico City.

spend a whole year in the hospital, in and out of the operating theater. She painted the doctor's portrait in *Self-Portrait with Dr. Juan Farill*, using her exposed heart as a palette. Ironically, this year of trauma brought her even closer to Diego. He slept in the room next door to hers and they played together in the evening like children. During the day she was visited faithfully by her many friends, who brought her tidbits of gossip and little toys for her vast collection. Her room filled up with treasured possessions from the Blue House, and looked as little like a hospital room as could be arranged. She painted her face, her nails, and even pictures. Her mood was febrile and excitable, slightly hysterical. The Demerol had something to do with this. Later she would boast, as was her curious wont, of having spent three years in the hospital, not one.

Diego brought her flowers, movies, and even a Huichol Indian in full regalia to pose for her. Any attempt to keep up her spirits was gratefully received. Frida was thrilled to find that Diego had arranged a fabulous party for her much-awaited homecoming, which coincided with the tenth anniversary of their remarriage. She and Diego dressed in wedding finery, and they married again in front of their friends in a ribald parody of the real thing.

In April 1953, Frida's work was finally given the honor it deserved in her own country. She was offered a retrospective at The National Institute for Fine Arts—a very great accolade. Diego quickly realized that Frida was now too ill to manage the rigors of an opening at a major state museum. Since her return from the hospital, she *had* managed to paint—rather shakily it must be said—but her health had seriously deteriorated, and she was taking large doses of painkillers. Their great friend Lola Alvarez Bravo mounted the retrospective (and valedictory) show at the Galería de Arte Contemporáneo. Frida designed the invitations and Diego hung the show personally. But it looked as though Frida would be unable to attend. She was getting weaker and weaker and could no longer walk. However, she *did* attend the opening, arriving in an ambulance with a motorcycle escort in her own canopied bed from the Blue House! Her admirers lined up to kiss and congratulate her. It was the greatest evening of her professional life. She had never been braver nor more stylish. It was a celebration of her life as much as of her art, and she knew it.

In July, the doctors reluctantly decided that they would have to amputate her right leg at the knee because gangrene

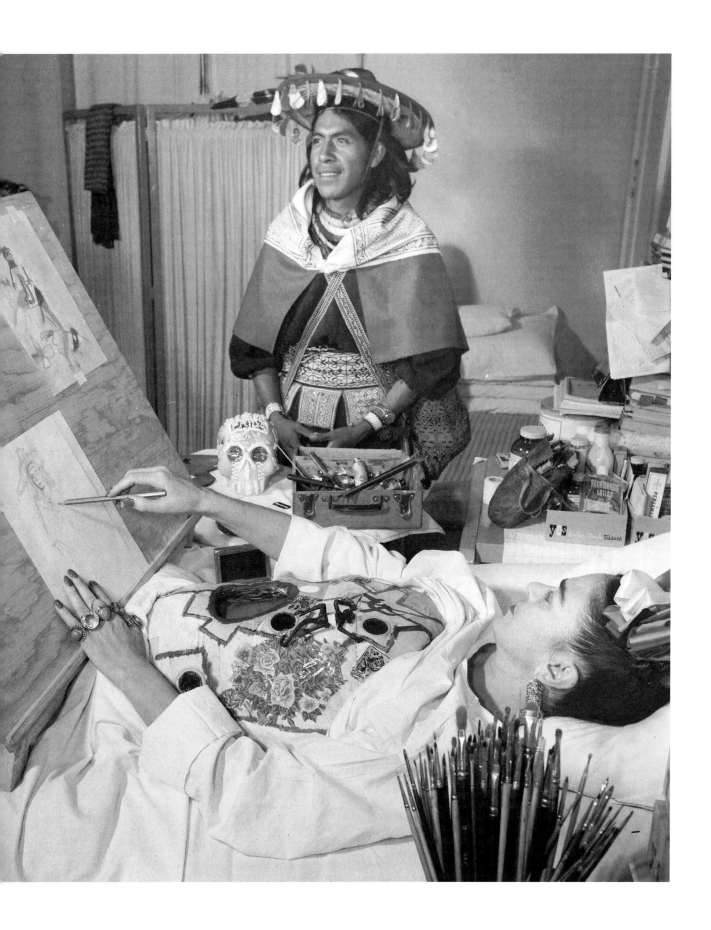

had set in. Frida had suffered with this limb since the bout of polio when she was six, but nevertheless was understandably grief-stricken and desperate at their terrible decision. Her diary is full of hysterical rambling at this point. "Night is falling in my life," she wrote in despair. As she had feared the polio invading her body as a child, the thought of gangrene was too, too terrible. It fed into her worst morbid fantasies. But soon her despair gave way to resignation and even optimism. With her customary bravery, Frida soon came to see this operation as a "liberation" from pain, and the operation was performed. A heroic, gut-wrenching drawing in her diary shows her two feet, with barbed vegetation growing out of the stumps, set as if a statue, on a plinth. It is accompanied by lines that speak of great courage and hope: "*Pies para que los quiero, si tengo alas pa' volar.*" (Feet, why do I need them if I have wings to fly?) One of her last paintings is the emotional *Viva La Vida* (page 146), a still-life of watermelons. It is crudely painted, in a hand that is not too comfortable anymore with brush and paint, but its message of triumph is unmistakeable—it is pure indomitable Frida.

After she recovered from this last operation, Frida was given an artificial limb. At first she stared at it continuously with horrified fascination. It looked like something that she might have painted herself! It was like the disembodied *milagros* (tiny metal charms which are pinned to the robes of patron saints) that she had seen in church when she was a little girl. But Frida stoically overcame her disgust, and eventually adopted the limb with customary humor and courage. She even learned to manage it quite well, and her long skirts hid it from the world. All that could be seen was a little red boot sewed with tinkling bells. As usual, her sense of style came to her rescue. She could manage short distances on the "new leg", but she also used crutches, with a wheelchair for very bad days.

Despite her attempts at gaiety, her mood darkened after the amputation, and she grew increasingly depressed. She depended more and more on both Diego and drugs, and sometimes she was not lucid. At other times her behavior was erratic and manic. She could insult her best friends—who were immensely supportive and loving throughout this time—and forget about her barbed remarks two minutes later. She spoke a few times of suicide, and wrote eliptical notes in her diary that imply that she thought of taking her own life. But I do not think that she contem-

Milagros. made from brass and tin, Mexico City and Morelia. These tiny medals are usually pinned to the cloak or gown of a saint in church to beg for Divine assistance in matters of money, health or the heart. Each tiny medal relates to the particular area of problem—the cow represents a sick animal, the eyes represent blindness. The significance of the broken heart is all too clear.

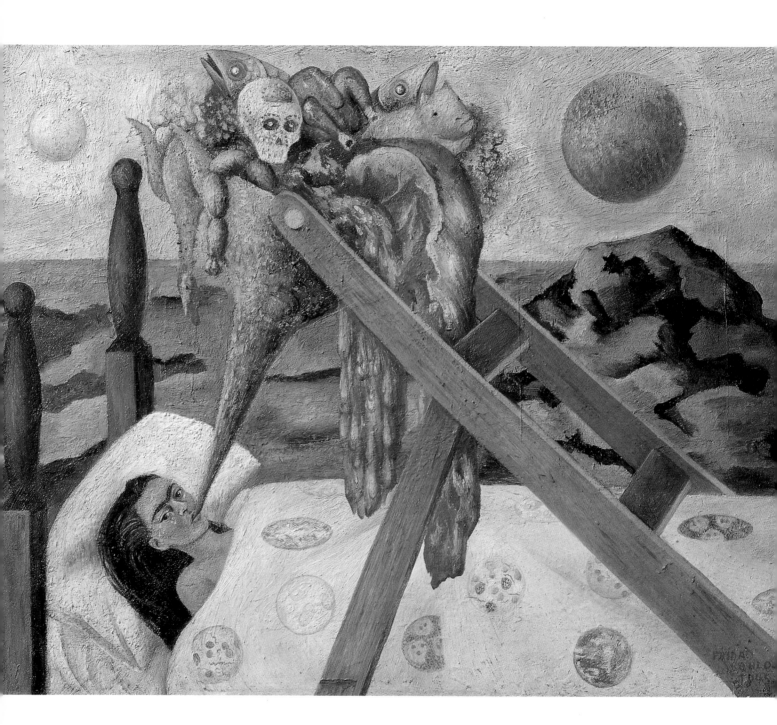

plated this option with conviction, no matter how tempting it must have seemed to her fading spirits. She seems to have always been brought back from the brink by her enduring love for Diego, her friends, her work, and curiosity about the future.

She made her last appearance in public on July 2, 1954, with Diego, at a political demonstration, protesting C.I.A. involvement in Guatemala. She looks frail, old, thin, papery-skinned, and wan in the photographs taken that day. She does not wear her gorgeous "Frida" clothes, but is wrapped in a coat and simple, rumpled headscarf, Diego's protective hand on her shoulder. She seems to have moved into a different sphere of being. She holds a banner reading "For Peace," but seems to be absenting herself before our eyes. Her eyes are vacant; the bold, brazen sensual gaze of the self-portraits has gone forever.

Some days after this rally, she celebrated her forty-seventh birthday with a small group of friends. In her weakened state of health she had contracted bronchial pneumonia at the outdoor demonstration and was actually very ill, but not too ill to enjoy her party. Frida always loved a party! Arturo García Bustos, her little *Bustitos* of *Los Fridos*, was with her every day over this period, and he wept quietly as he told me the story of how, a few days later, after this celebration, Diego's assistant Manuel Martinez found Frida lying in great pain on the floor of her bedroom. She had raised herself from bed, and had attempted to walk across her room without the support of her crutches—just to see if it were still within her power. She was grief-stricken at her own weakness and her loss of ascendency. Always the realist, she begged Manuel not to tell the *Maestro* about her patently impossible fantasy of walking free. "Diego will be so angry with me," she said. She knew that her great physical and psychic resilience was ebbing away. Manuel respected her confidence, and said nothing to Diego, but gently lifted her back into bed. She weighed nothing. That night, she gave Diego a ring to celebrate their twenty-fifth wedding anniversary. It was seventeen days away, but she knew that she was not going to make it. It was her good-bye to her lovable, fallible *carasapo* of a husband, and they both knew this. She was feverish, but calm. Diego sat and held her hand until late into the night, when she slept. Then, as he had always done, he left for the studio.

Without Hope, 1945.
Frida lies in bed weeping as she is being force-fed a symbolic deluge of food, in its rawest, crudest state. It is a protest against the puréed food she was given after her operations. Her bedsheet is decorated with a pattern of micro-organisms.
Oil on canvas, mounted on Masonite,
11" x 14¼".
Dolores Olmedo Collection, Mexico City.

Frida died early in the morning of the next day—on July 13, 1954. Diego, ashen and uncharacteristically silent, summoned her friends to her deathbed. A group of women came to the Blue House and lovingly dressed their friend in her favorite *huipil* from the Yalalag district. They braided her beautiful hair and bedecked her in jewels. Friends filed past her bier all day until evening, when her body was placed into a coffin and brought to the Palace of Fine Arts to lie in state. The chattering intellectuals of the city talked in whispers of suicide—that she had killed herself in a final gesture of despair seemed all too plausible to those who knew her in the last days. The death certificate which gave "pulmonary embolism" as cause of death was finally procured from Lupe Marín's brother, who was not Frida's own doctor. This was the cause of endless gossip, also fueled by the fact that no postmortem was ever performed.

But, while it is certainly true that despair stalked Frida as her familiar, I—like many of her best friends—do not believe that Frida ever succumbed to it. She expected, and finally embraced, her own inevitable death, but it seems impossible that she would have hastened it. At the time of her death, Frida was as engaged with the world and curious about what each day would bring as she had been when she was six, looking wistfully out of the window of her sick-room. Throughout her life Frida thrilled to the drama of life. She followed the twists and turns of her fate with intense curiosity, ever anxious to keep the plot moving along and *ever* set upon her role in the *masque*. She was always the most colorful, charismatic character in the story. My belief is that her heart—that part of her body that she painted so many times with such brutal honesty—just gave up the fight. It was so, so tired.

Frida lay in state at the Palace of Fine Arts, surrounded by a guard of honor made up of the Riveras' friends, students, politicians, and family for a day and a night. Then the Mexican people began, in their hundreds, to claim her in death as they had never truly claimed her in life. The cult of saintly Frida of the Wounds was born with her death. A

Self-Portrait with Ixcuintle Dog and Sun, 1953–1954.
This is probably the last self-portrait Frida ever painted, and she has painted her younger, softer self, from photographs, which are also the source of the rough sketch of Diego at the bottom of the picture. Her touch is sadly more uncertain in her last works, as her co-ordination deteriorated with her failing health. Oil on Masonite, 23¹/₂" x 15³/₄". Location Unknown.

Detail of a mural by "Bustitos" showing his beloved teacher with her student. Courtesy Arturo García Bustos.

myth began to grow rapidly around her untidy, wild, sad, glorious life like a pearl around a piece of grit, before her body was even committed to the flames. Having been told not to make any political capital out of her death, Diego gave Frida's faithful disciple Bustitos permission to drape the Red Flag, with its hammer and sickle, over her coffin. Thus, what was really important about Frida to those never fortunate enough to know her became eclipsed by an interesting anecdote, and a facile notoriety, which still prevails today.

The body of her work, which used her own body as its subject, became subsumed into the body-politic, where it still remains. What was, and still is, truthful and timeless about her art was hidden by a form of lie and a piece of theater. Frida had no political agenda. As she herself said: "I paint my own reality." But it's a painful irony that even in death she was able to help Diego. Disinherited by the Mexican Communist Party, his gesture achieved his devout wish to be clasped once more to its Stalinist breast; Diego was readmitted two and a half months after Frida's funeral. Frida had done it again. Diego said the gesture was for Frida, and his "only consolation." Frida, ever generous and loving, would have howled with laughter at this classic piece of self-serving self-deception. But she would have just loved the flamboyance of the gesture, and forgiven it. She always did.

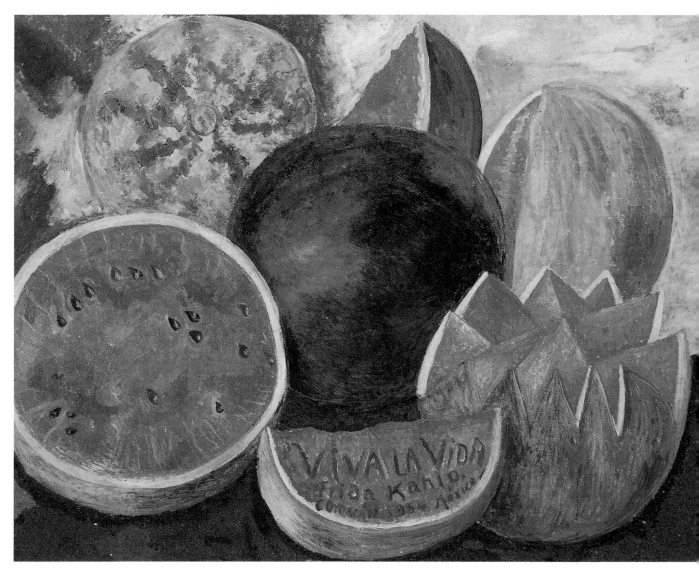

Magdalena Carmen Frieda Kahlo y Calderón de Rivera

July 6, 1907—July 13, 1954

Frida, Que descanse en paz.

Viva La Vida.

Viva La Vida
(Watermelons), 1954.
*Oil on Masonite,
23⅓" x 20".
Frida Kahlo Museum,
Mexico City.*

GLOSSARY & NOTES

Aguardiente:	literally "fire-water," an alcohol distilled from cane sugar.
Anáhuac:	the ancient name for the country now called Mexico.
Anáhuacalli:	*Anáhuac* means "the valley of Mexico," *calli* is the "house"— Diego Rivera's fascinating, but gloomy, personal museum of pre-Hispanic artifacts in the Pedregal district of Mexico City, which he created at some personal cost. It was given to the Mexican state after his death.
Autentica:	authentic.
Caciques:	Spanish term for the various Aztec tribal chiefs.
Cadavre Esquis:	literally "exquisite corpses"—a game for two or more players; one person draws a head on paper, folds it, and passes it on to a fellow player, who draws a torso, folds it and passes it on in turn—one of Frida Kahlo's favorite games. Her drawings were hilarious and often obscene.
Calavera:	a very common form of folk art, usually made of papier-mâché, which depicts a skeleton figure. Its purpose is to mock the very idea of death.
Carasapo:	"frog-toad," a cruel but affectionate nickname given by Frida to her husband, Diego Rivera, whose hyperthyroid gaze and overweight body made him look like a hybrid of these creatures.
Cé Acatl Topiltzin:	another name for Our Lord *Quetzalcóatl.*
Cé Ácatl:	1519, the returning year of "one reed" in the cyclical Xuihpohualli, the Aztec solar calendar.
Cem Anáhuac Yoyotli:	the *Anáhuac* name for the ancient capital *Tenochtitlán,* literally meaning "The Heart of the One World."
Chichen Itzá:	a very important religious and political center for the Classic Maya (7th - 10th centuries) and later, the post-Classic Toltec tribes (to c.1200). It is set in the north of the Yucatán Peninsula.
Chichimeca:	also known as *Mexica,* a tribe thought to have settled in the valley of Mexico in the fourteenth century; ancestors of the Aztecs (see *Mexica*).
Chinampas:	floating rafts of reeds anchored to the bottom of Lake Texcoco, used as platforms for agriculture by the Aztecs.
Cinco de Mayo:	literally "the 5th of May," the day in 1862 on which Napoleon III's army was beaten at Puebla.

Citli:	hare
Coatlícue:	Aztec goddess, mother of the moon, the stars and *Huitzilopochtli.* She is traditionally depicted wearing a skirt of snakes and a necklace of human hearts and hands.
Conquistadores:	the Spanish conquerors of Mexico who arrived in 1519.
Cuauhtémoc:	"descending eagle," last of the Aztec rulers, reigned 1520-24, nephew of *Moctezuma II,* captured by Cortés and executed. Now celebrated as a national hero in Mexico.
"El grito":	literally, "the shout" of Father Miguel Hidalgo on September 16, 1810, given in the town of Dolores, which marked the beginning of the War of Independence from Spain.
Encomienda:	the trust system of labor, post-Conquest, which was designed to replace slavery. The system gave the Indians certain freedoms, but ultimately became feudal and was later abandoned.
Ex-voto:	(or *retablo*) a painting which represents a miraculous cure or petitions God to create a miracle.
Fridomania:	the Mexican cult of the woman and artist—the "Fridolators."
Guacamole:	a delicious mixture of avocado (*aguacate*) and ground chilies (*mole*), flavored with lime; eaten as a first course or as an accompaniment to meat dishes.
Gringos:	a disparaging term used to describe the citizens of North America.
Haciendas:	homesteads and land belonging to the Spanish.
Huey Tlatoani:	"He who speaks with authority"—*Nahuatl* for the hereditary ruler of the Aztec state.
Huipil:	colorfully embroidered blouse worn loosely over a long skirt.
Huitlacoche:	a culinary delicacy that consists of a purple fungus found on young ears of corn.
Huitzilopochtli:	"Hummingbird on the left," the Aztec god of war and the sun.
La Chingada:	the violated woman, associated with the first sexual encounter between the conquistador Hernán Cortés, and *La Malinche,* or *Malintzin,* his Nahua mistress. The term has connotations of cultural violations (see *Malintzin*).
La Esmeralda:	the school where Frida taught in the 1940s (see *Los Fridos*).
La Llorona:	the heroine of many a Mexican folk song, and a figure who represents grief and bereavement. She is probably a descendant of the Aztec goddess Cihuacóatl.
"La Noche Triste":	literally, "the sad night," June 30, 1520, when Cortés ordered a retreat from *Tenochtitlán.* Two-thirds of the Spanish army were drowned, butchered, or captured on the western causeway of the city.
La raza:	the Indian race, with emphasis on its heritage.

Los Fridos:	the nickname given to Frida's four favorite students at *La Esmeralda*—Fanny Rabel, Arturo Estrada,Guillermo Monroy, and "Bustitos," Arturo García Bustos. They were thought of as her artistic "heirs."
Los Tres Grandes:	"The Three Great Ones"—the name given to the painters David Alfaro Siqueiros, José Clemente Orozco, and Diego Rivera.
Maestro (a):	master/mistress/teacher—a term of respect from a student or admirer.
Malintzin:	the young Nahua mistress of Hernán Cortés, known as Marina in Spain, and also as *La Malinche* in Mexico.
Mariachi players:	much-loved, ubiquitous, strolling, singing musicians—mostly dependent on tips for wages—who interpret traditional ballads for an invariably appreciative and sentimental public.
Maxtlatl:	a form of knotted loin cloth worn around the hips by Aztec farmers.
Mestizo (a):	the racial mixture of indigenous Indian and other races, notably Spanish.
Metl:	maguey cactus.
Metztli:	*Nahuatl* name for the moon.
Mezcal:	There are three strong liquors to be found in Mexico. In order of refinement they are *tequila, mezcal,* and *pulque.* All derived from the juice of the extraordinarily useful and versatile maguey (or agave) cactus, which also can provide vinegar, fiber (*ixtle*), needles and thread, paper, fuel, medicine for healing open wounds, tools, tubing and roofing materials (see *Tequila*).
Mexica:	one of the seven Aztec tribes, believed to have witnessed the sign of the eagle on the nopali cactus, snake in its beak, (the fulfillment of an ancient prophesy), thus founding *Tenochtitlán.* They were also known as the Aztecs and the Tenochca. The modern country of Mexico owes its name to this tribe.
Mexicanidad:	literally, "Mexican-ness."
Mexixin:	bitter-tasting pepper grass.
Michoacán:	state in Mexico, bounded on the north and south by the Leima and Balsas Rivers, and on the west by the Pacific Ocean, it stretches to the state of Guerrero in the east.
Mictlantecuhtli:	Aztec Lord of the Dead.
Mi jefe:	"my chief"—Frida's ironic name for her mother.
Milagros:	literally, "miracles"—tiny metal objects usually representing parts of the body, used by those seeking miraculous cures by the intervention of God. Accompanied by solemn prayer, they are pinned onto the robes of saints in church to effect a

miracle. Frida had a collection of these.

Moctezuma II:	(sometimes spelled Moctecozoma or Montezuma) the ninth Aztec ruler of *Tenochtitlán,* 1502-20; grandson of Moctezuma I.
Nahuatl:	the language and culture of *Anáhuac.*
Nemontemi:	literally, "days in vain." In the Aztec calendar, time was divided into 18 "months" of 20 days each, making a year of 360 days with 5 spare days, which were considered useless. People born on these days were thus born without a destiny, since the Aztecs believed that birthdate determined each individual's future.
Olmecs:	the "rubber people," active c. 1500-400 B.C. in what are now the states of Veracruz and Tabasco. Famous for their monumental sculpture and their cult of the werejaguar, which combines man and cat.
Omeyocan:	the ancient name for the domain of duality for the Aztecs.
Pan dulce:	sweet bread usually eaten in the evening as a snack.
Pantheism:	the worship of more than one deity.
Panzas:	"fat belly," another apt nickname given to Diego by Frida.
Piñata:	a large straw toy, usually an animal, stuffed with candy, that is beaten by children with sticks until it bursts open to disgorge its delights.
Polvo de pongo:	an indigenous yellow paint; Frida used it for the floors of the Blue House to great effect.
Porfiriato:	the term applied to the rule of the dictator Porfirio Diaz, 1876-1911.
Quechquemitl:	Aztec garment, still seen today in certain parts of the country, consisting of a woven triangular shawl, worn by women over their shoulders and breasts. The wrap-around skirt underneath is called a *cueitl,* and is held by a wide sash. The modern *poncho* is very similar to the *quechquemitl.*
Quetzalcóatl:	Aztec and Toltec god of regeneration; the Plumed Serpent, benefactor of mankind.
Rebozo:	Woven shawl worn by Mexican women over the head and shoulders.
Retablo:	(see *Ex-voto*).
"Smoking mirror":	a name which refers to *Tezcatlipoca,* sometimes symbolically represented by a smoking obsidian mirror in place of his left foot, which was ravaged by the earth monster, according to Aztec mythology. Frida Kahlo's right foot was amputated shortly before her death.
Tarascans:	the people of what is now known as *Michoacán,* in central western Mexico. Their powerful nation, whose capital was Tzintzuntzan on Lake Pátzcuaro, fell to the Spanish in 1528.

Tatas:	*Nahuatl* name given by the Indians to the first Spanish missionaries; literally, "daddies."
Tenochtitlán:	"Place of the fruit of the nopali cactus,"—the center of the Aztec world and its capital, now Mexico City.
Teotihuacán:	site of the city "where men became gods," destroyed between A.D. 650-850.
Tequila:	(see *Mezcal*).
Tezcatlipoca:	the "smoking mirror"—a creator god with many forms, associated with night, evil, and death; the adversary and dark counterpart to *Quetzalcóatl*.
The Blue House:	Frida Kahlo's birthplace, and later home, built in 1904, on the corner of Londres and Allende streets in the Mexico City suburb called Coyoacán. Now the Frida Kahlo Museum.
Tlaloc:	the Aztec rain god.
Tlatelolco:	twin city of *Tenochtitlán,* on the swampy Lake Texcoco—a great center of commerce, founded in 1370.
Tlaxcalans:	unvanquished peoples of the ancient state of Tlaxcala, founded 1328, ally in 1519 of Cortés in his "flowery wars," with *Tenochtitlán.*
Toltecs:	A.D. 950-1150—pre-Hispanic culture based at Tollan, now called Tula.
Tonantzin:	*Nahuatl* for "little mother"—the ancient earth-goddess associated with the Virgin of Guadalupe. Her ancient temple of Tepeyac, outside Mexico City, is the site of the shrine of the Virgin.
Tortillas:	long a staple ingredient of the Mexican diet, the *tortilla* is a form of pancake which is used to contain a filling of meat, beans, chilies, cheese, etc. They are usually eaten in the hand, obviating the need for utensils like plates or cutlery. Made from soaking corn grains in water and lime, the *tortillas* are later boiled, dried, and then ground with a stone roller on a *metate,* a three-legged stone grinding implement. The dough is then rolled out into circles and baked over an open fire on a *comal* (a griddle set onto stones). Tortilla dough can be made into *enchiladas* by cooking a filling inside the tortilla; fried and made into *tacos;* or stuffed and then fried and thus made into *quesadillas. Tamales* are made by beating the tortilla dough with some kind of shortening, and then steaming them in corn husks or banana leaves.
Xipe:	the Aztec "flayed god"—representing Spring, Xipe is commonly portrayed wearing a human skin.
Zócalo:	central square of Mexico City, site of the Cathedral and National Palace, once the site of the great pyramid of *Tenochtitlán.*

Glossary terms are denoted by *italics* at their first appearance in the text.

ACKNOWLEDGEMENTS

It has taken many Virgils to guide me through the dark wood of bureacracy, ego, and vested interests that became the corridors of my own personal labyrinth in writing this book. Lic. Norma Rojas Delgadillo, Director of Legal Affairs of the Instituto Nacional de Bellas Artes showed me part of the way. Antonio Luque and Richard Conkling at the Palacio de Bellas Artes were brilliant at explaining the lateral (rather than linear) way of negotiating the politics of the labyrinth, and I thank them now for their good advice. Frida's dearest friend, Ella Wolfe, kept me enchanted for many hours in Palo Alto, California, answering all of my invasive questions with humor and generosity. In Los Altos Hills, California, the late Marjorie Eaton described life with Diego and Frida, as a student and model for Diego—and then modeled for me, too. I want to thank my dear old friend, the late, great Mexico expert and fanatic Kate Simon, who ordered me to go to Mexico many years ago, for which I am still grateful. I am also indebted to Mrs. Dolores Olmedo and the Frida Kahlo Museum and Archive, Mexico City, and to the Bertram Wolfe Archives in the Hoover Institution Archives, Stanford University, Stanford, California— invaluable sources of both information and inspiration.

Peter Fonagy, Freud Memorial Professor of Psychoanalysis at University College, London, was also a source of inspiration to me. I am grateful to him for illuminating certain aspects of Frida's childhood, and concomitant themes in her work. I want to thank the psychotherapist Jean Engel, who was both a stimulating and enlightening friend to me in our many discussions over the years on child psychology. Lucienne Bloch Dimitroff and Steven Dimitroff were full of hospitality in Gualala, California, and told fabulous stories about their old friends and colleagues, Diego and Frida, in the glory days. Lucienne, with immense generosity, allowed me to use her photographs, and they capture the essence of a rare friendship. Arturo García Bustos and Rina Lazo were wonderful hosts in Mexico City, unstinting in their attempts to convey the essence of their beloved Frida with all the imagination and generosity of two true artists at life. I also want to thank my editor, Treld Pelkey Bicknell, for her unwavering devotion to the book.

My husband, Dr. James Hampton—who made many helpful contributions to the manuscript—and my children, Adam and Saskia, were marvelously patient and supportive through both my absence and my difficult presence—Frida was not always an easy ghost to live with in my home. Lastly, I want to thank Jenny Cook. Most of what I know and love about Mexico comes from this rare friendship.

R.R.

ILLUSTRATIONS

The author and publishers wish to thank the following for permission to reproduce copyright material: Art Resource, New York for pp. 11, 16, 18 *above*, 21, 53, 61, 65, 67, 69 *above*, 76, 77, 85, 86, 91, 92, 99, 107, 127 *above*, 140 (Dolores Olmedo Collection, Mexico City/Bob Schalkwijk), 24 (Bob Schalkwijk), 40-41 (Giraudon), 56 *main picture* (Frida Kahlo Museum, Mexico City/Nicolas Sapieha), 111 (Museum of Modern Art, Mexico City/Bob Schalkwijk), 118 (Frida Kahlo Museum, Mexico City/Bob Schalkwijk), 127 *below* (Robert Brady Museum, Guernavaca, Mexico/Bob Schalkwijk), and 143 (Bob Schalkwijk); Frida Kahlo Museum for pp. 69 *below*, 71, and 146; Centro Cultural Arte Contemporaneo/Collection Jacques and Natasha Gelman, Mexico City for pp. 14, 79 (Laura Cohen), 33, 126 *below* (Jorge Contreras Chacel), 97 *main picture*, and 122 (Javier Hinojosa); Mary-Ann Martin Fine Art, New York for p. 8 (Private Collection); Musée National d'Arte Modern, Centre George Pompidou, Paris for the frontispiece and p. 108; San Francisco Museum of Modern Art, Albert M. Bender Collection for p. 83 (Ben Blackwell); The Museum of Modern Art, New York for pp. 58 and 112 (Mali Olatunji); The National Museum of Women in the Arts for p. 102; Mrs. Bertram Wolfe, Palo Alto, California for p. 105 *above*; Phoenix Art Museum, Phoenix, Arizona for p. 114 (Gift of an Anonymous Donor); Harry Ransom Humanities Research Center, University of Austin, Texas for p. 116 (Reproduced by permission of the Instituto Nacional de Bellas Artes y Literatura, Mexico City); Albright-Knox Art Gallery, Buffalo, New York (Bequest of A. Conger Goodyear) for p. 126 *above*; Rina Lazo for pp. 131 *both* (Guillermo Zamora), and 132; Arturo Garcia Bustos for pp. 13 *main picture* (Guillermo Zamora), 121 (Juan Guzman), 125, 130, and 138 (Juan Guzman), 130, and 144; Mrs. Carolyn Farb, Houston, Texas for p. 134; Center for Creative Photography, Arizona Board of Regents for p. 12; Lucienne Bloch for pp. 89, 94, and 97 *left*; The Imogen Cunningham Foundation for p. 72; Jenny Cook for pp. 28-29, 32, and 48 *both*; Laura Kech for p. 49; Instituto Nacional de Bellas Artes, Mexico for pp. 75, 82, and 115; pp. 35 and 36 are courtesy of the Trustees of the British Museum; the painting on p. 19 and the photographs on pp. 15, 17, 27, 37 *below*, 39, 42, 43, 47 *both*, 54, 54, 55, 56 *right*, 81, 120 *left: above, middle and below*, and 129 *all*, are courtesy of the author; the photographs on pp. 13 *left: above and below*, 18 *below*, 37 *above*, 88, 104 *all*, 105 *middle and below*, 106, 119, 120 *main picture*, 124, 128 *both*, and 139 are by Alex Saunderson from private collections; the paintings on pp. 31, 44-45, 62, 80, 105 *top*, 109, and 136 are all from private collections. Every effort has been made to locate the copyright owners of all the paintings featured in this book; we apologize for any omissions in crediting those concerned and will give full acknowledgement in subsequent editions of the work.

The decorations are Aztec flat stamps and seals found in Mexico City, Oaxaca, Chalco, Teotihuacán, Azcapotzalco, Puebla, and Veracruz, reproduced in *Design Motifs of Ancient Mexico*, by Jorge Enciso (Dover Publications, New York, 1953).

The works of art by Frida Kahlo are reproduced by permission of the Instituto Nacional de Bellas Artes y Literatura, Mexico City.

 TEXT REFERENCES

The quotes appearing in the text are based on private conversations and public lectures as well as on the archives noted in the Acknowledgements and the published works listed in the Select Bibliography. Specific references are as follows:

Chapter 3: *The Faulty Mirror*
Page 61. D.W. Winnicott, "Ego Distortion in Terms of True and False Self," *Maturational Processes and The Facilitating Environment* (London, 1960), 147.
Pages 64-66. D.W. Winnicott, *The Piggle* (Penguin Books, London, 1991). Page 66. Melanie Klein, "The Emotional Life of the Infant," *Envy and Gratitude and Other Work 1946-1963* (Hogarth Press and The Institute of Psychoanalysis, London, 1983), 62.
Chapter 6: *Death and Laughter*
Page 128. Terry Smith, "From the Margins - Modernity and the Case of Frida Kahlo," *Block* No. 8 (London, 1983), 12.

The Index was prepared by Angie M. Baxter

SELECT BIBLIOGRAPHY

Baquedano, Elizabeth. *Aztec Sculpture.* British Museum Publications, London, 1984.

Bernal, Ignacio. *A History of Mexican Archeology.* Thames and Hudson, London, 1980.

Borges, Jorge Luis. *Poems.* Allen Lane, London, 1972.

Brenner, Anita. *Idols Behind Altars.* Payson and Clarke, New York, 1928.

Burland, Cottie; Forman, Werner. *The Aztecs.* Orbis, London, 1985.

Chadwick, Whitney. *Women Artists and the Surrealist Movement.* Little Brown, Boston, 1985.

Cockcroft, Weber, and Cockcroft. *Towards a People's Art.* E.P. Dutton, New York, 1977.

Davies, Nigel. *The Ancient Kingdoms of Mexico.* Penguin Books, London, 1983.

Edwards, Emily and Emanuel Alvarez Bravo. *The Painted Walls of Mexico.* University of Texas Press, Texas, 1966.

Freud, Sigmund. *Three Essays on the Theory of Sexuality;*

———*On the Sexual Theories of Children;*

———*The Dissolution of the Oedipus Complex;*

———*Some Elementary Lessons in Psycho-Analysis;*

———*The Ego and the Id.* Penguin Books, London, 1991.

Glantz, Margo. *The Family Tree.* Serpent's Tail, London, 1991.

Goldman, Shifra M. *Contemporary Mexican Painting in a Time of Change.* University of Texas Press, Texas, 1981.

Greene, Graham. *The Power and the Glory.* Penguin Books, London, 1940

Helm, Mackinley. *Modern Mexican Painters.* Dover, New York, 1968.

Herrera, Hayden. *Frida Kahlo; The Paintings.* Bloomsbury, London, 1992.

———*Frida; A Biography of Frida Kahlo.*

Harper and Row, New York, 1983.

Horcasitas, Fernando. *The Aztecs Then and Now.* Editorial Minutiae Mexicana, Mexico, 1988.

Klein, Melanie. *Envy and Gratitude, and Other Work, 1946–1963.* Hogarth Press and the Institute of Psychoanalysis, 1980.

Johnson, William Weber. *Heroic Mexico.* Harcourt Brace Jovanovich, San Diego, New York, London, 1968.

———*Kahlo, Frida and Tina Modotti.* Catalogue Whitechapel Art Gallery, London, 1982.

Knafo, Danielle. *Egon Schiele and Frida Kahlo; the Self-Portrait as Mirror.* Journal of the American Academy of Psychoanalysis, USA, 1991.

Lafaye, Jacques. *Quetzalcóatl and Guadalupe, The Formation of Mexican Consciousness.* University of Chicago Press, Chicago, 1974.

————Latin American Poetry: Selected Poems. Penguin Books, London, 1979.

Lowe, Sarah M. Frida Kahlo. Universe, New York, 1991.

Miller, Mary Ellen. The Art of Meso America. Thames and Hudson, London, 1986.

Mitchell, Juliet. Psychoanalysis and Feminism. Penguin Books, London, 1975.

Myers, Bernard S. Mexican Painters in Our Time. Oxford University Press, Oxford, 1956.

Natchez, Gladys. Frida Kahlo and Diego Rivera, Transformation of Catastrophe to Creativity. Haworth Press, USA, 1988.

Neruda, Pablo. Extravagaria. Jonathan Cape, London, 1972.

Paglia, Camille. Sexual Personae. Yale University Press, New Haven, 1990.

Parkes, Henry Bamford. A History of Mexico. Houghton Mifflin, Boston and New York, 1988.

Paz, Octavio. The Labyrinth of Solitude. Grove, New York, 1961.

Poniatowska, Elena and Carla Stellweg. Frida Kahlo; A Photographic Portrait. Arthaud, Paris, 1992.

Porter, Katherine Anne. From A Mexican Painter's Notebook. Arts Magazine, VII No.1, Jan. 1925.

Reed, Alma M. The Mexican Muralists. Crown, New York, 1960.

Riding, Alan. Distant Neighbors. Alfred Knopf, New York, 1985.

Rivera, Diego and Gladys March. My Life, My Art. Citadel, New York, 1960.

————Rivera, Diego, A Retrospective. Catalog Founders Society, Detroit in association with W.W. Norton, New York and London, 1986.

Simon, Kate. Mexico, Places and Pleasures. Harper Colophon, New York, 1984.

Smith, Bradley. Mexico, A History in Art. Doubleday, New York, 1968.

Spillius, Elizabeth Bott, ed. Melanie Klein Today. Routledge, London, 1988.

Tibol, Raquel. Frida Kahlo; Cronica, Testimonios y Aproximaciones. Ediciones de Cultura Popular, Mexico, 1977.

van Heijenoort, Jean. With Trotsky in Exile. Harvard University Press, Cambridge, Mass. 1978.

Vernon, P.E. ed. Creativity. Penguin Books, London, 1973.

Winnicott, D.W. The Piggle. Penguin Books, London, 1991.

————Ego Distortion in Terms of True and False Self. from Maturational Processes and the Facilitating Environment, London, 1960.

Wolfe, Bertram. The Fabulous Life of Diego Rivera. Stein and Day, New York, 1969.

————Bertram Wolfe Archives. Hoover Institution Archives, Stanford University, California.

————Rise of Another Rivera. "Vogue," New York, Oct/Nov, 1938.

Zamora, Martha. Frida Kahlo; The Brush of Anguish. Chronicle Books, San Francisco, 1990.

INDEX

A Few Small Nips 68; *69*
A Few Small Nips (preparatory sketch for) *69*
Acamapichtli 37
Acolhuatl 37
Aguardiente 47, 147
Alvarado, Pedro de 39
Anáhuac 25, 28, 34, 35, 46, 147; Valley of 31
Anáhuacalli 128, 130, 135, 147
Arango, Doroteo 55
Architecture 48, 49; *48*
Arias, Alejandro Gómez 77, 78; *80*
Austria, Emperor of 54
Aztec 28, 29, 30, 31, 32, 34, 35, 37, 38, 39, 42, 46, 47, 50, 80, 89, 124, 128, 133; *40, 80, 116*
Aztec calendar 36
Aztlan (the place of cranes) 31

Beloff, Angelina 87
Berggruen, Heinz 115
Bloch, Lucienne 93, 95, 96; *89, 94, 97*
Blue House 13, 17, 43, 57, 59, 75, 76, 82, 90, 101, 103, 104, 115, 117, 119, 123, 124, 128, 129, 130, 137 142, 151; *56, 59, 121, 129*
Bolsheviks 101
Booth Luce, Clare *115*
Bosch, Hieronymous 100
Boytler, Arkady and Lina 133
Bravo, Lola Alvarez 137
Breton, André and Jaqueline 103, 106, 108, 113; *108*
Bride Frightened at Seeing Life Opened, The 79
Broken Column, The 20, 124; *21*
Bus, The 77
Bustos, Arturo Garcia ("Bustitos") 20, 130, 133, 141, 145; *32, 130, 144*
Bustos, Hermenegildo 133

Calavera 104, 147; *105*
Carasapo 83, 141, 147
Cardenás, President 101
Caribbean Sea 27, 28
Catholic/Catholicism 15, 17, 29, 46, 47, 48, 51, 59, 66
Cé Ácatl Topiltzin 36, 147
Cem Anáhuac Yoyotli 28, 147
Chadwick, Helen 64
Chapultepec 54
Chichén Itzá 32, 147
Chichimeca 31, 147
Chick, The 91
Christianity 24, 29, 34, 46, 50, 51, 64
Cinco de Mayo 10, 53, 147
Circle, The 11

Civil War 53
Coatlícue (She of the skirt of snakes) 32, 51, 128, 148
Colhuacan 37
Colonial 18, 25, 59; *48*
Columbus, Christopher 28, 29
Conde, Teresa del 22
Conquest of New Spain 38
Conquest, the Spanish 25, 30, 35, 43, 46
Conquistadores 25, 148
Cortés, Hernán 28, 29, 30, 37, 38, 39, 42, 43, 46; *39*
Coyoacán 13, 43, 57, 76, 101, 115, 117, 128, 130; *56, 59, 129*
Crusades 29
Cuauhtémoc (the falling eagle) 37, 42, 43, 148
Cuauhtlahtoatzin, Juan Diego 50
Cuba 27, 28, 37, 39
Cuitláhuac 39

Day of the Dead 103, 104, 124; *105, 124*
Deceased Dimas, The 106; *107*
Detroit 90, 95
Diaz, Porfirio 42, 55, 59
Diego and I 9, 135; *8*
Diego in My Thoughts (Frida as a Tehuana) 123; *14*
Disembarkation of the Spanish at Veracruz 39
Distributing Arms 81
Duchamp, Marcel 108

Eaton, Marjorie *19*
El grito 52, 53, 55, 148
Eloesser, Dr. Leo 78, 90, 93, 108, 110,115, 123; *109*
Emperor Charles V 29
Encomienda 46, 148
England 53
Esmerelda Street 130
Europe 46, 117; *49, 80* war in 29
Exquisite Corpse(s) 106, 133, 147

Farmers Embracing 53
Farill, Juan, Dr. 135, 137; *136*
Ferdinand (King of Castille) 29
Flaubert, Gustave 20
Flower of Life 16
Folk art 10; *82, 85, 108*
Four Inhabitants of Mexico, The 104; *105*
Fourth International 101, 103
Frame, The 108; *frontispiece, 108*
Freud, Dr. Sigmund 20, 59, 63, 66, 73, 113
Frieda and Diego Rivera 82
Frida and the Miscarriage 86

Fridomanía 10
Fulang Chang and I 108

Galería de Arte Contemporáneo 137
Gauguin, Paul 79
Germany 57, 70
Gold 29
Great City of Tenochtitlán, The 27, *40/41*
Grimberg, Salomón 63, 78, 79
Gringolandia 95
Guatemala 34, 141

Haiti 27
Heart of the One World 28, 43
Henry Ford Hospital 93; *93*
Henry Ford Hospital 93, 95; *93*
Herrera, Hayden 64, 86
Hidalgo 52, 53
Hitler (Adolf) 70, 110
Holy Father 51
Holy Mother 51
Holy Sepulcher 29
Huastec Civilization, The 24
Huerta (General) 55
Huey Tlahtoani (Emperor) 29, 38, 40, 42, 148
Huichol Indian 137; *139*
Huitzilopochtli (Hummingbird on the Left) 28, 32, 34, 35, 37, 38, 46, 51

Iduarte, Andrés 76
India 29, 30, 31, 42, 46, 47, 50; *14*
Inquisition, Holy Office of the 47, 52
International Communist League 101
International Exposition 113
Italy/Italian 26, 27; Renaissance 76
Iturbide, Agustin de, Captain 52
Iztaccíhuatl 32

Jesus Christ 51
Judases (papier-mâché) 104; *104*

Kahlo, Cristina 59, 60, 66, 68, 98, 119, 133
Kahlo, Frida
 abortions 83, 84, 91, 106, 110; accident 60, 75, 77, 78, 80, 81; alcohol 135; and Alejandro Gómez Arias - see Arias; amputation 73, 124, 139; artificial limb 139; back 123, 137; birth 43, 55, 57, 75; children 78, 96, 100; cinema 15, 100; commissions 108, 115, 118; convalescence 135; *80*; cooking 15; crash 77; death (as symbol) 100, 106, 110, 123; *91, 115*; death 25, 57, 142, 145; depression 139; and Diego - see Rivera, Diego; divorce 110; dress,

style of 82, 90, 96, 108, 119, 124, 128, 141, 142; *14, 82*; early years 57, 61, 63; European art influence 80; European origins 17, 18, 25; exhibitions 106, 108, 137; family identity 76; father 17, 57, 59, 66, 68, 70, 73, 74, 81, 82, 101, 123; first pictures 81; food 118; *141*; foot 90, 104, 108, 139; Frida Kahlo Style 108; grandparents 59; *59*; hair 8, 17, 113, 135; health 74, 113, 117, 130, 137, 141; homecoming 137; hospital 81, 93, 95, 115, 125, 135, 137; hypochondria 60; identity 15, 25, 34, 59, 60, 61, 63, 66, 74, 82, 93, 96, 97, 104, 106, 109, 124, 128, 139; *59, 80*; imaginary friend 63, 74; Indian origins 15, 17, 18, 24, 25, 59, 76, 110; *127*; infidelities 100, 101, 103, 108, 115, 119; jewelry 12, 15, 82, 108; *13, 97, 109, 126*; kidney 108; kitchen 123; last public appearance 141; masochism 78; mi jefe 66, 149; miscarriage 93, 95, 106, 110; mother 17, 43, 59, 60, 63, 66, 70, 73, 75, 78, 81, 82, 96, 123; movies/plays about her 20; name 57; operations 20, 80, 81, 83, 84, 86, 87, 133, 135; osteomyelitis 115; pata de palo (peg-leg) 74; pets 110, 123; *116, 126, 127*; poetry 133; polio 73, 74, 78, 79, 139; politics 76, 81, 101, 113n, 128, 141, 145; *77*; pregnancy 18, 63, 84; psychoanalysis 60; sadism 10; self-portraits 10, 15, 26, 34, 61, 64, 82, 87, 103, 108, 110, 113, 123, 133, 137, 141; *8, 45, 80, 97, 102, 108, 109, 112, 116, 122, 126, 127, 136, 143*; sense of style 139; sexuality 10, 82, 98, 100, 101, 113, 118; *115, 118*; sister - see Kahlo, Cristina; spina bifida 79; spine 20, 64, 78, 81, 108, 133; St. Frida of the Holy Wounds 142; status 9, 10; still-life painting 139; *118 , 146*; suicide 139, 142; as teacher 130, 133; trophic ulcers 73, 90, 104; tuberculosis 113, 115; as victim 22; *126*; wet nurse 59, 60, 63
Kahlo, Guillermo (Wilhelm) 57, 59, 60, 66, 68, 70, 76, 82, 101, 123; *59, 71, 75*
Kahlo, Henrietta Kaufmann 57
Kahlo, Jakob Heinrich 57
Kahlo, Matilde 59, 60, 63, 66, 70, 73, 75, 76, 82, 96; *14, 59*

156

Knafo, Danielle 93
Kulkulkán 37

La Chingada 18, 148
La Esmerelda 130, 148
La Llorona 18, 148
La Maestra 133, 149; 130
La Malinche 18, 30
La Noche Triste 42, 148
La Raza 24, 55, 76, 148; 55
La Venta 30
Lawrence, D.H. 34
Lazo, Rina 89, 133; 131, 132
Lenin 88, 128
Leonardo da Vinci 26, 27
Leopold (King, of the Belgians) 54
Little Deer, The 133; 134
Lord of the Dead 32
Los Fridos 130, 141, 149
Los Tres Grandes 76, 149
Love Embrace of the Universe, The
 Earth (Mexica), Diego, Me, and
 Señor Xolotl, The 32

Madero, Francisco 55
Maguey plant 36
Malintzin (Marina) 30, 149
Mao Tse Tung 88, 128
Mariachi 87, 118; 88
Marín, Lupe 82, 83, 87, 142
Marx (Karl) 88, 128
Mask, The 18
Maximilian (Archduke) 53, 54
Mayan 30, 32, 34, 37; 37
Mejia 54
Mercader, Ramón 103
Mexica 31, 32, 37, 45, 149;
 32, 45
Mexican Communist Party 88, 101,
 113, 145
Mexican dress 48, 96, 142, 150; 14
Mexicanidad 17, 24, 75, 108,
 123, 149
Mexique 108; 108
Mexixin 31, 149
Michelangelo 9, 10, 26, 27
Michoacán 38, 106, 107, 149;
 13, 28
Mictlantecuhtli 32, 149
Milagros 139, 149; 139
Ministry of Public Education 82,
 130; 81
Miramón 54
Mixtec 55
Moctezuma 29, 37, 38, 39, 54, 150
Modotti, Tina 81
Morelos, José Maria 52
Motolinia 37
Muray, Nickolas 108, 110; 116
Museum of Modern Art 90
My Birth 63, 96; 62
My Nurse and I 63, 66, 104; 64, 66
My Parents, My Grandparents, and I
 70, 108; 59
My Parrots and I 123

Nahuatl 31, 34, 38, 54, 150
Napoleon 52, 53, 54
National Academy of San Carlos 55
Nayarit 104
New Workers' School, The 96; 89
New World 27, 29, 46
Nopali cactus 16, 32; 32, 59

O'Gorman, Juan 96
Oaxaca 17, 87, 119, 124; 18, 88,
 120 ; Governor of 53
Obrégon (General) 76
Olmecs 30, 31, 150
Omeyocan 26, 150
One Reed (Aztec Year) 36
Orozco, Clemente 76

Paglia, Camille 68, 70
Palace of the Fine Arts 142
Pan-American Unity 55
Panzas 82
Papalotl 116
Paseo della Reforma 42
Paz, Octavio 26, 57
Pedregal 128
Picasso, Pablo 20, 108; 109
Piggle 64, 66; Piggle, The 64
Plumed Serpent - see Quetzalcóatl
Pope, the 51
Popocatépetl 32
Porfiriato 55, 76, 150
Portrait (Nude) of Eva Frederick 61
Portrait of Don Guillermo Kahlo
 70; 71
Portrait of Donã Rosita Morillo 66
Portrait of Virginia (Niña) 85
pre-Hispanic 12, 17, 23, 24, 25,
 26, 30, 34, 37, 43, 47, 50, 59,
 64, 82, 97, 104, 116, 117, 128;
 37, 116
Preparatoria (Prepa) 74, 75, 76, 77,
 82
Psychoanalysis 20
Pulqueria la Rosita 130

Queen Isabella of Aragon 29
Querétaro 54
Quetzalcóatl (Plumed Serpent) 17, 32,
 34, 35, 36, 37, 50, 51, 150; 13,
 36; fall of 34; names of 34

Radio City, New York 88
Raphael 26, 57
Revolution 25, 51
Rivera, Diego
 as artist 17, 55, 68, 76, 90, 113,
 117, 118, 128, 133; 27, 39, 40,
 42, 43, 55, 89, 90; and Cristina
 60, 68; and family 87; and Frida
 12, 17, 22, 57, 68, 70, 76 (first
 meeting), 81 (second meeting), 82
 (wedding), 84, 86, 87, 88, 89, 90,
 93, 95, 96, 98, 100, 101, 104,
 106, 108, 110, 113, 115 (second
 marriage), 117, 118, 119, 123,

128, 133, 135, 137 (tenth
 anniversary), 141 (twenty-fifth
 anniversary), 142 (Frida's death),
 145; 13, 14, 55, 61, 82
 (wedding), 97, 109, 115, 143; in
 Frida's paintings 8, 14, 32, 82,
 143; infidelities 84, 86, 87, 89, 98,
 100, 115, 118, 135; and Lupe
 Marín 82, 87; politics 88, 101,
 113, 141, 145; and Rina Lazo 89,
 133; 19, 131; as storyteller 89
Rockefeller Center 95
Rockefeller Mural 96
Rockefeller, Nelson 88
Roots 45
Rosas, Dimas 106; 107

San Angel 96, 98, 100, 101, 117
San Francisco Art Institute 113
Sandblom, Philip 79
Santa Anna (General) 52, 53
Schiaparelli, Elsa 108
Self-Portrait 80
Self-Portrait Dedicated to Dr.
 Eloesser and Daughters 108,
 110; 109
Self-Portrait Dedicated to Leon
 Trotsky 102
Self-Portrait with Braid 123; 122
Self-Portrait with Cropped Hair
 110; 112
Self-Portrait with Dr. Juan Farill
 137; 136
Self-Portrait with Heavy Necklace
 97
Self-Portrait with Ixcuintle Dog and
 Sun 143
Self-Portrait with Monkey 127
Self-Portrait with Monkey and
 Necklace 126
Self-Portrait with Monkeys 126
Self-Portrait with Small Monkey
 127
Self-Portrait with Thorn Necklace
 and Hummingbird 8; 116
Sepia Ink Drawing 31
Siquieros, David Alfaro 76
Slavery 46
Smoking mirror 32, 34, 83, 150, 151
Spain 25, 27, 28, 29, 37, 39 42,
 46, 50, 51, 52, 53, 59, 101, 110;
 14, 48
Spanish America 46
Spanish Civil War 101
Stalin 101, 103, 113, 128; 124
Still-Life 118
Sugar skulls 103, 104; 124, 125
Suicide of Dorothy Hale, The 115
Surrealism 98, 106, 108, 113; 109

Tarascans 38, 150
Tehuantepec 82, 124
Tehuantepec Peninsula 17; 14
Tenochtitlán (place of the fruit of the
 nopali cactus) 16, 23, 28, 30, 32,

38, 39, 42, 43, 47, 50, 151; 40,
 42, 45
Teotihuacán 32, 34, 35, 151; 37
Tepeyac 50
Texcoco (Lake) 31, 32, 39, 42
Tezcatlipoca 17, 32, 34, 35, 36, 37,
 51, 151; 35
Thinking About Death 123
Tlaloc (rain god) 30, 32, 46, 51, 151
Tlapallan 36
Tlatelolco 38, 43, 151
Tlaxcala 39
Tlaxcalans 38, 42, 151
Tollen (place of the rushes) 32
Toltec 32, 37; 37
Toluca 108
Tonantzin 51; holy shrine of 50
Totonac civilisation 42, 43; 42, 43
Totonac Civilization 42, 43
Treaty of Guadalupe Hidalgo 52
Tree of Hope, Stand Fast 135
Tres Zapotes 31
Trotsky, Leon 101, 103, 104, 106,
 113; 102, 124
Trotsky, Natalie 101, 103, 106
Tula 32, 34
Tunas 108
Two Fridas, The 34, 110; 110
Tzintzuntzan 38; 116

United States 10, 53, 90, 95, 96
Universal Exhibition 54

Van Gogh, Vincent 79
Vasconcelos, José 55, 75, 76
Velásquez, Diego (Governor of Cuba)
 28, 37
Villa, Pancho 55
Virgin of Guadalupe 50, 51, 52
Viva La Vida (Watermelons) 139;
 146
Voladores (flying men) 43
Vorobiev, Marievna 87

War of Reform 53
Way of the Dead 35
West Indies 28
What the Water Gave Me 98, 106,
 108; 99
Winnicott, D.W. 61, 63, 64
Without Hope 141
Wolfe, Bertram and Ella 83,
 87, 110

Xipe (flayed god) 32, 151
Xiuhpohualli 36

Yeats, W. B. 15
Yucatán 28, 29, 34, 38; 37
Yucatán Peninsula 27, 32

Zamora, Martha 59, 86
Zapata, Emiliano 55
Zapotec Indians 53
Zócalo 104, 151

The numbers in *italic* refer to illustration captions.

Guadalajara

Queretaro

Veracruz

Mexico City

Acapulco

Frida Kahlo's
MEXICO